OUTDOOR SCULPTURE IN OHIO

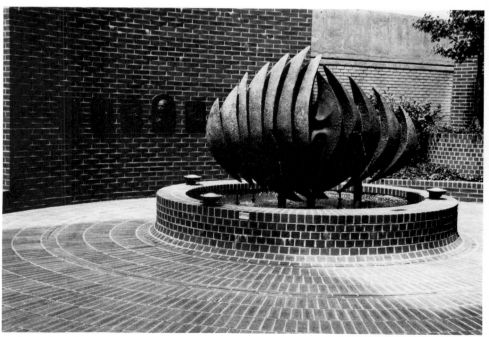

Eminent Sound

by Haycock

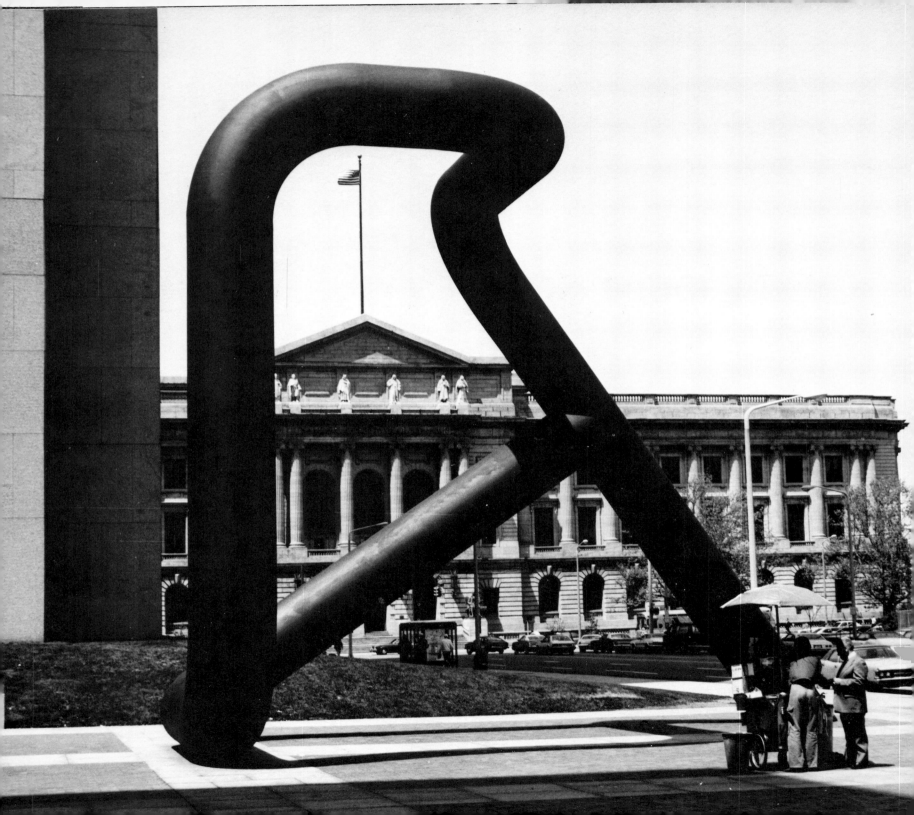

Richard N. Campen

OUTDOOR SCULPTURE IN OHIO

WEST SUMMIT PRESS, CHAGRIN FALLS, OHIO

Commitment . . .

. . . Until one is committed there is hesitancy, the chance to draw back, always ineffectiveness. Concerning all acts of iniative (and creation) there is one elementary truth, the ignorance of which kills countless ideas and splendid plans: that the moment one definitely commits oneself, then Providence moves too. All sorts of things occur to help one that would never otherwise have occurred. A whole stream of events issues from the decision, raising in one's favor all manner of unforseen incidents and meetings and material assistance which no man could have dreamt would come his way. I have learned a deep respect for one of Goethe's couplets:

Whatever you can do or dream you can do,
begin it.
Boldness has genius, power and magic in it.

. . . W. H. Murray

This book is dedicated to the memory of my father, M. J. Campen, and to the promise of my grandchildren— Richard Kramer, Peter, Sarah, Geoffrey and Andrew

Copyright © 1980 by Richard N. Campen
and West Summit Press
All rights reserved
Library of Congress Catalogue No. 79–57393
ISBN #0–9601356–2–6
Type-face: Palatino
Book design by author assisted
by Harold Stevens
Virtually all photographs by the author
Printed by Watkins Printing Co., Columbus, Ohio

4

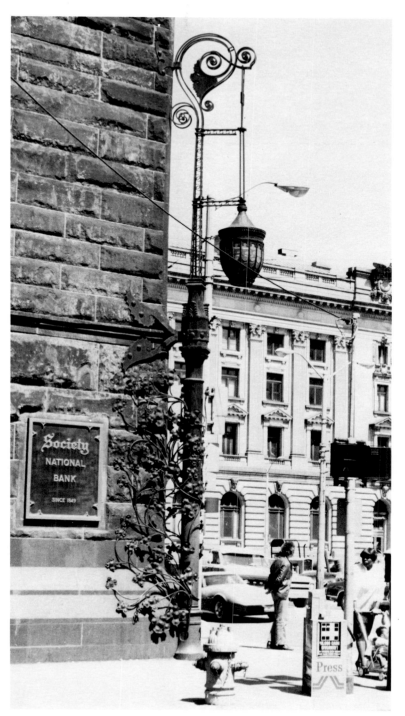

Table of Contents

00. Street Lamp (c. 1890), cast and wrought iron, approximately 35' in height. When affixed to Burnham & Root's Society National Bank Building on Cleveland's Public Square c. 1890, this handsome, art nouveau lamp was the first outdoor, lighting fixture in America.

INTRODUCTION

A tremendous reversal has taken place over the past 500 years in the relationship between buildings and sculpture. In Romanesque and Gothic times, i.e. between the 10th and 14th centuries, the sculptor was almost totally involved with stone-carving intended to be incorporated *into* the fabric of a building—usually a great cathedral. His work is seen, as one tours Europe today, in the 'gallery of kings' across their facade as at Notre Dame (Paris) or Amiens; in the tympanums over principal entrances where eternal bliss in heaven contrasted with damnation in hell, was a favorite theme; in the receding orders of arched door jambs and, most exuberantly, in the impost blocks atop Romanesque columns and in Gothic gargoyles. It has been said that this was the golden age of the sculptor in that, unfettered, he was allowed to give full vent to his imagination. This sculpture had great meaning to the parishioners, the vast majority of whom could not read. It was a principal means by which the message of the church and the bible stories were conveyed. Sarcophogi, too, defined as stone coffins bearing sculpture, then provided the stone-carver a splendid opportunity to display his skill.

Free-standing sculpture, *apart* from a building, rarely occurred throughout the Middle Ages. This development awaited the Renaissance Florentines who flanked the entrance to their Pallazzo Vecchio with Michelangelo's *David* (c. 1501) and Bandinelli's *Hercules*; also the Paduans who commissioned Donatello's *Gen. Gattamalata* equestrian in 1453. Towards the middle of the 16th century Florence's Loggia dei Lanzi, built before the Palazzo for the performance of public ceremonies, was converted into a sculpture 'garden' of sorts—perhaps the first in modern times, containing such well known works as Donatello's *Judith and Holofernes*, Cellini's *Perseus* and Giambologna's *Rape of the Sabines*.

However, the sculptural decoration of buildings continued apace, until comparatively recent times—even flourishing in America in the 1880's and '90's under the influence of architect Henry Hobson Richardson's personal interpretations of a revived Romanesque. In Ohio, Richardson's typically ponderous Chamber of Commerce Building (demolished, cf. Fig. 204), Asa Bushnell's polychrome residence in Springfield and Cleveland's Society National Bank are cases in point. All have sculptural embellishment, not the least interesting element of which is the famous, art nouveau street-lamp at the bank's southwest corner (page 5). In this connection, we also ought not lose sight of Louis Sullivan's splendid Sidney, O. bank (Figs. 130, 131, 132), nor the fine pediments of Cleveland's Ameritrust headquarters (Fig. 20) and Stark County's Courthouse (Fig. 21) in Canton.

As we moved well into the 20th century, exterior, sculptural embellishment became less and less a design element of important buildings. The decorated pylons which flank the huge, arched facade of Cincinnati's Union Station (1931), as well as those associated with Cleveland's Lorain-Carnegie bridge (1931-32), in the prevailing Art Deco style, virtually mark the last gasp of this dying convention. Thereafter, building dried up in America for the duration of the great depression of the 1930's and World War II. The new architecture of the post-war era, often post and spandrel with glass panel-wall, while not without beauty for its soaring verticals, is ostensibly void of sculptural decoration. The stone-carver of medieval times would find himself in today's unemployment line. Even his material, stone, has become largely obsolete as the sculptor's medium in the final decades of the present century.

Sculpture, today, has come down off the building and increasingly is found as a free-standing environmental entity on an adjacent plaza or greensward; as a humanizing element in contrast with the vast, impersonal structure with which it is associated. In addition to relieving the overbearing architecture, it is often a symbol of pride and prestige on the part of the occupant. Furthermore, contemporary, outdoor sculptures rarely commemorate heros and events; rather

they are abstract expressions challenging each to make his own assessment in the search for meaning or message. Jean Dubuffet, upon the unveiling of his mammoth, black and white *Group of Four Trees* on the Chase-Manhattan Bank Plaza in New York City, October 12, 1972, made this revealing statement:

"Obviously the work stands in full view of everyone here and each of us must now look at it with his own eyes and bring to it his own associations. My own belief is that a work of art fails in its function if its meaning is too limited. I believe that the meaning, or the meanings of any work of art should be wide open so that each of us can absorb it into our own particular universe".

This, I think, is the frame of mind in which one must confront Tony Smith's huge *Last*, now being installed before Cleveland's new State Office Building (November, 1979), George Rickey's fascinating *Two Rectangles Vertical Gyratory IV* before Cincinnati's Central Trust Co. and the other abstract works included in this volume. Their purpose is to aesthetically enhance the environment in which they exist and, as Margaret A. Robinette states in her *Outdoor Sculpture—Object and Environment,* "to contribute visually and experientially to the quality of life of those who experience it as an element in their daily environment". How different in placement and purpose from the work of the medieval stone-carver! Furthermore, as has been intimated above, steel and the acetylene torch have largely supplanted stone, chisel and mallet. Steel, as the sculptor's medium, has made possible works of a shape and size not previously conceivable.

A further, important, modern development, pointed up in the text which follows, is the innovation of the sculpture garden as we know it today. In these, the works of many, diverse artists are organized in a park-like setting, in varying degrees of formality, for the pleasure and enlightenment of the public. Examples at point are: the Smithsonian's Hirschorn sculpture garden in Washington, D. C., the sculpture garden within the courtyard of New York's Museum of Modern Art and the Brookgreen Gardens, near Charleston, S.C., established by Anna Hyatt Huntington and her husband. Ohio is very much in this picture, early with Cleveland's unique Nationality Gardens developed during the 1940's and '50's, more recently with the sculpture gardens at the Cleveland and Columbus Museums as well as Franklin Commons Park on the former site of the Victorian, Franklin County Courthouse. All are abundantly illustrated herein.

It is believed that in perusing this book the casual reader will be much impressed by the variety and the quantity of sculpture existing within Ohio's borders. It is, in fact, a primary purpose of the book to make Ohioans and the nation-at-large aware of the fine sculptural heritage which exists in the Buckeye state. This book is not a critique; seldom does the author pass judgement on a particular work. Rather, it seeks to bring the collective corpus together for all to view and for each to form his own opinions. It is hoped, however, that the compilation will lead to a greater understanding and appreciation, particularly, of what the contemporary artist, whose works comprise the greater part of the illustrative content, is attempting to "say" to us.

Perhaps it ought to have been obvious, but the author would like to share this observation with the reader; namely, that each sculptor, at any particular period in his career, tends to *explore* a particular bent or system (Isamu Noguchi is quoted herein as saying that each sculpture he undertakes is an *exploration*): Clement Meadmore, represented in the Columbus Museum's garden, has spent the past decade investigating the unlimited convolutions of the hollow, square tube on a massive scale; David E. Davis of Cleveland, in his Harmonic Grid series, has long since passed model number 44 (these experiment with varying arrangements of geometric shapes bearing incised lines which become a kind of Davis trademark); John Clague of Gates Mills, working in the area of kinetic sculpture, is currently and has for some time been intrigued with sculpture which produces sound as a part of its message—he often regards the rod-like, vertical elements in his work as

being botanical in character; George Rickey, also a "kineticist" continues to explore dual, triangular, tapered, stainless-steel wands and other shapes, in motion, ad infinitum. —each following a different drummer, as it were.

A word about the photo captions: An attempt has been made to frame each in such a way that the book will have immediate meaning and impact even though, at first, the reader may only examine the photographs. Hopefully, his interest will be stimulated to the point that he may wish to delve deeper at a later date. Information in the captions often supplements that in the essay and vice versa.

Finally, it will be obvious, from the numerous references made thereto herein, that the author found *200 Years of American Sculpture*, published by The Whitney Museum of American Art (1976), to be an invaluable source book. The author also owes a debt of gratitude to Prof. June Hargrove and Marianne Doezema for their splendidly researched *The Public Monument and its Audience* (1977) published by the Cleveland Museum of Art. Thanks are hereby expressed to the many individuals, too numerous to name, who kindly responded to the author's queries for specific information.

Richard N. Campen
January 1, 1980

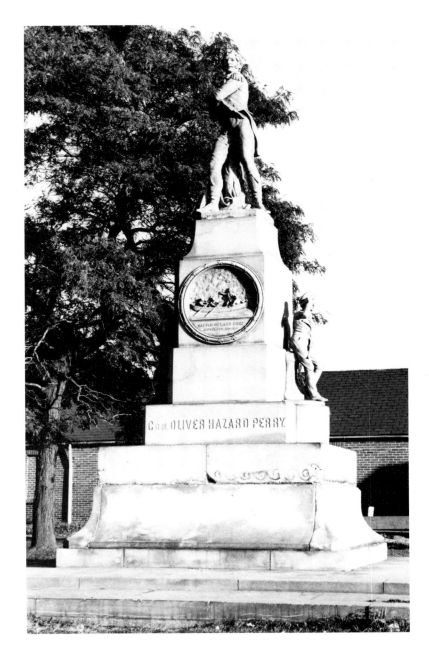

3. **Commodore Oliver Hazard Perry Monument** (1860) by William Walcutt, a native of Columbus, Ohio, marble with granite base, height-25'. Originally located in the SE quadrant of Cleveland's Public Square, this statue was moved to Wade Park in 1894 to make way for the Soldiers and Sailors Monument and ultimately (1929) replaced by the bronze copy seen in this photo. The original marble was presented by Cleveland to Perrysburg, Ohio where it was re-dedicated in September of 1937. The monument commemorates Perry's decisive defeat of a British fleet in The Battle of Lake Erie (September 10, 1813) after which he made his famous declaration, "We have met the enemy and they are ours".

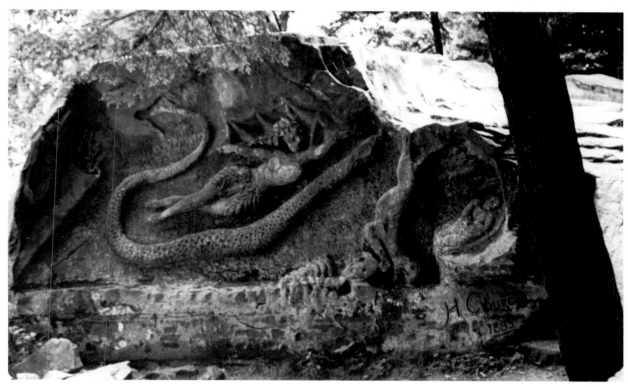

4. Squaw Rock (1885) by Henry Church (1836–1908) of Chagrin Falls, O.
Located on a trail along the Aurora Branch of the Chagrin River in the South
Chagrin Reservation of Metropolitan Park, Cleveland. Henry Church was the
second white child to be born in the Village of Chagrin Falls. A blacksmith by
trade, his shop was located at the SW corner of Franklin and Washington Streets
in the Village. Although he had barely three years of schooling, he read widely in
theology and other disciplines. Miriam (Mrs. Donald) Stem, his grand-daughter,
relates that the elder Church would set off in the late afternoon or evening, with
lantern in hand, to carve **Squaw Rock** which, she says, depicts the 'western
movement'. In the portion herein portrayed, one sees an Indian squaw and below
her, a snake-like beast representing pre-historic life. Above left is a quiver with
arrows while below right a skull and skeleton may be observed. Henry Church's
grave in Evergreen Cemetery is marked by a sandstone lion, sculpted by himself.
He did paintings as well.

BEGINNINGS: Early Statuary

Every civilization has expressed itself through the
medium of sculpture. Evidences of this may be seen in
the sphinxes and cenotaphs of the ancient Egyptians, in
the Lion Gates of the Anatolians and Myceneans, in the
pedimental friezes, metopes, steles and, above all, in the
remarkable, free-standing figures of the ancient Greeks,
executed in marble and bronze and in which the human
figure is idealized. The Romans carried on in the Greek
tradition, albeit in a more self-indulgent way, in that
representational, portrait sculpture proliferated.
Following the non-productive Middle Ages, sculpture
reappeared in the 11th and 12th centuries in the form of
elaborate impost blocks, carved tympanums and
engaged figures on the facades of Romanesque and
Gothic cathedrals.

The seeds of present-day sculpture were sewn during the Renaissance by such giants as Michelangelo, Donatello, Verrocchio and others who derived their inspiration from ancient Greece and Rome. Mostly, they chose religious and mythological figures for their subjects, but we commence to see impressive memorials to civic and military heroes such as Donatello's bronze equestrian monument of the Venetian General Gattamelata (1445-50) standing beside the Church of St. Anthony in Padua; also Verrocchio's equestrian monument of General Colleoni (1483-88) in the piazza beside the Church of SS. Giovanni e Paolo, Venice.

The tradition of honoring rulers, soldiers and statesmen continued, apace, in 18th and 19th century Europe. A few representatives of this type spilled over into Colonial America. One of these was a guilded-lead equestrian statue of King George III of England erected in 1770 for Bowling Green Place in New York City. Five days after the signing of the Declaration of Independence on July 9th of 1776, this was pulled down by an aroused populace and the King's head rolled in the dust. Melted down, it is said to have supplied material for 42,000 Continental bullets. The only other statue in New York City, the population of which approximated 20,000 at the time, was a full-figure, marble representation of William Pitt, the parliamentary champion of the colonists, also dating to 1770. This was "beheaded" and dismembered by British troops later in the year in reprisal for the King's earlier abuse.

Except for a few other wooden figures executed by ship carvers—one of Saint Paul in the pediment of historic Saint Paul's Chapel, still to be seen in lower Manhattan, and a "Justice" placed atop its historic City Hall in 1818—New York City was virtually without visible sculpture until mid-century. According to Frederick Fried[1], the first outdoor monument of any consequence to be erected in New York City was the bronze equestrian of *George Washington* by Henry Kirke Brown, assisted by John Quincy Adams Ward, which was placed upon a 14' high granite pedestal in Union Square in 1856.

The dearth of public sculpture in the three-quarters of a century following the Nation's founding, as exemplified by the situation in New York, may be attributed to the complete absorption with "getting-on-in-the-world." J. Q. A. Ward (1830-1910), an Urbana, Ohio farm boy who migrated to New York, was eventually to add more to the sculptural embellishment of the City in the 19th century than any other single individual[1a]. In 1868, Henry Kirke Brown's *"Abraham Lincoln"* joined *Washington* in Union Square. In the 1870's statues commemorating American statesmen occurred with increasing frequency in New York. Among these were a bronze *Benjamin Franklin* (1872) by Ernst Plassmann at Park Row, Nassau and Spruce Streets, and a *William Henry Seward* bronze (1876) in Madison Square Park. The Philadelphia Centennial Exposition of 1876 gave a tremendous impetus to the arts in America. As might be expected, the unparalleled growth and opulence of New York City in the final decades of the 19th century, coupled with the presence there of sculptors of the calibre of August Saint Gaudens and Daniel Chester French, resulted in a proliferation of commemorative and memorial sculpture.

Considering the above, is it any wonder that the first piece of monumental sculpture in Ohio was the marble *Oliver Hazard Perry Monument* erected in 1860 on the northeast quadrant of Cleveland's Public Square? Perry was the local hero of "The Battle of Lake Erie" which took place near Put-in-Bay in 1813. The original statue was given to the City of Perrysburg, Ohio, where, placed atop a tall, black, granite-faced plinth, it was re-dedicated in 1937. A bronze replica (Fig. 3), made possible by Cleveland's Early Settler's Association, has since found its way to Cleveland's lake-front at Gordon Park[2]. It is said that Hiram Powers (1805-1873) and Erastus Dow Palmer (1817-1904) were invited to bid on the *Commodore Perry Monument*, but that the funds available for its execution ($6,000) were not sufficiently attractive to interest these eminent practitioners of the day. Thus the commission fell to William Walcutt of Columbus. It ought to be noted (since this is a treatise on sculpture in Ohio) that highly regarded Hiram Powers, though born in Woodstock,

Vermont, spent his young manhood in Cincinnati, to which city his family had moved when he was a lad of thirteen. There, he learned to model in clay from the Prussian sculptor, Frederick Eckstein, who had also recently migrated to the "Queen City of the West". Having achieved some considerable success as a sculptor and with several important commissions in his "pocket", Powers set off for Florence, Italy, in 1837 and spent the remainder of his life there. He is perhaps best known for his *Greek Slave* which now resides in the Smithsonian Institution. Marble busts which he did of Charles Taft and Anna Sinton Taft are featured in the entrance hall of the Taft Museum, located at the eastern extremity of Lytle Park in downtown Cincinnati.

Cleveland's bronze casting from Walcutt's original marble work stands upon a granite base; lateral socles atop this bear a midshipman (left) and a sailor (right). The face of the plinth displays a lively medallion depicting action during the decisive naval engagement. This Cleveland composition, presented exactly as originally conceived by the sculptor, is pyramidal in form and visually considerably more satisfying than Perrysburg's monument lacking the auxiliary figures. Walcutt's lifelike presentation is in the heroic style of the time. A native Ohioan, he had little formal training in art until, at mid-life, he went to Paris where he studied with the best painters of the time. He is said to have won the first medal ever awarded an American by the French Academy. Not until comparatively late in life did he devote himself to sculpture. He died in 1882. A portrait statue of Dr. Samuel M. Smith, which stands before St. Francis Hospital, Columbus, is the only other Walcutt, outdoor commission known to the author.

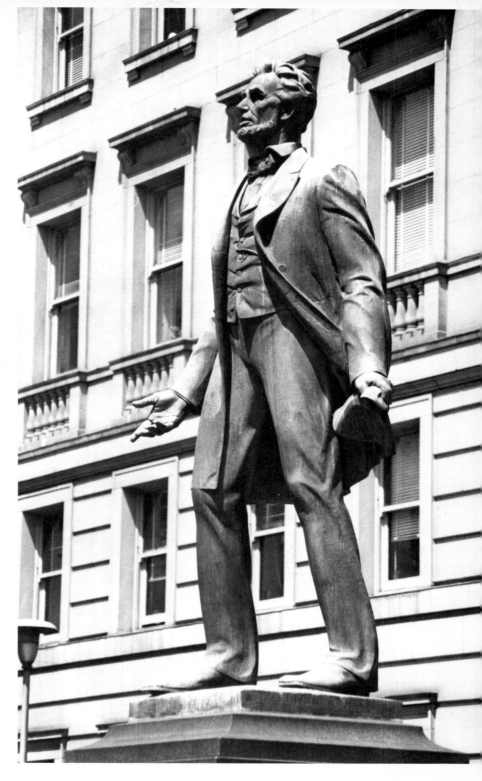

5. **Abraham Lincoln** (1932) by Max Kalish (American, 1891–1945), figure height-12'. The Kalish Lincoln, located on the Mall in downtown Cleveland, portrays the Great Emancipator in the act of delivering his Gettysburg address which is inscribed on the plinth below. This is Cleveland-reared Kalish's most prominent monument in the City and, to the best of our knowledge, the only one displayed out-of-doors. (cf. Fig. 81, page 70, for alternate aspect)

Aside from a plethora of Civil War Monuments standing before courthouses, or gracing public spaces in Ohio cities and towns, one can literally count on the fingers of both hands the public monuments which appeared on the Ohio scene prior to the 20th century. Virtually all of these are thoroughly documented by Marianne Doezema and Prof. June Hargrove in *The Public Monument and its Audience*, published in 1977 by the Cleveland Museum of Art. This carefully researched book has reference to public monuments in Ohio with particular attention to Cleveland. It concerns itself little, however, with Ohio sculpture and/or sculptors of the post World War II era and only incompletely with those of the preceding decades. It is the intent of this book to provide the reader, for the first time, with the broadest possible spectrum of notable sculpture in Ohio. A listing of Ohio, pre-20th century, outdoor monuments of note follows:

Commodore Oliver Hazard Perry Monument (1860) by
 William Walcutt (Fig. 3)
 Gordon Park, Cleveland, also Perrysburg, Ohio
The Sentinel (c. 1865) by Randolph Rogers
 Spring Grove Cemetery, Cincinnati (Not illus.)
Tyler-Davidson Fountain (1871) by August von Kreling
 Fountain Square, Cincinnati, Ohio (Figs. 7, 8, 9)
Liberty (1879) by William F. Gebhart and employees
 Originally installed atop Gebhart Opera House in
 celebration of U.S. Centennial; before Dayton Art
 Institute since 1969.
Garfield Monument (1890) design by George Keller,
 architect
 Garfield statue within by Alexander Doyle
 Lakeview Cemetery, Cleveland (Figs. 42, 43)
Soldiers and Sailors Monument (1894) by Levi Scofield
 Public Square, Cleveland, O. (Figs. 13, 14, 15)
These Are My Jewels (1893) by Levi Scofield
 Statehouse grounds, Columbus (Fig. 17)
Moses Cleaveland (1894) by James G. C. Hamilton
 Cleveland Public Square (Fig. 86)
Harvey Rice Memorial (1899) by James G. C. Hamilton
 Cleveland Museum of Art grounds (Figs. 83, 84, 85)

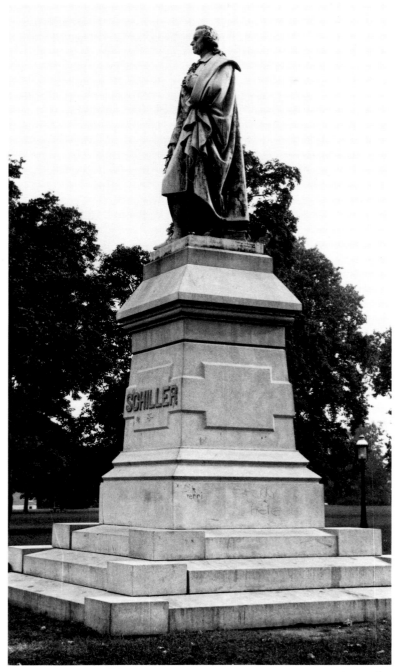

6. Friederick Schiller (1891) cast by Royal Bronze Foundry, Munich. Schiller Park, German Village, Columbus, O.

These pre-20th century Ohio sculptures are, without exception, executed in the traditional and completely representational manner following European, classical prototypes. All but Gebhart's *Liberty* honor heroes, poets, and notable citizens. If the number seems small—and it is—it must be remembered that Cincinnati had a population of only 216,000 in 1870; that Cleveland had only 92,000 (which was to quadruple by 1900); that Columbus had only 31,000. More importantly, Ohio was far too busy tapping its resources, developing its industry and building its cities and towns to think very seriously about public sculpture. It is of interest to note that of the ten monuments listed above, three were cast in Munich, Germany, either by, or under the supervision of Ferdinand von Müller (*The Sentinel, Friederick Schiller* and *The Tyler Davidson Fountain*). Of the balance, two were executed in marble and one (*Garfield's Monument*) is largely architectural. Founders, experienced in sculptural bronze casting, were few and far between, if existent at all, in America to mid-19th century. It may well be that The Ames Manufacturing Company of Chicopee, Mass., which cast Henry Kirke Brown and John Q. A. Ward's *Washington Equestrian* (Union Park Square, New York) in 1855-56 were the first bronze founders in America to attempt a monumental statue[3]. In a chapter, "Statues to Sculpture: From the Nineties to the Thirties", which appears in *200 years of American Sculpture* (1976), Daniel Robbins writes:

"Fueled with social idealism that made sculpture identical with statues, it was not hard for sculptors to find or invent subjects. In every important building, from library to railroad station, bridges, parks, zoos—where ever people were to congregate—there must be monuments to the accomplishments and ideals of American democracy.

"Monuments continue to be inspired by Lincoln and the Grand Army. Endless rows of the great men and women of all time were needed: Old Testament prophets, lawgivers from antiquity, classical poets, allegories of continents and of time, of fame, of truth, justice and integrity, of commerce and industry, of the seasons, of victory, of peace."

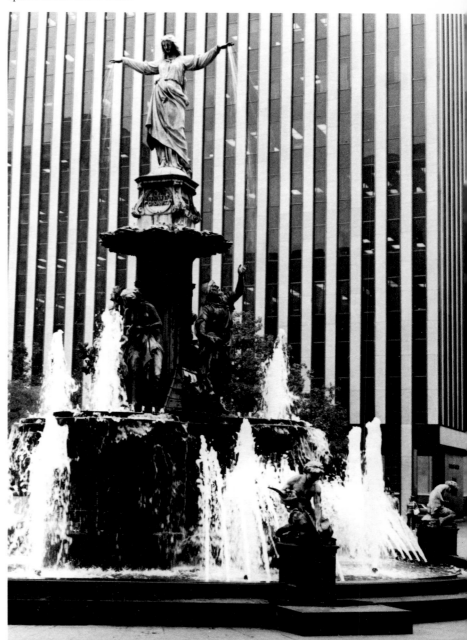

7. Tyler-Davidson Fountain (1971) by August von Kreling, bronze, c.35'H, The fountain, cast in Munich, Germany by Ferdinand von Müller from an old bronze cannon, was donated to the City of Cincinnati by Henry Probasco, a highly successful, civic-minded hardware merchant, in honor of his brother-in-law, Tyler Davidson. When originally erected, it was on the site of the old Fifth Street Market which ceased operations in 1870. With the redevelopment of Fountain Square in the 1970's, the fountain was moved slightly to its present off-center position as the center-piece of the Square—one of the most successful urban spaces in the entire State.

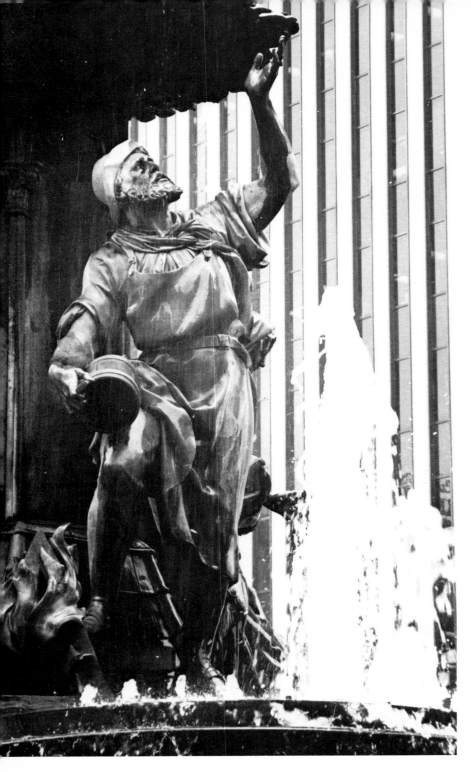

This is certainly an apt description of the sculpture of this period which one finds in Ohio as we shall see in the following paragraphs. Let us take stock:

Of Lincolns: we have the fine Max Kalish on the Mall in Cleveland (Fig. 5), also George Grey Bernard's popular but unflattering conception in Lytle Park, Cincinnati (Fig. 10). Cincinnati has another touching Lincoln memorial in a small park at the corner of Reading Road and Forest Avenue (Fig. 12), sculptor unknown, cast by the Bureau Bronze Foundry. Its plinth is inscribed with his famous words—"with malice towards none"—from the Second Inaugural. Wooster College in Wooster, Ohio, has (or had, cf. caption) yet another statue of *Lincoln, the Emancipator,* (Fig. 11) which, in 1964, stood before the entrance to the College Chapel (demolished).

8,9. Tyler Davidson Fountain, details, left and below, Fountain Square, Cincinnati, Ohio.

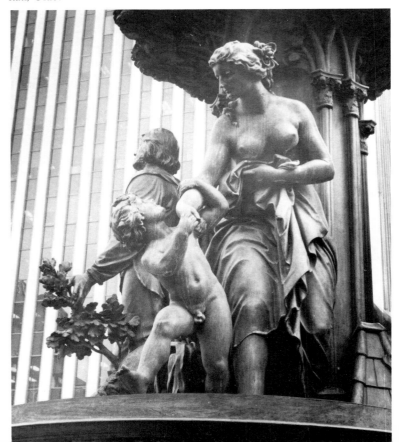

Moving to another category, without question the State's greatest memorial to the "Grand Army" is Cleveland's and Levi Scofield's huge *Soldiers and Sailors Monument* (Fig. 13) which fills an entire quadrant of the ten acre, Public Square. Also executed by the versatile Scofield, architect and former engineer in the Grand Army as well as sculptor, is his *These Are My Jewels*, a monument on the Statehouse grounds in Columbus (Fig. 17) immortalizing the Ohio generals and statesmen who served with Lincoln. In this, surrounding *Cornelia*, symbolizing Ohio, the realistic, life-size, standing figures of Generals William T. Sherman, Ulysses S. Grant, Phillip Sheridan and the statesmen Salmon P. Chase and Edwin M. Stanton, are represented.

The *General Phillip Henry Sheridan* monument (Fig. 16) by Carl Heber, which occupies a position of honor in his birthplace, Somerset, Ohio, is the most interesting representative in a surprisingly sparce equestrian category within the State. The only other equestrian, in the round, within Ohio's borders is that of the hero of Tippecanoe, President William Henry Harrison, in the regalia of an officer, located at Piatt Park in the heart of downtown Cincinnati (Fig. 44). Its sculptor, Louis Rebisso,[4] did a similar equestrian of General James B. McPherson, another Ohioan who distinguished himself in the Civil War. This is located in McPherson Square, Washington, D.C.

"Of Commerce and Industry," we have the groupings by Daniel Chester French before Cleveland's Old Federal Building and Post Office in which an idealized maiden holds a "whale-back", ore carrier in one arm while the other rests on a globe of the earth (Fig. 18). Its counterpart (Fig. 19) at the westerly extremity of the building symbolizes *"Jurisprudence"*. *Energy* by Henry Hering, at the Superior Avenue entrance to Cleveland's Federal Reserve Bank Building (Fig. 22) symbolizes labor's creativity in the Fourth Federal Reserve District, while the huge, classical figures, flanking the Bank's principal entrance (Figs. 23, 24) represent *Integrity* and *Security* to all who enter.

For *"endless rows of great men and women of all time"*, we turn to the Cuyahoga County Courthouse (Cleveland) where, flanking the steps before the
(continued on page 21)

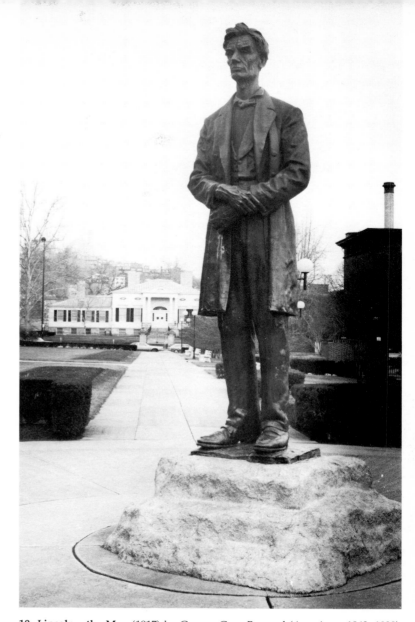

10. **Lincoln—the Man** (1917) by George Grey Barnard (American, 1863–1938), bronze on a stone base, 11' in height. Barnard's Lincoln, although portraying an awkward man with clumsy hands and feet, is much beloved by Cincinnatians. It was a gift to the City by Mrs. Charles Taft. Although commissioned in 1910, it was not unveiled in Lytle Park until March 31, 1917. Barnard was born in Bellefonte, Pa. Following one year of study at Paris' Ecole des Beaux Arts (1883), he lived there in poverty and loneliness from 1884 to 1896. Back in America, in 1903 he was commissioned to do the sculptural elements before the Pennsylvania State Capitol—the largest project enjoyed by any American sculptor to that date. He returned to France to execute it and remained there for 10 years. His collection of medieval art, purchased by John D. Rockefeller Jr. and given to the City of New York, is the backbone of the Metropolitan's Cloister Museum.

11. Lincoln at Gettysburg (1915) by John G. Segesman of Canton, O., lifesize in bronze. This statue of Lincoln, dedicated in October of 1915 before Kauke Hall at the College of Wooster, has had a very checkered 'Career'. In 1923 it was moved to the south side of the college chapel, but eventually, a subject of pranks and vandalism, it was placed in storage. In 1963 when our photo was taken, the statue was re-erected over only one of the elements of the original pedestal in celebration of the Civil War Centennial. Sadly, following some unfortunate handling, it is once again in storage. Segesman was 83 years of age in 1948.

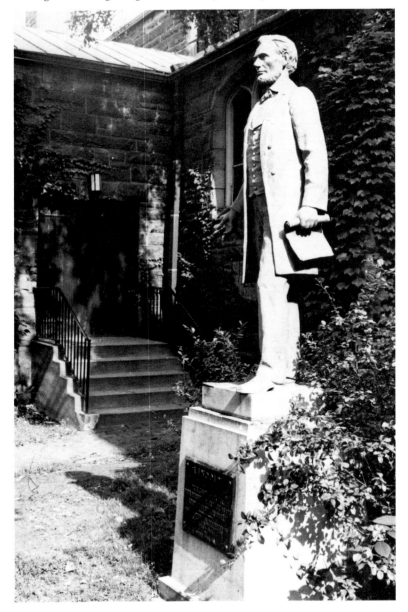

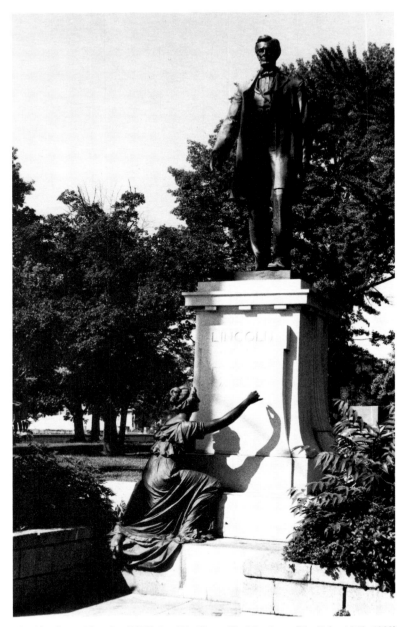

12. Abraham Lincoln (1902) by W. Granville Hastings (English, 1868–1902) bronze on a granite pedestal, overall height-19'. Hastings came to the United States in 1891 after having studied sculpture in London and Paris. In his Lincoln, Liberty, symbolized by the female figure, rather touchingly, inscribes the pedestal with those famous words from the President's second inaugural address—"with malice towards none . . ." The statue, cast by the Bureau Bronze Foundry, was a gift to the city by Captain Charles B. Clinton, a Civil War veteran.

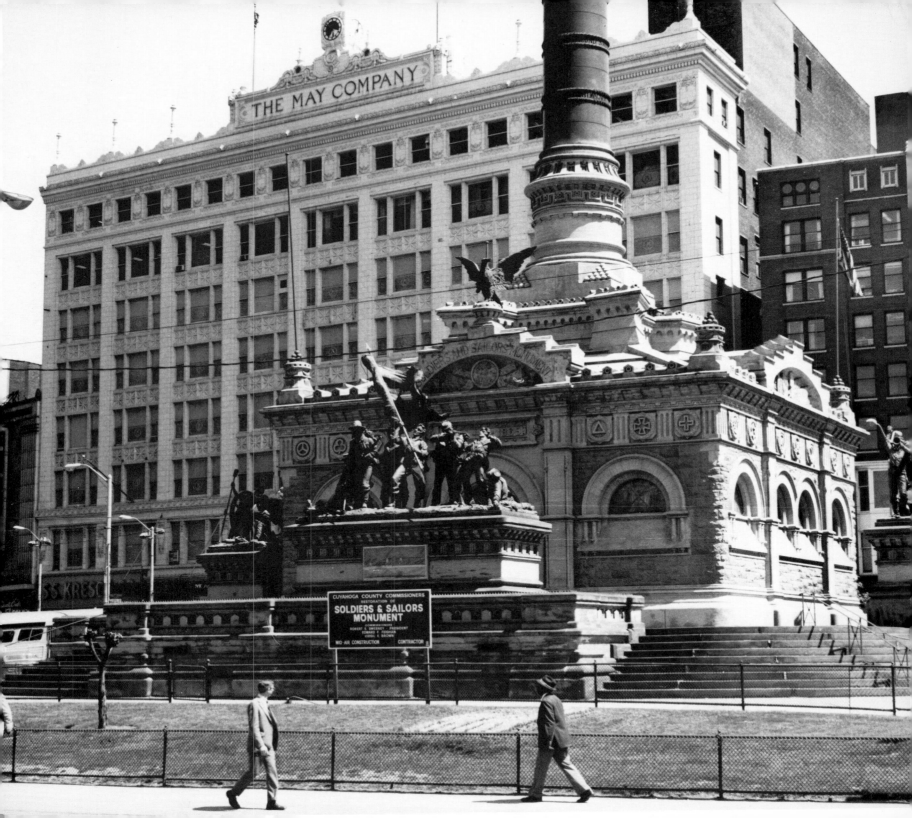

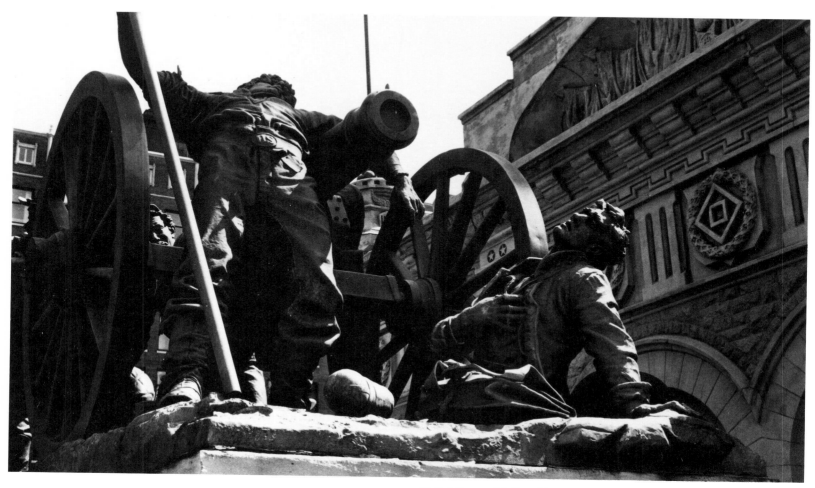

14. Soldiers and Sailors Monument—The artillery in action is the subject of the sculptural group on the monument's east side. Captain Schofield brought first-hand experience to these realistic compositions.

13. Soldiers and Sailors Monument (1894) overleaf, by Levi Schofield (sculptor and architect), sandstone base (building) with a Quincy granite shaft, four bronze figural groupings, located on Cleveland's Public Square. This is indeed a monumental monument—one of the last in the State commemorating the Civil War of 1861–1865. Each side of a "relic room" (the base) is preceded by a dramatic sculptural grouping depicting the several branches of the military in action. These, set on bases 7' to 8' in height, ought stimulate the interest and imagination of every schoolboy. The round, black, granite shaft, topped by Victory, reaches a height of 125'. This monument, totally representative of Victorian tastes, deserves more attention and pride on the part of Clevelanders than it receives. It is a foremost symbol of the City! Pres. William McKinley was the principal speaker at the 1894 dedication.

15. Soldiers and Sailors Monument—Schofield's subject for the west grouping is desperate men in a cavalry action. Quarter-size bronze models of these groups, for years housed in Cap't Schofield's office high up in the Schofield Building, SW corner of Euclid Ave. at E. 9th street, Cleveland, are now on display in the Cuyahoga County Courthouse.

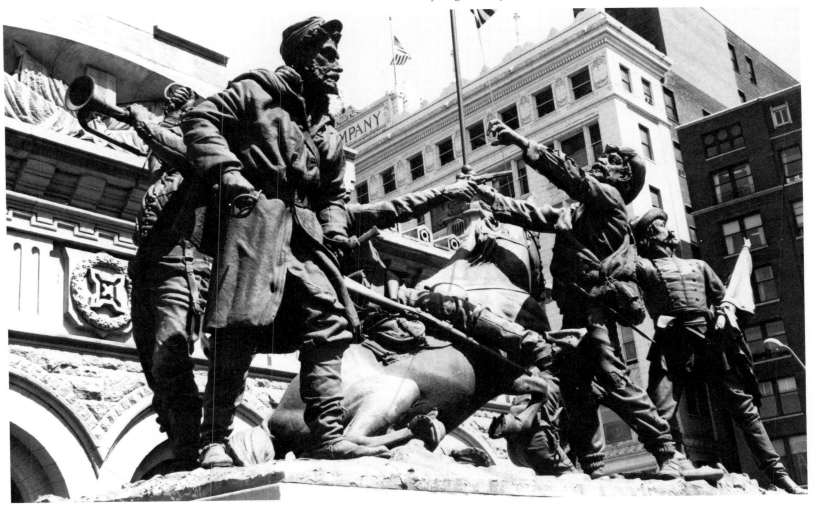

16. General Phillip Sheridan Monument (1905) by Carl Heber (American, b. 1874), bronze on a granite pedestal, 24' in height. A grant of $10,000 by the State made it possible for the little town of Somerset, originally the county seat of Perry County, to honor her native son with this impressive equestrian monument located on the town square. Sheridan is considered to be the most successful cavalry commander with the Union forces during the Civil War. Although our capital city, Washington, D.C. is literally 'awash' with free-standing equestrian monuments, mostly dating from the last three decades of the 19th century, there is only one other in the entire State of Ohio, namely that of William Henry Harrison in Cincinnati (the John H. Patterson Memorial in Dayton (cf. photo No. 138) is in high relief).

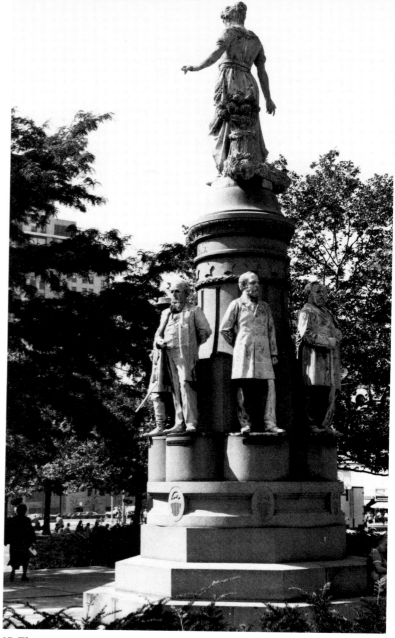

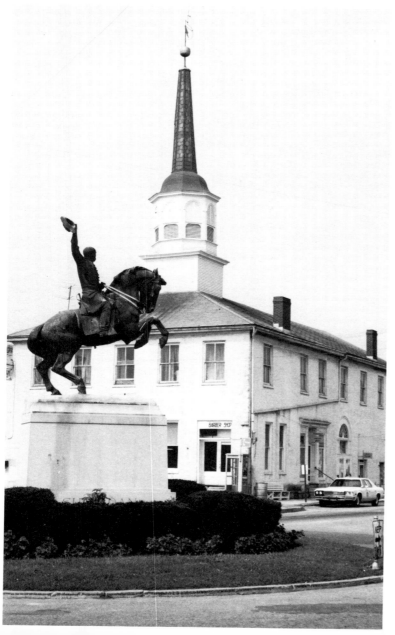

17. These are my Jewels (1893) by Levi Schofield (1842–1927), bronze with granite base, 30' in height. In this, the other major sculpture by Levi Schofield, recalling the parable of the Roman matron, Cornelia, who introduced her sons as "my jewels", Ohio honors her sons: Rutherford B. Hayes, Salmon P. Chase, William Tecumseh Sherman, Ulysses S. Grant, Phillip Sheridan, Edwin Stanton and James A. Garfield. The monument, located off the NW corner of Ohio's venerable, Greek Revival Statehouse, was dedicated in 1893. The figures, all modeled by Schofield, were with one exception, cast by either the Ames Bronze Foundry of Chicopee, Mass. or The Bureau Bronze Foundry.

Lakeside Avenue entrance one observes seated, bronze statues portraying *Thomas Jefferson*, author of the Declaration of Independence on the left (Fig. 26) and at the right, *Alexander Hamilton* (Fig. 28), author of the Federalist Papers and First Secretary of the Treasury—both by Karl Bitter. Similar recognition is given to John Marshall, Third Chief Justice of the United States Supreme Court, and Rufus P. Ranney, an Ohio Supreme Court Justice, on the north side of the building—these from the hand of Herbert Adams. Six additional life-size *"greats"* stand in a row below a pediment on the south side of the structure (cf. Fig. 27) as follows: Stephen Langton (of Magna Carta fame), Simon de Montfort (member House of Commons), Edward I (enlightened legal reformer), John Hampden (English statesman whose attempted arrest by Charles I helped to precipitate England's Civil War), Lord John Somers (English jurist, framer of the Bill of Rights [1688]), William Murray, Lord Mansfield (Commercial Law)—all of whom obviously contributed much to the development of English law from which our own is derived. Langton and de Montfort are by Herbert Adams; Edward I and John Hampden by Daniel Chester French, John Somers and Lord Mansfield by Karl Bitter.

(continued on page 28)

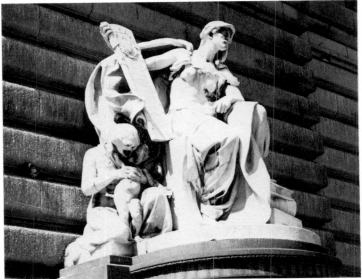

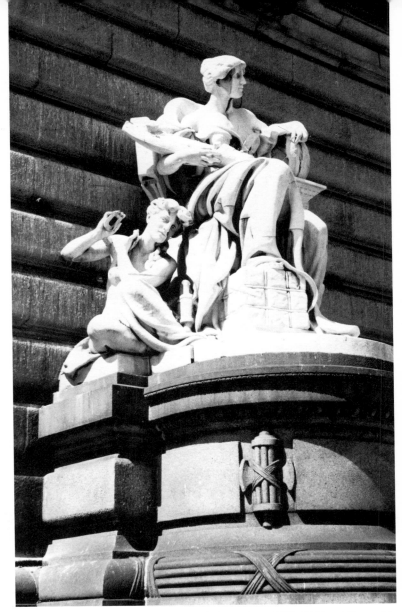

18. Commerce by Daniel Chester French (American, 1850–1931), white marble upon a massive granite base. French, the most noted sculptor in America at the time Cleveland's Beaux Arts Federal Building was completed (1912), received the commission to execute two pieces flanking its south facade: one depicts Commerce, the other Jurisprudence (major Federal courtrooms are housed therein). This Cleveland commission followed his successful allegorical representations of Asia, America, Europe and Africa which are very much a part of the architecture of New York's U.S. Custom House (1907) at Bowling Green. Their whiteness, too, stands in rich couterpoint against the gray granite facade. Daniel Chester French is best known for his Abraham Lincoln within the Memorial at Washington.

19. Jurispurdence (left) by Daniel Chester French, Federal Building, Cleveland Public Square. Allegorically, the law is portrayed protecting a mother and child.

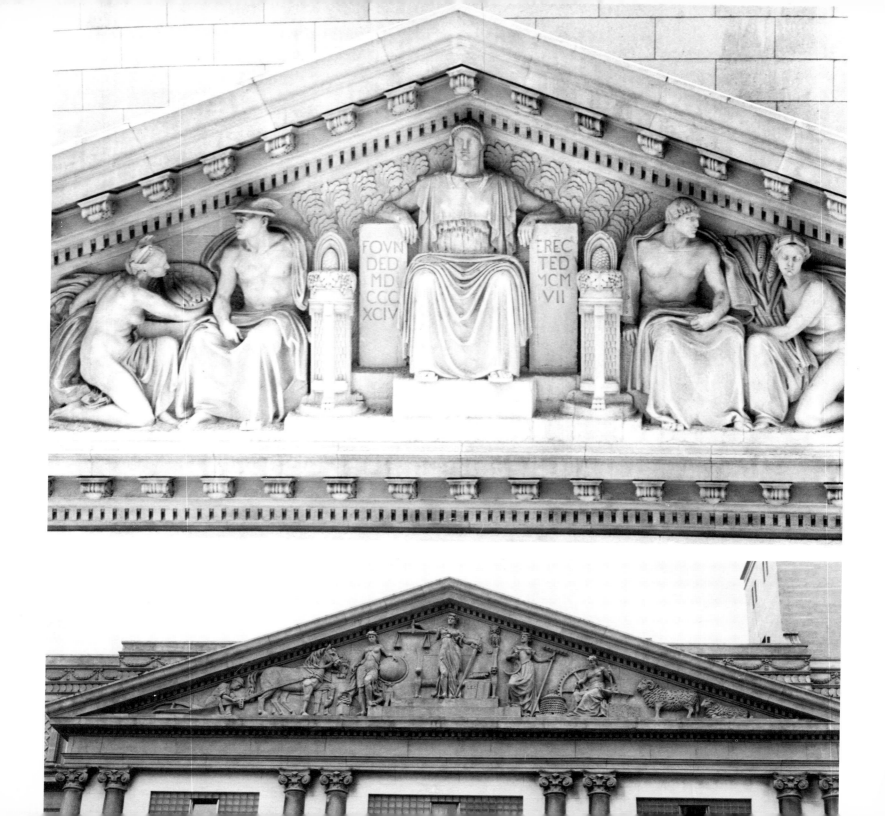

22. Energy in Repose (right) by Henry Hering of New York City, bronze upon a granite base, overall height c. 15'. Energy is located at the Superior Ave. entrance to the Federal Reserve Bank of Cleveland. The figure portrays a man in the fullest development of his physical powers. He is meant to typify physical energy, intelligently employed—symbolic of the industrial might of the nation's fourth Federal Reserve district. **Energy** was in place at the time of the opening of the Bank in August of 1923.

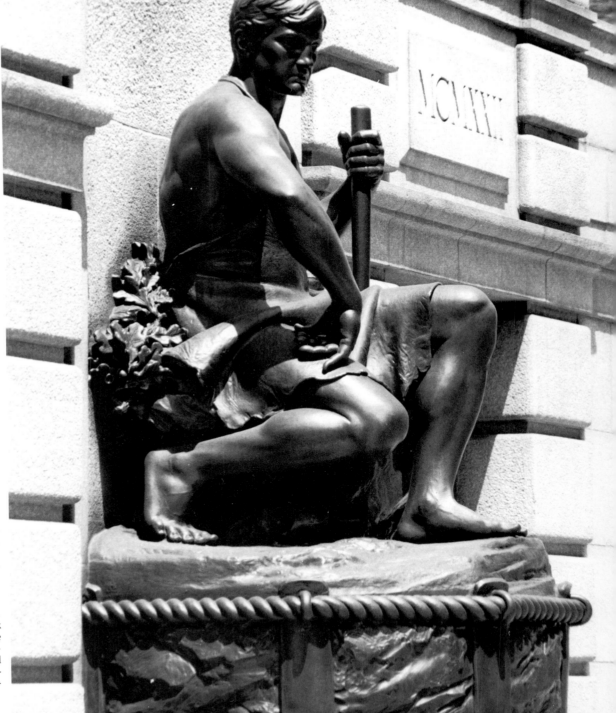

20. Pediment-Ameritrust Corporation (left above) by Karl Bitter (American 1867–1915). Bitter's theme in this 1907 work is the sources of wealth: that from the sea on the left; that from the land on the right, with banking and commerce epitomized by the noble, seated figure. The main office of Ameritrust Corp., located at Euclid Avenue and East 9th Street, was completed in 1909. The firm of George B. Post & Sons were architects.

21. Pediment-Stark County Courthouse, Canton, Ohio, (left below) sculptor unknown. The Stark County Courthouse was completed in 1895. The theme of its pediment is reminiscent of that at Ameritrust: agriculture represented by a man, horse and plow at the left; grazing by the sheep at right; inbetween, commerce, industry and justice are represented.

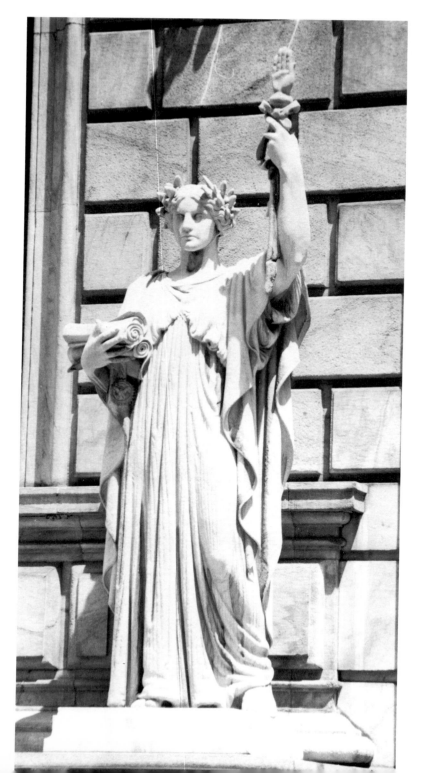

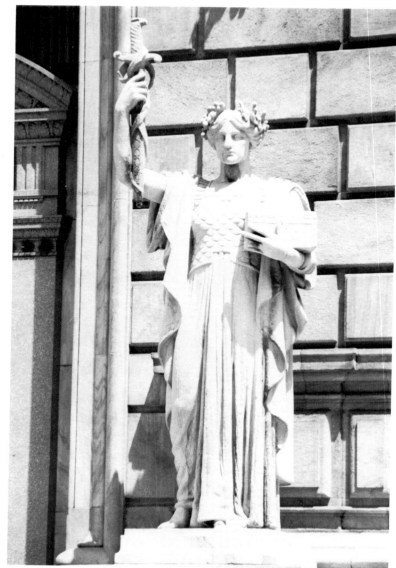

23, 24. Integrity and Security by Henry Hering (and Frank Jirouch), carved by Hering in the same pink Etowah, Georgian marble of which the building is constructed, 13' in height. These companion statues flank the main, East 6th Street entrance to the Federal Reserve Bank of Cleveland. **Security** is at the right with a strong-box in one hand and a sword with which to protect it in the other. **Integrity**, at the left, holds the rolls of office in one hand while the other holds a rod at the end of which there is a hand swearing allegiance thereto.

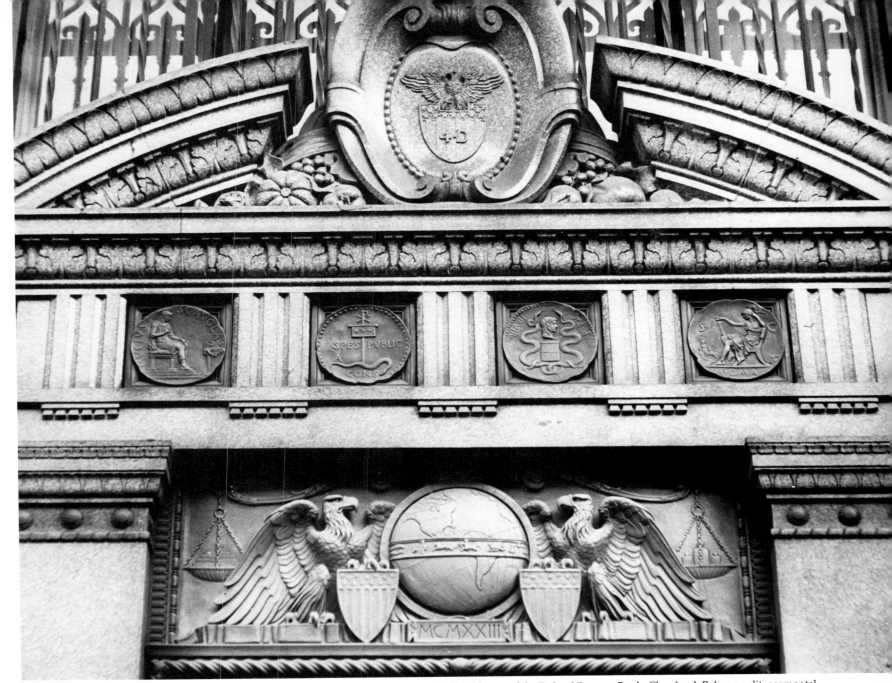

25. Entablature of the Federal Reserve Bank, Cleveland. Below a split, segmental pediment, bearing an escutcheon of the Fourth Federal Reserve District, one observes a marvelous frieze, following classical dictates, consisting of tryglyphs and metopes reproducing ancient coins. A bronze panel below represents the earthly orb surrounded by the zodiac, defended by the national eagle—all under the scales of commerce.

25

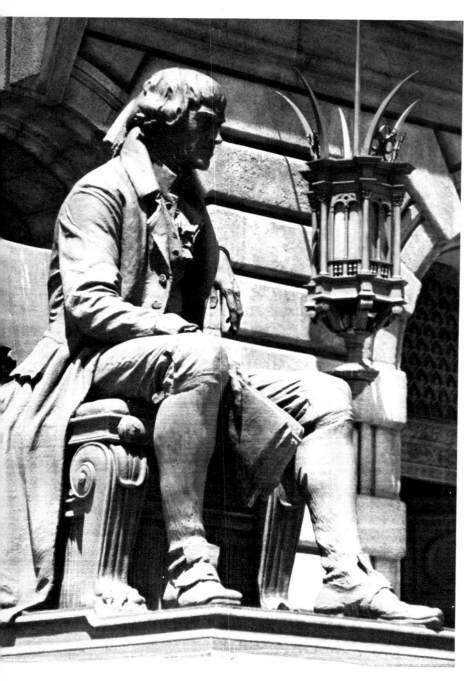

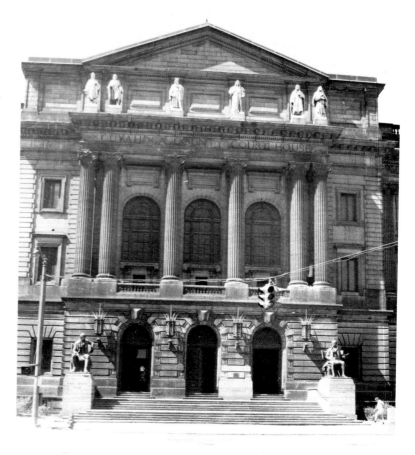

27. Cuyahoga County Courthouse, central facade (south), architects-Lehman and Schmitt (1913). In the attic on the south (Lakeside Avenue) side of the building, we see 8' to 10' statues of Stephen Langdon and Simon de Montfort by Daniel Chester French, Edward I and John Hampden, sculptor-?, and John Somers and Lord Mansfield by Karl Bitter. The north side of the Courthouse is similarly adorned with six figures in the attic (two, **Moses** and Pope **Gregory I** by Herman Matzen) while the bronze figures on the street level pedestals have as their subjects: John Marshall, Supreme Court Justice, and Rufus P. Raney, important interpretor of the Ohio State Constitution—both modeled by Herbert Adams of New York. The **total** cost of the carved statuary was, by today's standards, a meager $16,700!

26. Thomas Jefferson (1743–1826) by Karl Bitter, (left), bronze, height-6'. Jefferson is portrayed, contemplatively, with the papers of state in hand, attired in the accoutrements of his day and seated in a chair of Greek klismos derivation.

28. Alexander Hamilton (1787–1804) (right). Here, sculptor Bitter, in a companion-piece to the Jefferson, portrays Hamilton, 1st Secretary of the Treasury and leader of the Federalist party, with a somewhat more assertive countenance—walking stick in hand.

29. Entrance—Cuyahoga County Courthouse, Lakeside Avenue, Cleveland. This general view serves to locate the bronze Thomas Jefferson and Alexander Hamilton statues modeled by Karl Bitter.

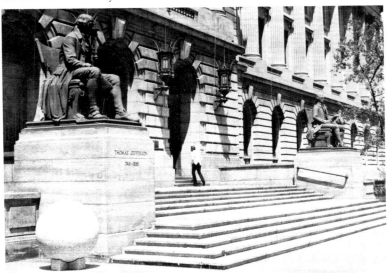

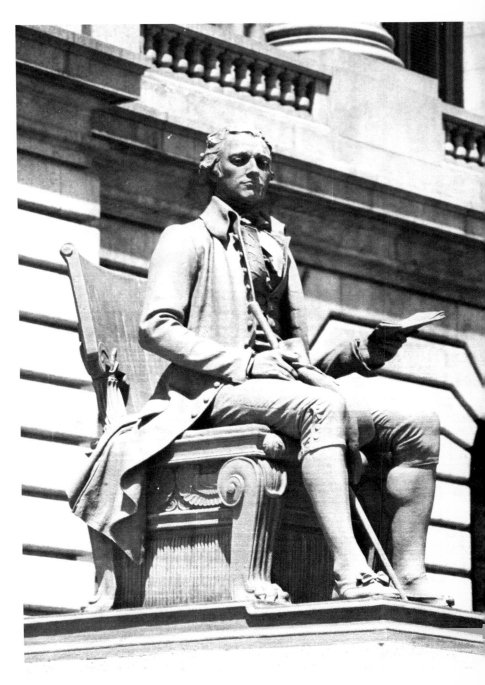

30. Perry Victory and Peace Memorial (1913) by Joseph H. Freedlander and Alexander D. Seymour, associated architects, New York City, Milford granite, height-352', location—Middle Bass Island, Lake Erie. This granite monument in the form of a huge Doric column, under construction between 1912 and 1915, commemorates Commodore Perry's victory over a British fleet in September of 1813 (photo courtesy National Park Service).

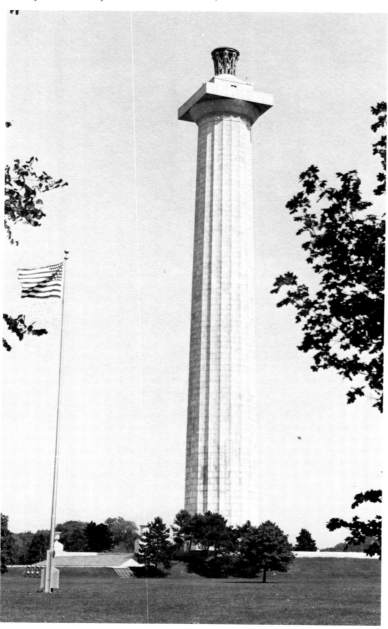

In the "victory and peace" categories, Ohio has *Perry's Victory and Peace Memorial* (Fig. 30) located on Put-in-Bay Island where Commodore Oliver Hazard Perry's fleet lay at anchor both before and after the Battle of Lake Erie (1813). Freedlander and Seymour, architects from New York City, won the competition for this project. *Peace* is also celebrated by a winged, allegorical figure on the Statehouse grounds by Bruce Saville (Fig. 31) who headed the Department of Sculpture at Ohio State University (1921-25).

In the presidential category, more monuments have been erected to William McKinley than to any other Ohioan. Two of these are largely architectural; the *Memorial Mausoleum* (Fig. 35) containing the sarcophagi of the President and his wife, located at Canton, Ohio (Harold V. Magonigle, architect) and the *McKinley Birthplace Memorial* (Figs. 32, 34) at Niles, in which a greater than life-size statue of the President is contained within an open, Greek, semi-circular peristyle (McKim, Mead & White, architects; Massey Rhind, sculptor). Elsewhere, before the Statehouse in Columbus, there is a fine memorial to McKinley consisting of an exedra with a large, central statue of the President on a high pedestal and allegorical groupings at either extemity (Fig. 38). Here the sculptor was Herman Atkins MacNeil of New York City. Still another, impressive memorial to the 24th President, this time at the hand of Albert Weiner, stands before the Lucas County Courthouse in Toledo (Fig. 39). Dayton honors McKinley with an 8' bronze, standing figure by Augustus Lukeman of New York City, dedicated in 1910 which stands in Library Park.

There are at least three memorials to Ohio's native-son and President, James A. Garfield. The largest and most elaborate of these, one of the most massive monuments in the State, is the 180' high, 50' diameter tower in Cleveland's Lakeview Cemetery. Within, there is a marble statue of the President, 7½' in height, by Alexander Doyle (1858-1922), a native of Steubenville. (Doyle has four statues in New Orleans, the largest being a bronze Robert E. Lee, 16½' in height, atop a 100' high hollow pillar; others are of Confederate Gen. Pierre Beauregard and Jefferson Davis). A second bronze

Garfield presides over Garfield Park in downtown Cincinnati (Fig. 44). Here the sculptor was Charles Henry Niehaus, a native Cincinnatian (b. 1855) whose bronze conceptions of John Paul Jones and Samuel Hahnemann (German-American physician) grace the nation's capital. We have already briefly noted a Columbus (O.) Garfield, namely one of the figures by Levi Scofield in his *These Are My Jewels* composite on the Statehouse grounds.

The marvelous *Tyler Davidson Fountain* unveiled in 1871 (Figs. 7, 8, 9) hardly satisfies any of the sculptural categories suggested above by Daniel Robbins. For over a century a thing of beauty and of interest to all who view it, it was (and is) a touching tribute on the part of Henry Probasco to his brother-in-law, Tyler Davidson. Probasco, to his everlasting credit, gave the large and complex fountain to the city for which it has become a symbol. One could not imagine a more appropriate center-piece for the city's redeveloped Fountain Square—the most successful urban space in the State. A work by August von Kreling, it was cast in Munich, Germany under the supervision of Ferdinand von Müller with metal from an old, bronze cannon.

(continued on page 38)

32. William McKinley National Birthplace Memorial (1917) McKim, Mead and White, architects, Georgia marble, 232' in width, located at Niles, O. Joseph G. Butler of Youngstown sparked the public subscription which made this imposing monument possible. A library is appended thereto through the generosity of Henry Frick. Behind the dual, Doric colonnade there is a semi-circular colonnade in the center of which stands a statue of the martyred president (by Massey Rhind). Lining the wall of the latter there are a number of busts of associates and contemporaries of McKinley—all by Massey Rhind of whom Joseph G. Butler was a splendid patron.

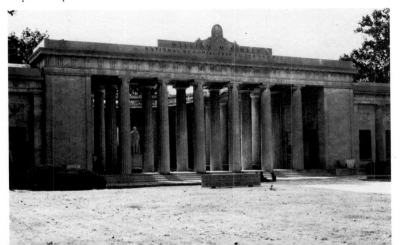

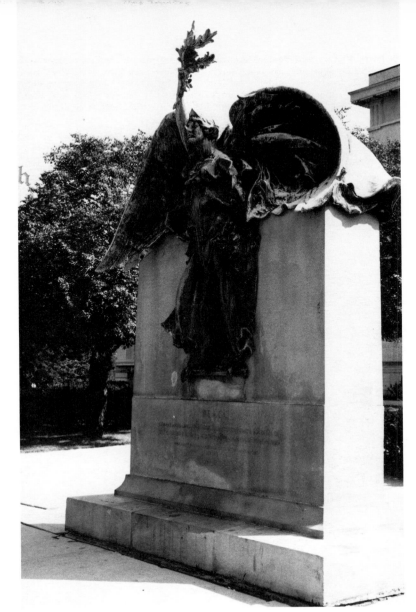

31. Peace by Bruce Saville (American, b. 1893), bronze and granite, 12-15' in height. This monument "commemorates the heroic sacrifices of Ohio's soldiers in the Civil War and the brave women of that period". The classical figure in bronze appears to be a winged victory with upraised arms holding oak or laurel leaves—symbols of peace. The plinth bears the date 1923. Saville was a native of Quincy, Mass. After studying under Henry Kitson in Boston for four years, he became an instructor in modeling at Ohio State University. His other major, Ohio work is a monument commemorating the **Battle of Fallen Timbers**, near the Maumee River south of Maumee, O. In this an Indian, a trapper and a soldier, representing the inhabitants of the Northwest Territory at the time, are portrayed. **Fallen Timbers** (August, 1794) in which Gen. Anthony Wayne finally subdued the Indians, opened the Ohio Territory for settlement.

29

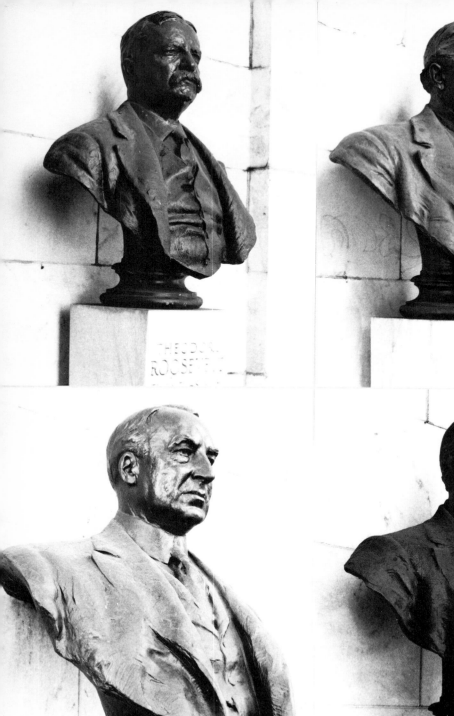

33. Busts—McKinley Memorial, Niles, Ohio, Massey Rhind, sculptor.
Upper left—Theodore Roosevelt
Lower left—Warren G. Harding
Upper right—William H. Taft
Lower right—Marcus A. Hanna
The busts are all of bronze and weigh between 800 and 1,000 pounds each. They are at head height on marble plinths and are obviously excellent likenesses of their respective subjects.

34. William McKinley statue (1917) by Massey Rhind (American, 1860–1936), marble, larger-than-life. The President is shown, standing before a splendid, classic chair—the base of which is embellished with an anthemion. His left hand engages his trouser pocket. Posterity will have a very good idea of McKinley's appearance since there is excellent agreement among his several statues represented herein.

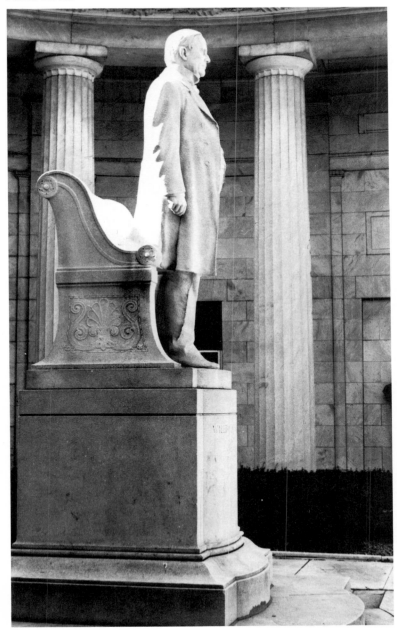

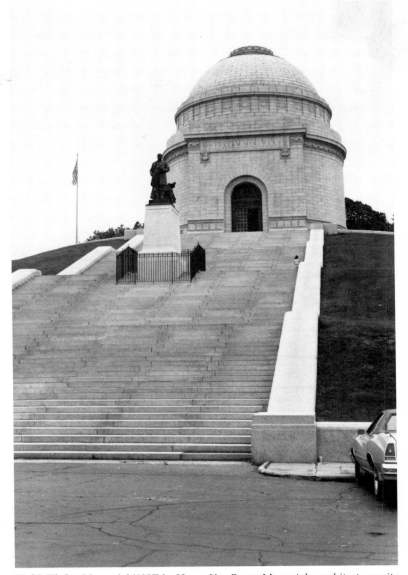

35. McKinley Memorial (1907) by Henry Van Buren Magonigle, architect, granite and marble, 97′ in height x 75′ in diameter, Canton, Ohio. McKinley statue (halfway up steps) bronze with granite pedestal, by Henry Niehaus (American, 1855–1935). When compared with Cleveland's Garfield Memorial which preceded this by almost two decades, it is apparent that a new, neoclassicism has replaced the Victorian frills and the Romanesque Revival of the 1880's and 1890's. The rotunda, bearing the sarcophagi of Pres. McKinley and his wife, suggests the Roman Pantheon—the coffered ceiling of which it imitates.

36. McKinley Memorial—statue of President William McKinley (1907) by Henry Niehaus (1855–1935), bronze, 9½' in height. The sculptor portrays McKinley delivering the final speech before his assasination at the Pan-American Exposition in Buffalo, New York, September 6, 1901. Niehaus was a pupil at the McMicken School in Cincinnati. Subsequently, he studied at the Royal Academy in Munich, Germany. Other notable works by this Cincinnati-born artist are: a larger-than-life **James A. Garfield** in Cincinnati, a **John Paul Jones** in Washington, D.C. and a **Soldiers and Sailors Monument** in both Hoboken and Newark, New Jersey.

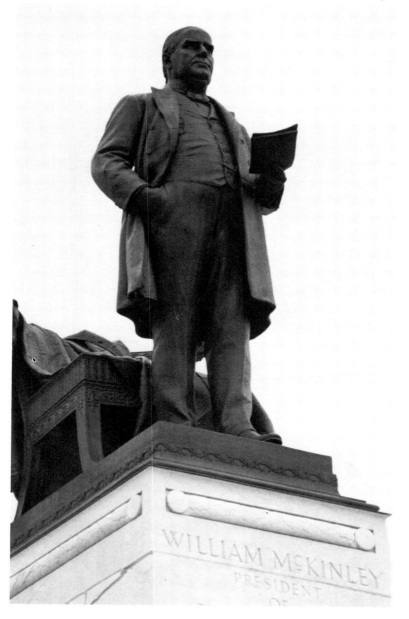

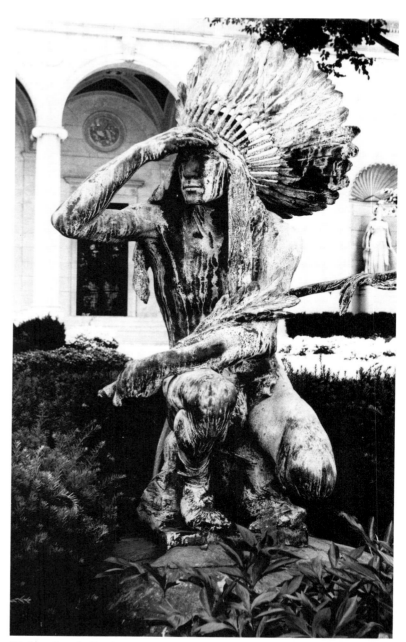

37. American Indian (circa 1919) by Massey Rhind (American 1860–1936), bronze on a stone pedestal, life-size. Rhind's realistic Indian, in full regalia, kneels before The Butler Institute of American Art in Youngstown. The Institute, created by Joseph G. Butler in 1919 and designed by McKim, Mead and White of New York City, contains the second largest collection of Indian paintings in the country. The lateral niches on its facade contain additional, classic figures sculpted by Rhind.

32

40. William McKinley Monument (detail) overleaf—statue of the President. MacNeil's portrayal of the President is remarkably similar to that of Niehaus in Canton. In this, his right thumb engages his pocket and his right foot is forward.

41. William McKinley Monument(overleaf right)—auxillary groupings. The idealized mother and child, at left, symbolizes the peace which McKinley, in the monument's inscription, proclaims "more glorious than the victories of war". The handsome blacksmith and maiden, at right, might be interpreted as extolling the virtues of honest work and learning.

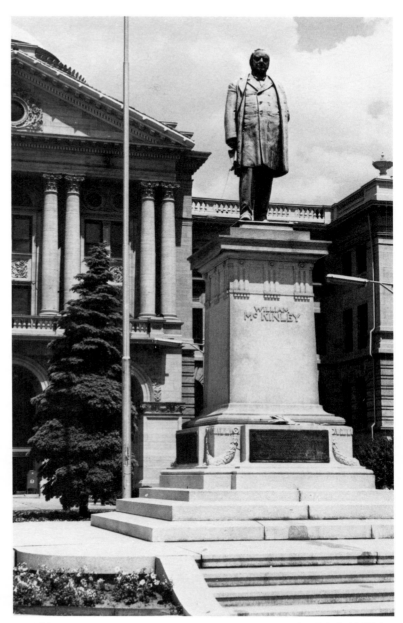

38. William McKinley Monument (1906) by Herman Atkins MacNeil (American, 1866–1947), bronze and granite, overall height-20'. MacNeil's McKinley occupies a commanding position on High Street in Columbus before the imposing State Capitol. The tall pedestal bearing the martyred President, articulates with an exedra, providing public seating, with sculptural groups at its extremities. Perhaps sculptor MacNeil's most notable commission is his **Justice, the Guardian of Liberty**—the subject of the 60' long x 18' high east pediment of the Supreme Court Building, Washington, D.C.

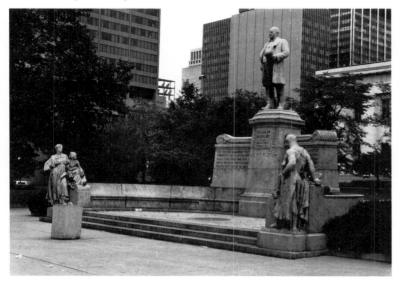

39. William McKinley Monument (1903) by Albert Weiner. This Toledo McKinley stands on a tall pedestal before the Beaux Arts, Lucas County Courthouse. As elsewhere noted, the several sculptors of the 25th President (Niehaus, MacNeil, Rhind and here, Weiner) agree, remarkably, on his physiognomy and portly bearing.

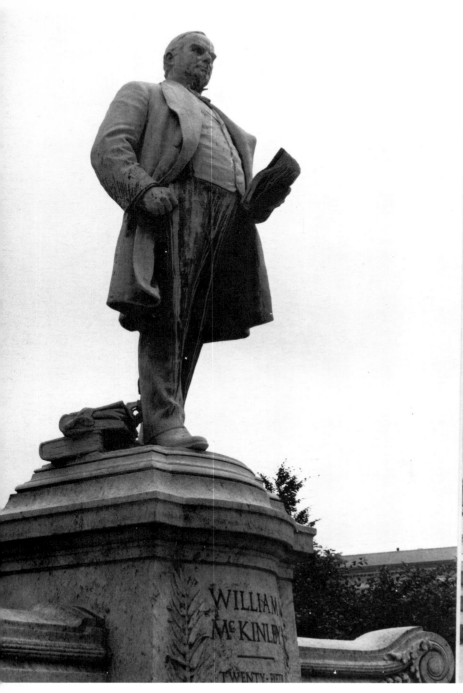

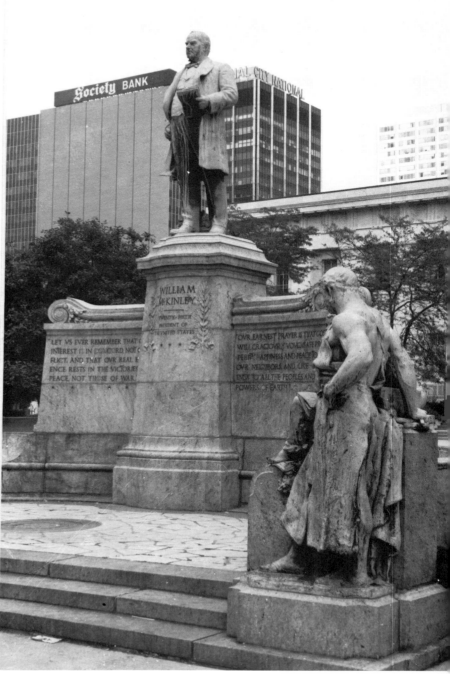

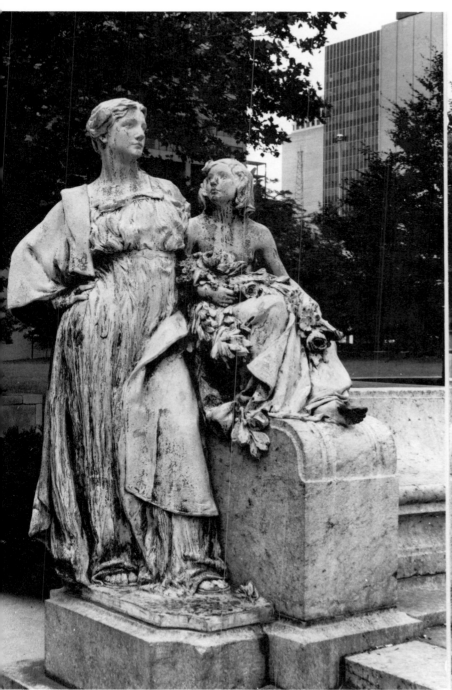

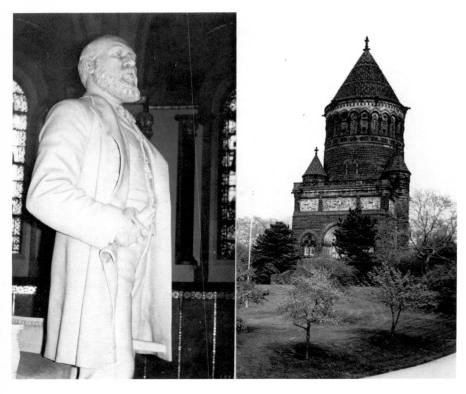

42. Garfield Monument (1890), left, Lakeview Cemetery, Cleveland, Ohio. Architect—George Keller of Hartford, Conn.; sculptor—Alexander Doyle (American, 1858–1922), a native of Steubenville, Ohio. The Garfield Monument is 180' in height and 50' in diameter. Architect Keller who won a competition with this design, may have taken the ancient, round towers of Ireland as his prototype to which he appended a rectangular porch—all in the prevailing Romanesque Revival style. The interior is lavishly decorated with mosaic scenes illustrating the life of the President, with colorful stained glass windows and, in the dome soffit, with gilded mosaic angels holding the signs of the compass overhead. As in many French, Gothic cathedrals, engaged columns, within, rise to the full height of the cylindrical tower.

43. Garfield Monument (below)—detail of terra cotta, porch, relief sculpture by Casper Buberl. These are tan in color and would have blended excellently with the original sandstone color of the monument itself. The upper relief shows Garfield being reverently carried to his grave; the lower (not shown) depicts him as a school-boy in Orange township, vicinity of Chagrin Falls, O.

44. General William Henry Harrison Monument, right, (dedicated 1896) by Louis Rebisso (born Italy 1837, died Cincinnati 1899). It is fitting that Cincinnati honor Gen. Harrison, victor over the Indians at Tippecanoe and first Governor of the Indiana territory, since much of his life revolved about the "Queen City of the West". Louis Rebisso was the first instructor in modeling at the Cincinnati Art Academy. His monument to another Ohioan, Gen. James B. McPherson, located on McPherson Square in Washington, D.C., is quite similar to this in Cincinnati. The former, dedicated in 1876, is 12' in height on an equally high plinth. The Cincinnati work, appearing to be of similar size, bears the name of M.H. Mossman, founder, Chicopee, Mass. on its base.

Garfield Monument (1885), far right, by Charles Henry Niehaus (American, 1855–1935) bronze on a granite base, located in Garfield Park, downtown Cincinnati. This is the major work of the native-son Cincinnatian in the City. With papers in his right hand, the assassinated president appears to be in the act of giving an oration; his attire suggests that he is out-of-doors. The base has a similarity to that of the Toledo McKinley in that both are girdled with a Greek frieze of tryglyphs with their attendant guttae.

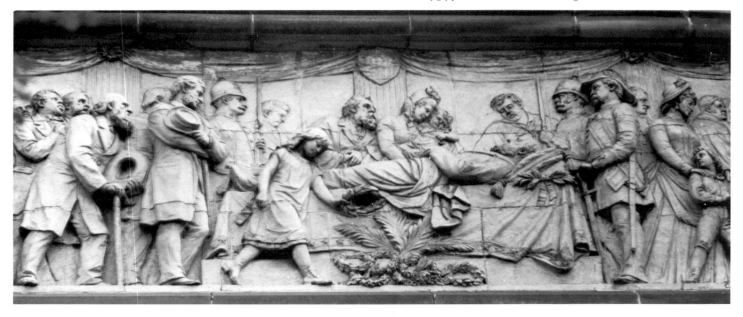

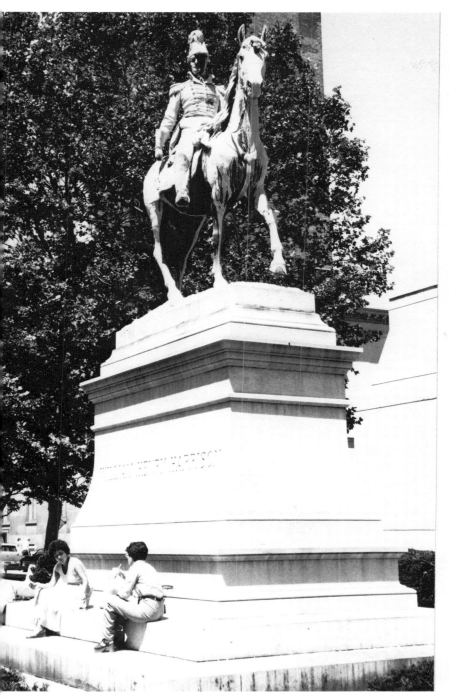
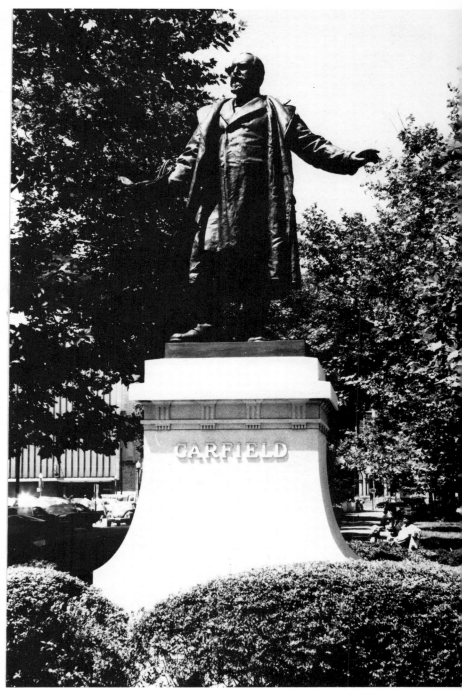

The two giants of American sculpture at the turn of the century were **Daniel Chester French** (1850-1931) and **Augustus Saint-Gaudens** (1848-1907). The former is perhaps most famous for his seated *Lincoln* within Washington's *Lincoln Memorial*. We have seen that he was called upon by architect Arnold Brunner to do a pair of monumental groupings to complement the facade of Cleveland's Old Post Office and Federal Building (1905-1911), as well as figures which stand above the entablature of the Cuyahoga County Courthouse (1913). These were the first buildings of the so-called "Cleveland Group Plan" inspired by Chicago's World Columbian Exposition of 1893. French's allegorical sculptures in Cleveland are entirely compatible with the Beaux Arts architecture and are very typical of his work elsewhere—particularly his *Four Continents* (1907) which similarly accent New York's United States Custom House (Bowling Green and Whitehall Streets).

The seated statue of Marcus A. Hanna (1837-1904), senator, party leader and capitalist, located at Cleveland's University Circle, (cf. Fig. 46) is, to the best of our knowledge, the only outdoor work by the esteemed Saint Gaudens in the State. This monument to the man who guided McKinley's 1896 campaign for the presidency, was cast in 1907 and dedicated in May of 1908. It is the author's impression, from the reading of Louise Tharp's excellent *August St. Gaudens and the Guilded Era*, that the *Hanna Memorial* was completed posthumously in the sculptor's studio.

The best known Cleveland-based sculptor of this period (i.e. 1890's to 1930's) was **Herman Matzen** (1861-1938), a Dane by birth. He first studied at the Royal Academy of Fine Arts in Berlin; then, subsequently, at the German-American Seminary in Detroit. In Cleveland, Matzen became a member of the "Old Bohemians", a group of artists organized by Fred C. Gottwald in 1876. At the time they occupied the top floor of City Hall, then located on Superior Avenue just east of Public Square. This group evolved into The Cleveland School of Art (forerunner of the present-day Cleveland Institute of Art) in 1884. He (i.e. Matzen) had at some indeterminant time worked briefly as a designer in the Louis Tiffany Studios (NY). Matzen was Cleveland's pre-eminent teacher of sculpture at the Art Institute for over a generation until he retired in the Spring of 1926. His home was at 2423 Woodmere Drive, Cleveland Heights.

For Clevelanders his best known and most obvious work is the seated *Tom L. Johnson*, progressive mayor of the city from 1900 to 1911, located on Public Square (Fig. 48)[5]. Although initiated in 1911, the statue was not dedicated until April of 1916. Many consider dynamic Tom Johnson to have been the best mayor Cleveland ever had. He got things done! He was dedicated! He was a character! Johnson believed in free speech and open debate; his Public Square memorial is a podium for this purpose. Additionally, Matzen enjoyed commissions for a considerable number of cemetery sculptures most of which may still be seen in Cleveland's Lakeview Cemetery. There, his engaged figures (herms) enhance the facade of the Stevenson Burke Mausoleum (Figs. 45, 47),—a thing of beauty.

He also did the *Thomas White* and the *Haserot Family Monuments* (Fig. 47); the exquisite doors of the Holden Mausoleum and the *Collinwood Fire Memorial* relief[5a] (Fig. 45). His *Moses* and *Pope Gregory IX*, located above the cornice on the north facade of the Cuyahoga County Courthouse, are, unfortunately, quite removed from view.

Elsewhere in Ohio Herman Matzen did the bust of *President Harding* at Marion, Ohio. One of his earliest works were the figures personifying "War" and "Peace" on the important *Soldiers and Sailors Monument* at Indianapolis. *(text continued on page 43)*

48. Tom L. Johnson Monument (1916), page 41, by Herman Matzen (1861–1938), bronze on a granite base, 10' in height, located on Cleveland Public Square. Tom L. Johnson was a colorful figure and certainly one of the most successful mayors that Cleveland ever had. He served from 1900 to 1910 and died in 1911 at the age of 50. Matzen portrays him seated on a podium with a copy of Henry George's **Progress and Poverty** in his right hand. Like the man, the monument is accessible to the people and is, in fact, designed to be a podium for free speech. It was, as is inscribed at the rear "Erected by popular subscription to the memory of the man who gave his fortune and his life to make Cleveland a happier place to live . . .". The bevelled base is beautifully carved, in low relief, with classical figures by Edward Geiselman.

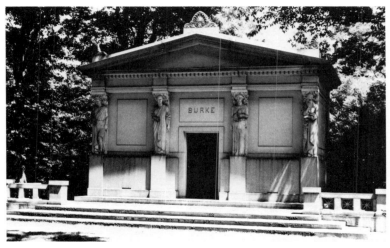

46. Marcus A. Hanna Monument (1908) by Augustus St. Gaudens (American, 1848–1907) bronze on a granite base, overall height-17½'. This is the only outdoor piece in the State by this noted sculptor who died before it was unveiled in 1908. Marcus Hanna (1837–1904) was one of the industrial giants who, in his time, made Cleveland a leading City in the nation—both industrially and politically. He handled McKinley's 1896 campaign for the presidency and himself became a senator from Ohio (1897–1904). St. Gaudens portrays him sitting assuredly on a senatorial chair against which are propped books and important papers of state. The bronze has acquired the characteristic, pale green patina which contrasts, handsomely, with the earth-tone of the base.

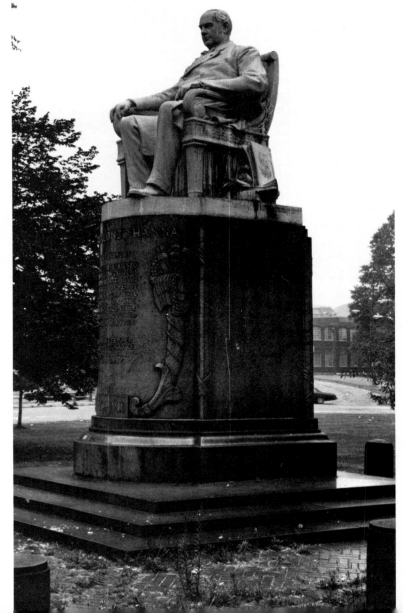

45. Collinwood Fire Memorial (1908) and **Burke Family Mausoleum**, both by Herman Matzen, bronze and granite. Matzen, a Dane by birth, came to Cleveland via Detroit. In Cleveland he shortly became a member of a group known as The Old Bohemians which, in 1884, became the Cleveland School of Art. There, for many years, he served as head of the sculpture department, until retiring in 1926. He was called upon to do a number of grave markers for prominent Cleveland families. The **Collinwood Fire Memorial** commemorates a tragic fire which took the lives of 174 children in March of 1908. Their names are listed on a plaque at the rear. The frightened children are shown seeking the comfort and protection of an angel who will escort them to heaven. The bronze relief is approximately 2' square. **Burke** Memorial (below) The architect has designed a small Greek temple as a mausoleum for the Burke family. Engaged caryatids, modeled by Herman Matzen, support the entablature.

47. overleaf **Haserot Memorial** (left)—a detail of the bronze, personified angel. **Burke Mausoleum** (right)—a close-up of the engaged, granite caryatids. Like much of this work in Cleveland, at the time, it is quite likely that the actual sculpting of the figures was done by Gandola Bros.(6)

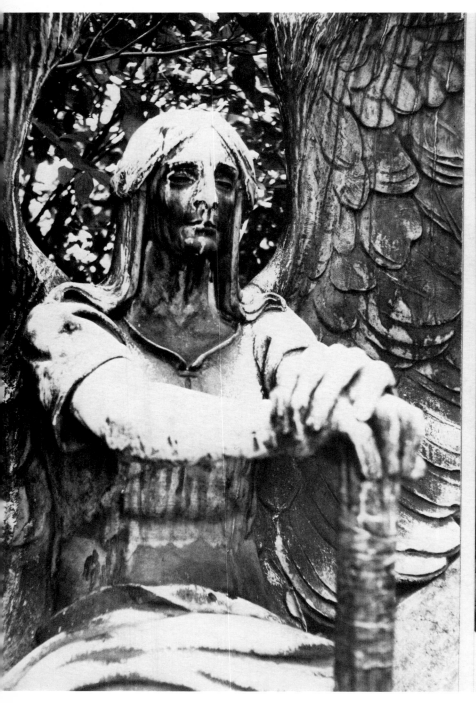

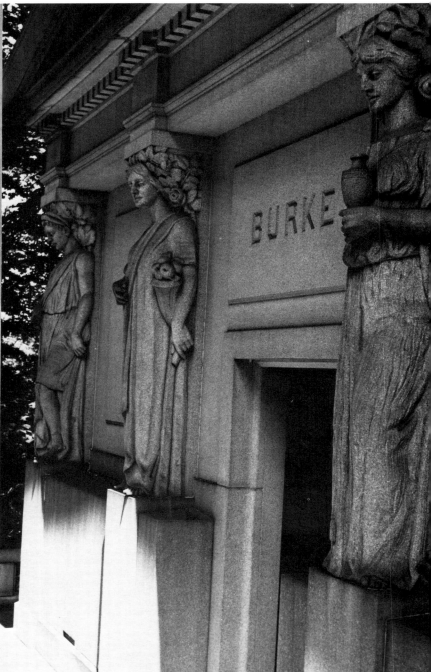

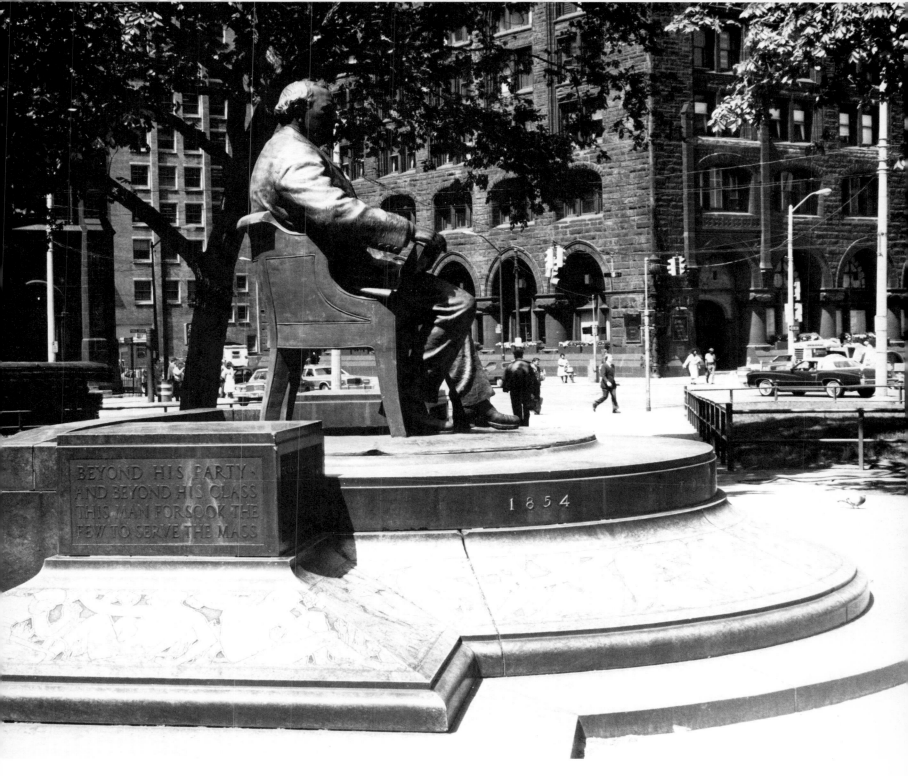

BEYOND HIS PARTY
AND BEYOND HIS CLASS
THIS MAN FORSOOK THE
FEW TO SERVE THE MASS

1854

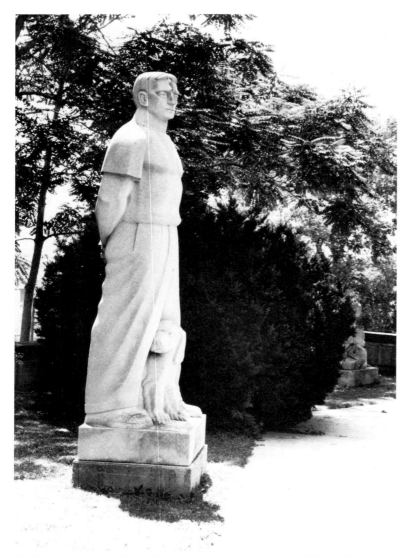

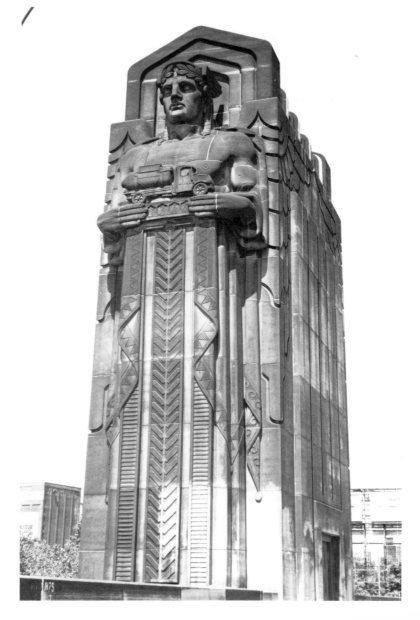

50. Lorain-Carnegie Bridge Pylons (1932) by Henry Hering (design by Frank Walker, Cleveland architect), Berea sandstone, height from bridge surface-43'. The pylons illustrated are at the eastern end of the bridge; a similar pair acts as a gateway to Cleveland's West Side. The style is Art Deco which evolved in the years between the first two World Wars of the 20th Century. Art Deco emphasized the simple, geometric line. The hermae, holding a tank-truck in one instance, and a coal-hauler in the other, symbolize the transportational function of the bridge. Henry Hering, who appears to have been favored by architects Walker & Weeks, also sculpted the allegorical figures before Cleveland's Federal Reserve Bank Building.

49. Standing Man and Dog c. 1940 by Seth Velsey (American, 1903–1967), Indiana Bedford limestone, height-approximately 7', located on the grounds of The Dayton Art Institute. Seth Velsey, born in Logansport, Indiana, studied at the University of Illinois, at the National Academy in Florence, Italy and under the noted American sculptor, Loredo Taft. During the 1930's he was an instructor in sculpture at the Dayton Art Institute. His **Man and Dog** represents a break with the realistically modeled figures we have considered to date. Nearby, there is another Velsey entitled **Seated Boys**, also in limestone. Both pieces were originally to have been acquired by Green Hills, a suburb of Cincinnati, which, at the time, refused to accept them. Green Hills' loss is surely Dayton's gain!

TOWARDS MODERN SCULPTURE

The sculpture which we have considered thus far in Cleveland and in Ohio—from the 1890's to the 1930's—is totally representational. It is in the classical, Beaux Arts tradition and is quite in keeping with what was appearing elsewhere in the Nation. There were, however, as early as 1915, departures from this absolute realism. The early work of Paul Manship was a significant step in this movement from studied realism. His one man show in New York (1916), following the return to these shores after winning a three-year coveted Prix de Rome prize, "created a veritable sensation among the large public interested in artistic achievement." His was a distilled, redefined, stylized classicism. As Daniel Robbins states in his contribution to *200 Years of American Sculpture* (p. 124):

> "Manship's elegance, clarity of outline, streamlining of form, (with continual references to archaic Greek sculpture) rapidly became the official art of the twenties and thirties."

Of course others such as Gaston LaChaise, Elie Nudelman, Alexander Archipenko, all Europeans, also greatly influenced the direction of "modern" art simultaneously. These influences were slow to be felt in Ohio though they are certainly apparent in some WPA art of the 1930's. However, there is little to which one can point in Ohio, expressing the new style in the category of outdoor sculpture. One such piece is the *Man and Dog* by Seth Velsey which may be viewed on the grounds of the Dayton Art Institute (Fig. 49). This is one of four pieces originally commissioned by the Works Progress Administration (WPA) for the Cincinnati suburb of Green Hills in the late 1930's. Two were completed, but for some reason were refused by Green Hills. Green Hills' loss is today Dayton's gain! There is a

directness, a boldness and genre quality about this marble work which is quite different from anything that we have heretofore considered. A second piece is located nearby.

A further example of the total departure from Beaux Arts classicism is the relief sculpture on the pylons of Cleveland's *Lorain-Carnegie Bridge* (Fig. 50), planned in 1927 and dedicated in the closing months of 1932. Henry Hering who, half a dozen years earlier, had worked closely with architects Walker & Weeks on the Federal Reserve Bank Building, was the sculptor. How differently here he portrays modes of transportation than when allegorically suggesting *Integrity* and *Security* with the marble maidens which flank the principal entrance to the Bank (cf. Figs. 23, 24). This new style of the 1930's is known as "Art Deco". The relief figures in the ground floor showcases of The Cleveland Public Library (Fig. 212), completed in 1925, if not in the fully developed Art Deco style, certainly are a departure from earlier classical precedent. The giant-sized reliefs on the pylons which flank the great facadal arch of Cincinnati's Union Station (1931, Fig. 202) are among the finest sculptural expressions of the style in the State.

Art Deco was the art of the 1930's. Its essence may perhaps be best understood in studying the works of Paul Manship and Lee Lawrie at Rockefeller Center, New York. (Manship did the 18' high *Prometheus* which provides the back-drop for the outdoor skating rink; Lawrie the 21' high *Atlas Bearing the Heavens* before the Central International Building at 5th Avenue and 51st Street. cf. *New York Civic Sculpture*). Cleveland had no Rockefellers to sponsor anything remotely approaching these major outdoor commissions. With the completion of Severance Hall in 1931, building and major art projects in Cleveland, and elsewhere in the State, came to a virtual halt for the duration of the Great Depression and World War II which followed soon thereafter. The decor of the Hall's elliptical foyer comes as close to the sophisticated, and sinuous character of Paul Manship's style as anything in the State. Not being outdoors, this lies beyond the scope of this book.

Animal sculpture became very popular in America in the teens, but particularly in the 1920's. We quote Daniel Robbins essay once again from *200 Years of American Sculpture* (p. 139):

"Within the less serious and less rigorously defined category of garden sculpture, the early 20th century American sculptor could innovate, since he was not required to fulfill commemorative expectations. From the turn of the century artists found in animal sculpture a vehicle to communicate individual emotion. Many a sculptor who desired to express either individual feelings or realistic formal observation, found that he could do it, and sell it, in the guise of animal sculpture. In the veritable zoo of animal sculpture that was widely produced during the 1920's, an important, even crucial, phase in the development of modernism can be detected."

One of the earliest animal sculptures to appear on the Ohio scene is the large *Lion* executed by Anna Hyatt Huntington (1876-1973), a Bostonian by birth, while she was in residence at Auvers sur Oise, France in 1907 (Fig. 51). The sculptress studied first under Hudson Kitson in Boston, subsequently under Hermon Atkins MacNeil (sculptor of our *William McKinley Monument* before the Ohio Statehouse) and briefly with Gutzon Borglum (creator of the *Start Westward Monument*, Marietta, Ohio, Fig. 113). Anna Hyatt spent her childhood summers at "Porto Bello", an old Maryland estate owned by her brother, Alpheus Hyatt, where she rode, trained and modeled horses and other animals. Much of her fame, derived from this early experience, is based on her animal sculpture, particularly horses, which she interpreted with a marvelous realism.

Ohio's most prolific and notable animal sculptor (though his work is by no means confined to this category) is **William McVey** (1905-), who was also born in Boston. The family, Canadian in origin, originally spelled its name "MacVey". McVey's father took up residence in Boston where he operated a drug store. When young McVey was of high school age (he graduated from Shaw High School, circa 1922), his father accepted an offer to come to Cleveland to market insulin. The senior McVey passed away before young

William finished school. His mother held body, soul, and family together operating a home for crippled children on E. 105th Street at Lakeshore Blvd.—a pet project of Mrs. Livingston Taylor. Young William was able to pay his board and pick up pocket money by assisting his mother in caring for the helpless wards of this institution.

He entered the Cleveland School of Art following high school graduation, but at that time, as he relates, the students seemed to him a "bunch of sissies." He learned that he could enter Rice University in Houston, tuition free, and there played football for a couple of years under Heisman (of trophy fame) while studying illustration. Eventually, he returned to the Cleveland School of Art, continuing his studies in illustration at night. He might have favored sculpture at this time, but

51. **Lion** (1907) by Anna Hyatt Huntington (American, 1876–1973), bronze, located on the grounds of the Dayton Art Institute. The Boston-born sculptress first studied under Henry Hudson Kitson, then (1902) under Herman MacNeil and Gutzon Borglum. From her earliest years she was fascinated with animals which became the subjects for much of her sculpture. The Dayton piece was modeled in 1907 in her studio at Auvers sur Oise, France. In 1915, when again in France, she modeled a **Joan d'Arc**, the bronze cast from which is located on Riverside Drive in New York City. Anna Hyatt and her husband, Archer M. Huntington, founded the Brookgreen Sculpture Gardens near Charleston, S.C.

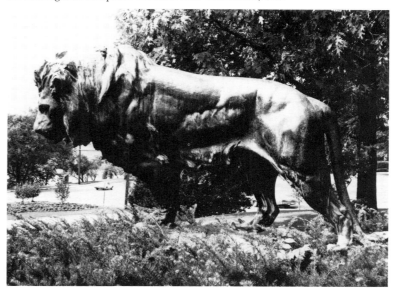

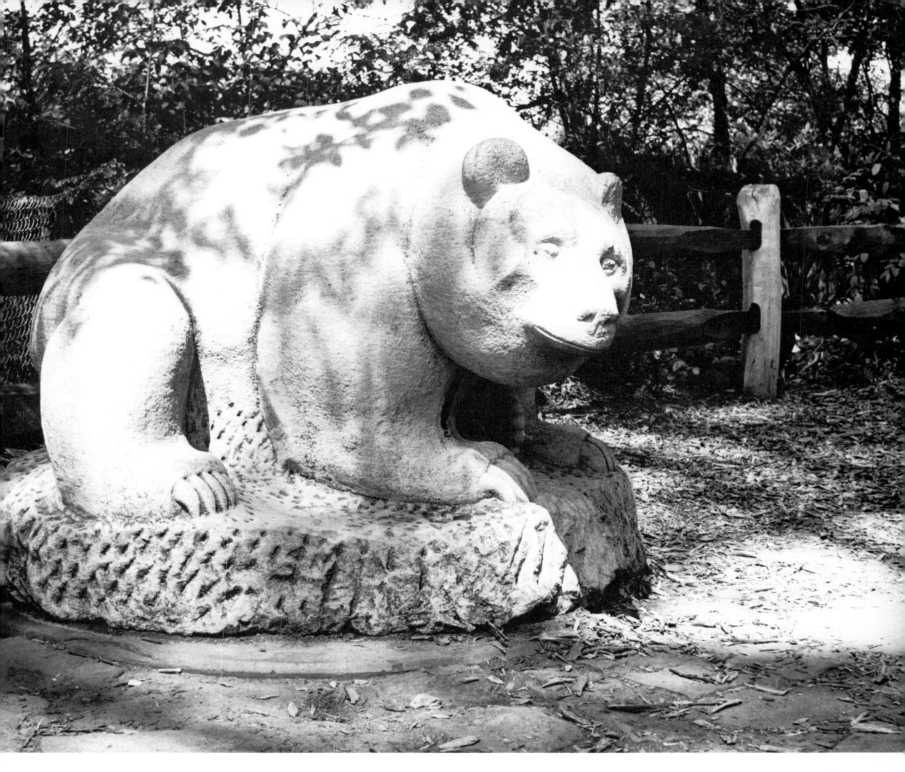

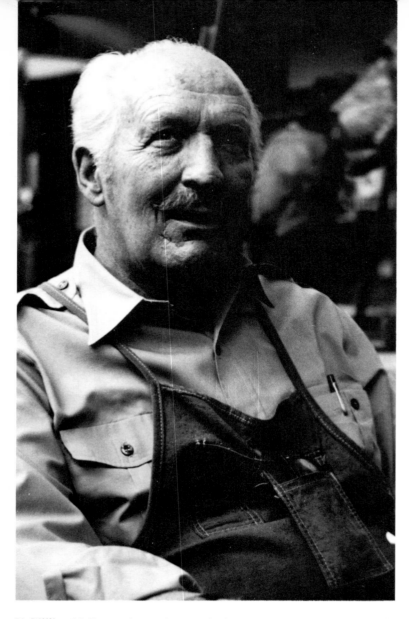

53. William McVey, sculptor, photographed in his studio at age 74. "I'm so old," he humorously declares, "that I'm instructing the children of my former students!"

52. Bruno, the bear (1932), page 45, by William McVey (American, 1905–), limestone, life-size, weight-3½ tons. As a part of the WPA art program, William Milliken, Director of the Cleveland Museum of Art, made a six ton piece of limestone available to the youthful McVey with a result that has pleased young and old, alike, ever since. The career of William McVey, dean of Cleveland-area sculptors, is related elsewhere in these pages. Like Anna Hyatt Huntington, he has always had a feeling for animals which comprise a considerable corpus of his sculpture.

found his personality incompatible with that of Herman Matzen, who headed the deparment. During this period he sustained himself by working days at Gandola's[6] on tombstone sculpture. In due course, Mrs. Taylor, who obviously observed that the youth showed promise, gave him a $2,000 letter-of-credit to study in Paris. There he attended the Academy Colarossi and the Academie Scandinave, where he studied under Despiau (1929-1931). He lived on a "shoe-string" while in the "City of Light."

McVey relates that he took a French freighter to Le Harve from Houston in which his accommodations were virtually steerage. The $2,000 gift of Mrs. Taylor lasted one year in Paris; he spent three years there! He made a bare living, eventually, as an official guide to the Louvre Museum—one of three Americans similarly employed. This was an easy job, he recalls with amusement, since most American visitors to the Louvre were interested in only three things: the "Winged Victory," the "Venus de Milo" and the "Mona Lisa." Off they went after seeing these! Eventually, he wound up in the American Hospital from over-work and malnutrition. Then, the Cleveland-connected painter, Alexander ("Buck") Warshawsky, made a place for him in the attic of his modest Paris apartment and succored him back to health. Prophetically, Leza's mother, McVey's mother-in-law to-be, had made extra sandwiches for "Buck" and her daughter when both studied at the Cleveland School of Art—thus, as McVey views it, "poetic justice was done."

Returning to Cleveland, he married Leza Marie Sullivan, a potter, in the early spring of 1932 while employed as a teacher at The Cleveland Museum of Art. It was at this time, under the Federal Government's WPA Program for artists that McVey was provided with the six-ton block of limestone from which he laboriously fashioned *Bruno, the bear,* (Fig. 52), which has ever since fascinated young and old visitors to the Cleveland Museum of Natural History. This project gave young McVey his first opportunity to work directly in stone on a large scale. It was, due to the comparatively high cost of the traditional materials of the sculptor (namely stone

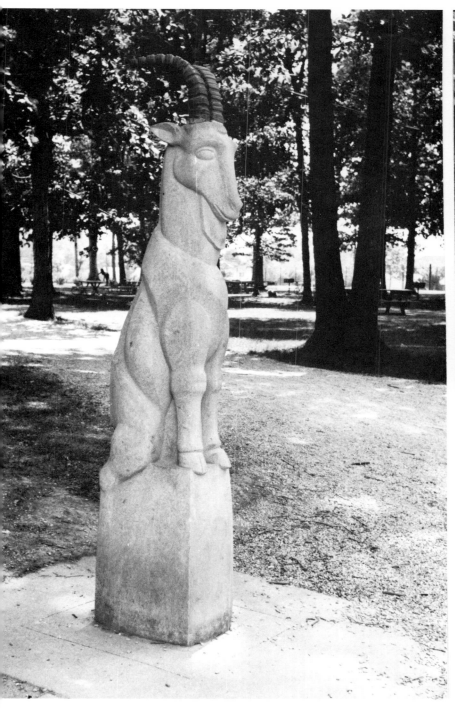
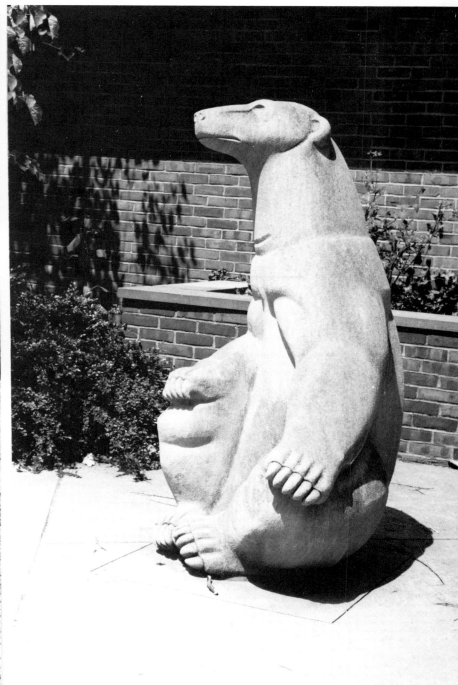

47

and bronze), the singular project of the WPA in northern Ohio on this scale.[7]

McVey delights in relating how, when *Bruno* was carefully being manually transported to its initial location in Wade Park, it got away from the workmen and tumbled down a hill without sustaining any significant damage, thereby bearing out Michelangelo's alleged contention that the test of a good piece of sculpture is that it pass this rigorous downhill test! Other, subsequent McVey sculptures have contoured, egg-like forms which would enable them, likewise, to withstand Michelangelo's criterion, should anyone wish to put them to the test. One wonders whether McVey might have been aware of John B. Flannagan's wonderful and quite similar animal sculptures of precisely this period, beautifully illustrated in the Whitney Museum's *200 Years of American Sculpture* (Plate No. 37, a chimpanzee [1928]; Fig. 197, an elephant [1929-30]).

Eventually (circa 1935) William McVey gravitated back to Texas to teach art at the University of Texas at Austin. At the inception of World War II he drew No. 56 in the draft which insured his early induction into the Army. A combination of circumstances, but particularly his artist's eye, found him teaching recognition courses at the Fort Randolph Army Base. In this capacity his ability to see and to draw proved highly useful! When it was reported that art was being taught in his classes, he was called-to-account before the commanding General. A competition in recognition, won by his students, vindicated his teaching methods which the entire base then adopted.

He returned to the University of Texas after the war and was offered the position of Art Department Head. Apparently his work in Texas was not totally fulfilling for when, at the recommendation of a former student, Carl Milles called him to Cranbrook Academy (Bloomfield Hills, Michigan), he acceded to the summons. While at Cranbrook for the next seven years (1946-1953), he came in contact with Eliel ("Pappy") Saarinen, designing architect of the Academy, who he states, greatly influenced his career. To this day he speaks of him with great affection. Carl Milles once said to him, "If you want to know something about a civilization, look to its art!"—a statement he has not forgotten.

In 1953 McVey returned to the Cleveland Institute of Art to become the head of its Sculpture Department. For the past decade, having retired from the Institute of Art, William McVey has been busily at work on private commissions at his unique studio-home in suburban Pepper Pike, Ohio.

In the Spring of 1979, in connection with a potential commission to do a full-figure sculpture of General George Catlett Marshall, McVey lunched with Richard Hubbard Howland of the Smithsonian Museum and Nicolas Biddle of the National Trust for Historic Preservation. On this occasion one or the other of these gentlemen questioned the compatibility of the architecture and the sculpture before I. M. Pei's new East Wing of the National Gallery of Art. "The architecture and art appear to be fighting with one another," one said.

"In that case," said McVey, "it is a good fight!" This response is characteristic of his directness and quick wit.

55. Happy Frog and **Swan** both by William McVey, right, bronze on granite pedestals. There are two **Happy Frogs**, one at the Washington, D.C. Zoo, the other in Riverside Park, Chagrin Falls, O. They are a great source of amusement to children who love to climb upon them. The stylized **Swan** is located in a natural setting on the campus of University School in suburban Pepper Pike, Ohio.

54. Goat and Polar Bear, page 47, by William McVey, located at the Cleveland Zoological Society, Brookpark. At left is one of a pair of goats executed by McVey which are located near the Zoo's Administration Building. They are 7' in height of limestone. Like much of McVey's animal sculpture, the goats have a somewhat humorous quality about them. The bear is one of a pair which originally marked the entrance to The Leisy Brewing Co. where they stood on 5' high plinths until acquired by the Zoo in 1968.

48

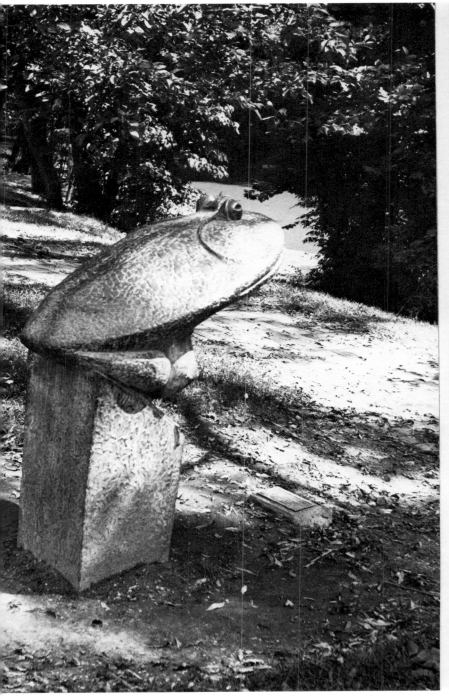

49

In addition to *Bruno*, other outdoor, animal sculptures by William McVey are a pair of goats (Fig. 54) at the Cleveland Zoo Administration Building; a pair of polar bears (Fig. 54), in limestone, originally done for The Leisy Brewing Company which, in 1968, were moved to the Cleveland Zoo; "Happy Frogs" (Fig. 55), one of which is in the Washington Zoo, the other in Riverside Park, Chagrin Falls, Ohio; and a bronze lion (Fig. 61), 5' tall, given to Orange High School, Pepper Pike, Ohio, by 155 appreciative donors. Other McVey animals exist elsewhere around the country. More often than not they are designed so that children may climb over and play upon them. It would appear that in the early *Bruno* piece, the sculptor was seeking a realistic interpretation of his subject; the goats, the frogs and the lion are stylized and evoke a more typically humorous response.

In addition to the aforementioned animals, other outdoor sculptures by McVey in the Cleveland area are: a young *George Washington* (Figs. 56,57) commissioned by the Early Settlers Association of Cleveland and installed on the Mall before the new Federal Office Building in celebration of the Nation's bicentennial (In doing this piece McVey studied Houdon's death mask of our first president, then consulted a doctor about taking a third of a century or more, of aging from this mature physiognomy. Who is to say that the result achieved is not the true George Washington of 1756?); a sculpture to the theme "*We Care*" (Fig. 58; cemente fondu over welded steel frame), which was considered to be much more compatible in its original location before the Community Health Foundation on Euclid Avenue at E. 117th Street, designed by architect Robert Little; the *Long March* (Fig. 59), an aluminum wall-sculpture affixed to the limestone facade of The Jewish Community Center, Mayfield Road, Cleveland Heights, Ohio. In this McVey portrays the "long march" of the Jewish people to a land of freedom. In the lower portion [Fig. 60, detail] one sees families which have found shelter in a free America; a *Medusa Head* (Fig. 64) affixed to the East facade of The Medusa Cement Corporation executive offices at Lee Road and Monticello Blvd., Cleveland Heights; and the *Memorial to Martha Holden*

Jennings, comprised of a bronze bird on a granite plinth, at Euclid Ave. and Abbington Road. But perhaps the work for which William McVey will be best remembered is the 9'-tall, bronze *Winston Churchill* before the British Embassy in Washington, D.C., where Cleveland architect Fred Toguchi did the splendid ambience.

In addition to his many outdoor works in the Cleveland area, McVey sculpted the monument to *Senator Byrd* which stands on the State Capitol grounds in Richmond, Virginia; the figures of *St. Margaret* and *St. Olga* which occupy niches on the facade of the Washington Cathedral (a niche figure of *Jan Huss*, the Czech reformation leader will shortly join these); a stylized "*Hippo*" at the Eastland Shopping Mall, Detroit; an "*Armadillo*" at the New Mexico Museum in Albuquerque; and the huge sculptural reliefs on the *San Jacinto Monument* in the vicinity of Houston which were done during McVey's years in Texas. He is currently working on a maguette of *General George C. Marshall* for a Leesburg, Virginia monument.

In 1979 William McVey was elected an Associate in the prestigious National Academy of Design, an honor shared by only 300 other American painters, sculptors, architects and designers since its founding in 1825. He is the beloved dean of his profession in northern Ohio.

(text continues on page 57)

56. George Washington (1973) by William McVey, far right, bronze on a granite plinth, height of figure-10', Washington Square, downtown Cleveland. The sculptor portrays Washington as a young man, perhaps on one of the pre-Revolutionary campaigns from his native Virginia into dangerous and wild, western Pennsylvania. Taking a plaster cast from Houdon's death mask of the first president and with the aid of a physician, appropriate changes were made so as to simulate the physiognomy of the youthful Virginian. The piece was commissioned by Cleveland's Early Settler's Association in celebration of the 1976 Bicentennial.

57. George Washington as a Young Man (detail) right. The following advisory from a letter by Washington to Gov. William Henry Harrison (1784) inscribed on the statue's granite base, bears witness to Washington's perspicacity, "Let the courses and distances be taken to mouth of the Muskingum and up that river to the carrying place of the Cuyahoga to Lake Erie. The object, in my estimation, is of vast commercial importance."

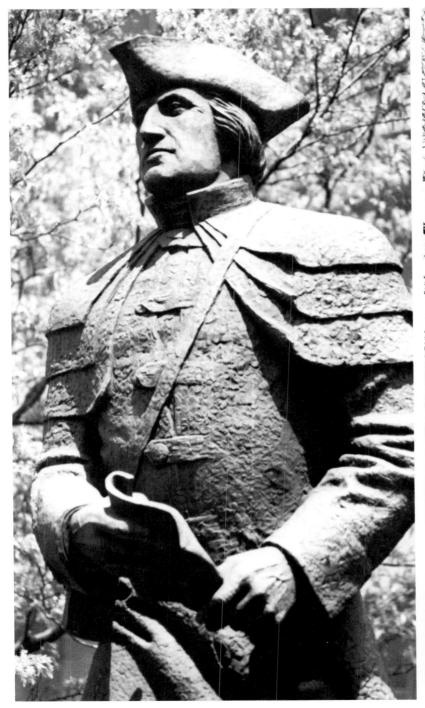
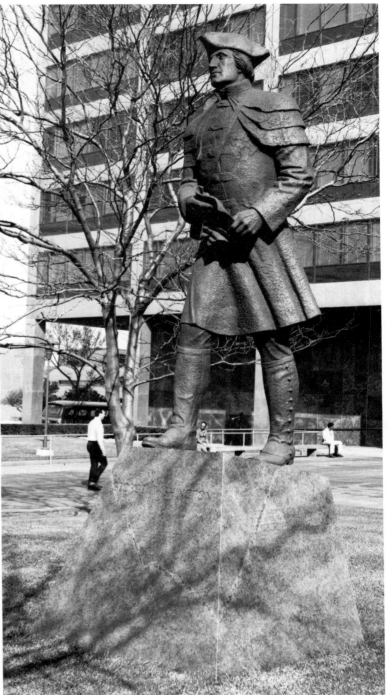

59. Long Road (1970) by William McVey, cast aluminum-buffed and patinaed, 16' in height, Jewish Community Center, Cleveland Heights, Ohio. The **Long Road**, symbolizing the 'march' of the Jewish people through the centuries in their search for security and equality, is positioned on an expanse of the limestone facade of the Community Center. Its lower, horizontal portion illustrates men, women and children sheltered by a free America.

60. Long Road, right. Closer study enables one to fully appreciate the abstrate character of the figures and the beautiful, rough-textured surface of the work.

58. We Care (1965) by William McVey, Lumnite cement over a welded, metal frame, 10' in height, Kaiser Medical Center, East Blvd., Cleveland. Two abstract figures 'caringly' embrace one another—a most appropriate theme for the institution which it precedes. This sculpture was originally designed to be placed before the contemporary architecture of The Community Health Center at Euclid Ave. and E. 117th St. with which it was in greater harmony. Grinding to expose the aggregate was the final, laborious operation in its production.

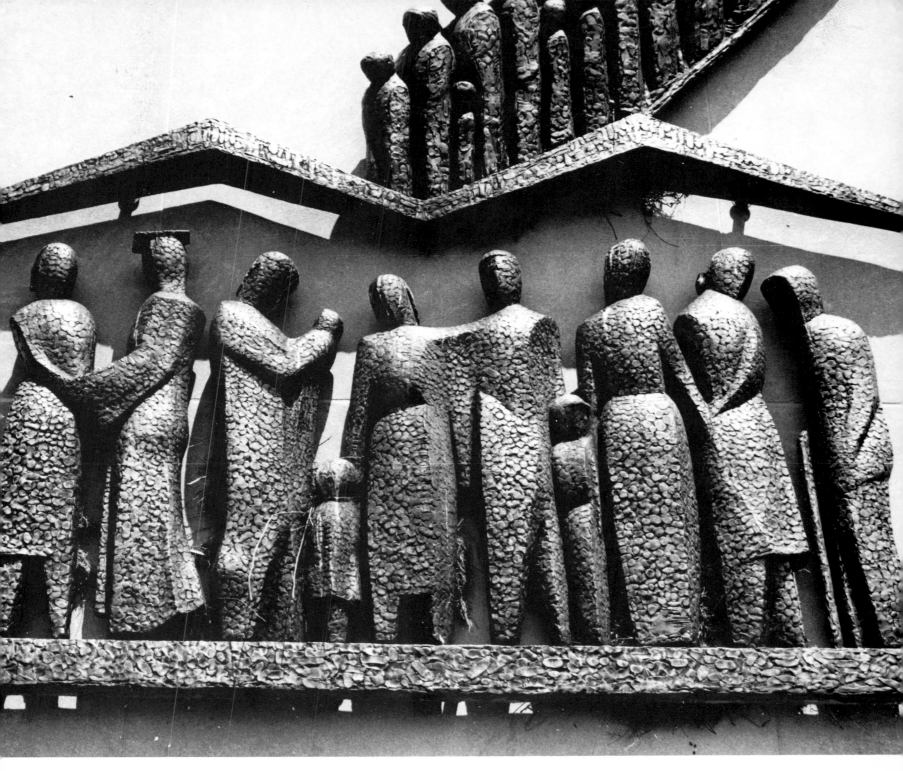

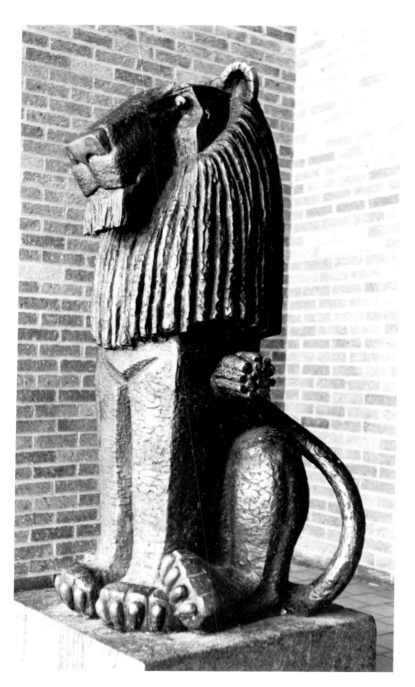

61. Orange Lion (1973) by William McVey, bronze, 5' in height. The Orange Lion is located in the entrance lobby of the contemporary high school serving Moreland Hills, Pepper Pike and Orange. It greatly pleased its creator that 155 donors contributed to its acquisition. Highly stylized, it exhibits the humorous quality we have observed in other McVey animal subjects.

62. Bright Medusa by William McVey, Tennessee marble, size of a four-month old baby, located at the entrance to a private home in Moreland Hills, Ohio. One familiar with the work of McVey would spot this piece immediately as coming from his hand. McVey seems always mindful of Michelangelo's dictum that a good piece of sculpture ought be able to roll down a hill without sustaining damage. This lovely sculpture sets the tone for the sophisticated residence one is about to enter.

63. Good Samaritan, right, by William McVey, Tennessee marble on a granite base. This expressive composition stands beside the entrance to the McVey studio. Hardly a yard in height, it is very contemporary in conception and execution—a totally charming work!

64. Medusa Head, p. 56, by William McVey, cast stone. This beautiful, six-foot Medusa was designed for the Cleveland Heights headquarters of The Medusa Cement Co. where it is the sole decorative element on an expansive, limestone facade. It also appears on every sack of cement produced. The Greek myth has it that Medusa, once beautiful, offended the God Athena who then made her so hideous that all who looked upon her were turned to stone. Perseus slew her and presented her head to Athena.

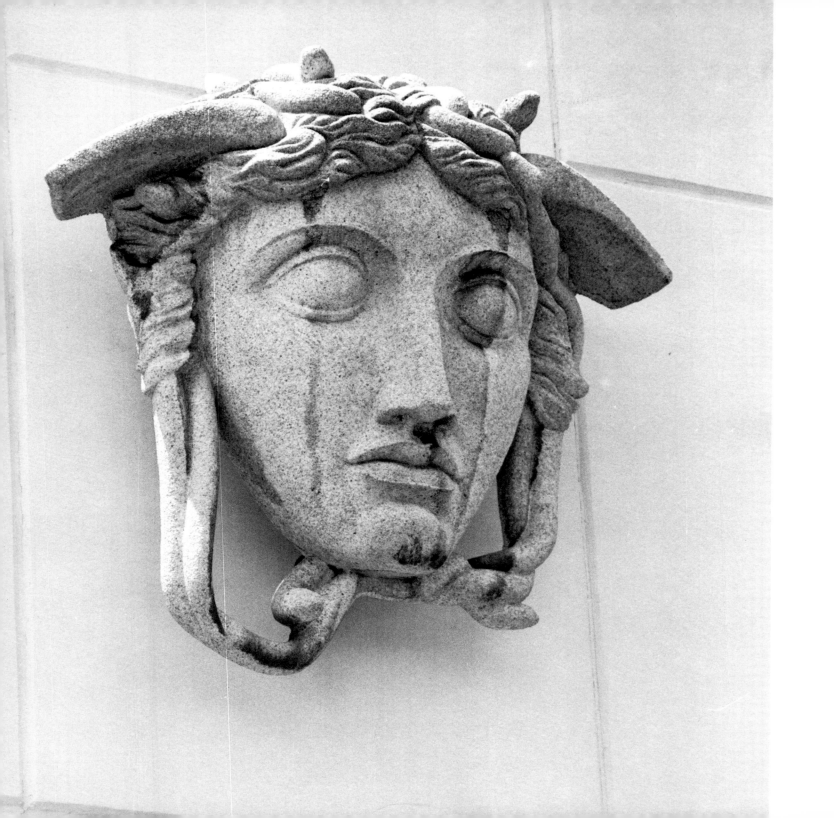

65. Frank Jirouch, sculptor. This 1964 photograph of Jirouch at age 86 was taken by the author in the sculptor's studio at the rear of 4812 Superior Ave. He was then busily at work on still another piece for the East Blvd. Cultural Gardens which are a monument to his career.

Frank L. Jirouch (1878-1970)

Frank L. Jirouch (Fig. 65) is known mainly for the legacy of his sculpture in Cleveland's Cultural Gardens which border East Blvd. between Superior and St. Clair Avenues. The idea for this chain of nationality gardens was conceived by Leo W. Weidenthal in 1926 with his sponsorship of a Hebrew garden, designed by J. Ashburton Tripp of New York. A Shakespeare garden had been established nearby in 1916, but this pre-dated the Cultural Garden concept—the purpose of which was (and is) to take note of the diverse cultures which make up the City of Cleveland. A focal point of the

Shakespeare garden is a bust of the poet executed by Jirouch in 1953. Each of the other gardens has one or more busts, statues or commemorative plaques honoring a poet, educator, philosopher, etc. of the sponsoring ethnic group. Jirouch claimed to have done as many as twenty-five of these, a number of which are represented herein.

Abraham Lincoln (Fig. 72, 1950)
John Hay (1838-1905) (Fig. 71, executed in 1938)
Artemus Ward (1834-1867) (executed in 1948)
Ernst Bloch (1880-c.1960) (executed in 1955)—75th birthday
Johann Sebastian Bach (1685-1750, German) (executed in 1965)
Heinrich Heine (1797-1856, German) (executed in 1957)
Thomas Masaryk (1850-1937, Czeck) (Fig. 67, executed in 1961)
Jan Amos Komensky (Comenius; Czech) (executed in 1957)
Anton Dvorak (1841-1904, Czech)
Nicolaus Copernicus (1473-1543, Polish) (Fig. 70, executed 1950)
MMe. Curie (Marie Sklodowski, Polish) (Fig. 66, executed 1949)
Frederic Chopin (1810-1941) (executed c. 1952)
Ignace Jan Paderewski (1860-1941) (Fig. 69)

As of 1973 there were 20 gardens linked in this nationality chain to which Frank Jirouch's contribution was greater than that of any other single sculptor by a considerable margin. Regretably, vandals have taken their toll.

Jirouch[8] was born in Cleveland of a Czech father and a German mother. At the turn of this century he and George J. Fischer, also a Clevelander, worked together as woodcarvers on the Prudential Building in New York City. The pay was irregular so that in 1902, on the strength of business promised by Charles F. Schweinfurth, Cleveland's leading architect of this time, they decided to return to Ohio and start their own enterprise, the firm long known as Fischer & Jirouch, the principal business of which was decorative, architectural, relief sculpture—a field which the firm dominated locally for many years.

66. **Marie Curie** (1867–1934) by Frank Jirouch for the Polish Cultural Garden. Polish-French chemist who discovered radium and polonium (1898).

Apparently not satisfied simply to be "in business," during World War I Jirouch took a leave-of-absence to attend the Pennsylvania Academy of Fine Arts in Philadelphia. In 1921, shortly after the War, he and Mrs. Jirouch went to Paris where they lived with a French family for three years. During this period he became a monitor at the Academie Julien; he also exhibited his work at the Salon Francais. Presumably, upon his return, he rejoined Fischer, but business dried up during the Great Depression and there was little or no work for the duration of World War II. After the war the trend was towards little of the type decoration offered by Fischer & Jirouch—rather simplicity and the lack of ornamentation were the order of the day. Fortunately, the Cultural Garden commissions kept him busy then and for the balance of his life.

In 1928 Jirouch did *Night Passing the Earth to Day* (Fig. 68) on the Holden Terrace overlooking the Fine Arts Garden before The Cleveland Museum of Art—a commission he won in a competition and of which he was quite proud. This is perhaps his best work. At about this time, also, he designed the frieze inside the *Indianapolis War Memorial*, a project of Cleveland architects, Walker & Weeks. The firm also did the ornamental work for Walker & Weeks in Cleveland's distinguished Federal Reserve Bank Building and in lovely Severance Hall. Additionally, Jirouch modeled the figures of *St. John* and the *Madonna*, occupying niches flanking the entrance to St. John's Cathedral in downtown Cleveland.

In 1931, with business depressed, Jirouch and his wife went again on a three-month cruise of the Mediterranean, visiting Italy, Greece, Lebanon, Palestine, Egypt and Spain. The total cost for both was $3.500!—not an inconsiderable sum at the time. Upon returning to Cleveland he discontinued his association with George Fischer at 4821 Superior Avenue, but maintained a studio at the rear of an upper floor for the balance of his life. The Jirouchs lived at 3095 Essex Road, Cleveland Heights. One wonders what has been the fate of his prized, bronze *Swimmer* (displayed in a Paris salon), of the lovely head of a young mother holding an infant to her cheek (a favorite of Mrs. Jirouch), of the bronze athlete about to make a hammer throw, of the bronze relief of *Diane the Huntress*—all of which embellished a studio addition to their home. The Jirouchs had no children. *(text continued on page 62)*

67. Tomas G. Masaryk (1850–1937) by Frank Jirouch for the Czech Cultural Garden. Masaryk was founder and 1st President of Czeckoslovakia.

68. Night Passing the Earth to Day (1928) by Frank Jirouch, bronze on a stone base, c.6′ in height, Fine Arts Garden, University Circle, Cleveland. This piece, a favorite of the sculptor, has a commanding view of the pond and gardens with the neo-Classical Cleveland Museum of Art in the background. In our view, Severance Hall is glimpsed behind the trees. Shortly, he would be modeling the medallions which flank the latter's proscenium arch. Indeed, the firm of Fischer and Jirouch did virtually all of the decorative, plaster work within The Federal Reserve Bank, Severance Hall, Cleveland City Hall, the Ohio Bell Telephone Building and others too numerous to enumerate.

69. Ignace Jan Paderewski (1860–1941) by Frank Jirouch for the Polish Cultural Garden. Paderewski was a pianist and statesman.

70. Nicolaus Copernicus (1473–1543) by Frank Jirouch for the Polish Cultural Garden.

71. John Hay by Frank Jirouch. Hay (1838–1905), American author and diplomat, was assistant private secretary to Pres. Lincoln. He was later (1899) responsible for the Open Door Policy in China.

72. Lincoln by Frank Jirouch—erected in memory of Peter Witt of Cleveland.

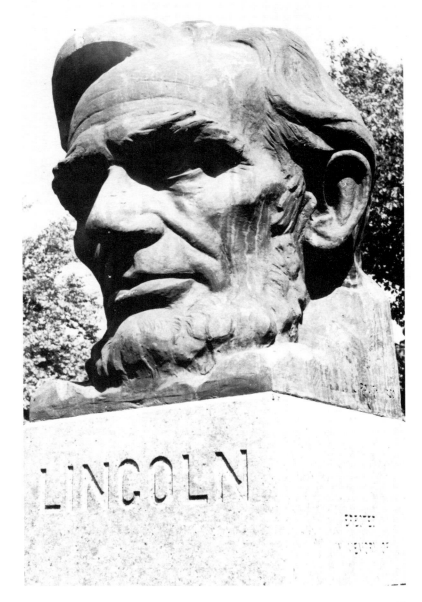

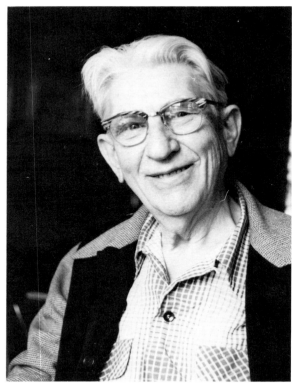

73. Walter Sinz, teacher and sculptor, photographed at his Cleveland Heights home in 1964 at the age of 83. Sinz is remembered, endearingly, as a kindly and self-less man by his students.

Walter A. Sinz, Sculptor

A treatise on sculpture in Ohio would be incomplete without mention of Walter A. Sinz, longtime teacher at the Cleveland Institute of Art. Sinz was born in Cleveland on July 13, 1881. Many in the family before him were artisans and artists; Sinz's father was a lithographer. His mother died when he was a child of four and he was orphaned upon the death of his father when he was fifteen. A brother, who died prematurely at the age of nineteen, made his first stone lithograph when only ten years old. Such was his precarious start in life.

While in his teens, Walter Sinz found employment with the firm of Shellentrager & Haushka, a competitor of Fischer & Jirouch, well known for its work in the field of architectural sculpture, which hoped that some of the family's talent was in his bones. He was set to work doing the crude, initial relief on sculptural elements which, in those days, were installed in the pediments of buildings of all types as well as homes. One day a man by the name of Stephen Gladwin happened by at a time when Sinz was minding the office. Fortuitously, he (Sinz) had with him a carved panel on which he had been working. "Who did that?" Gladwin asked.

Shortly Sinz found himself in partnership with Stephen Gladwin. One of his very earliest works, born of this association, were the cartouches on the facade of the Tolgarth Hotel on lower Prospect Avenue. While associated with Gladwin, Sinz executed the decorative elements within Cleveland's Hippodrome Theatre including, particularly, the cartouches over the arched openings within the proscenium arch and the festoons in the foyer. When completed in 1907, the theatre was unsurpassed in size and elegance in the United States (Knox and Elliot, architects). (As this is written there is talk of tearing it down in favor of a large office building complex.) In that same year the Gladwin and Sinz partnership was dissolved at the not inconsiderable loss to Sinz of $1,500—a year's work in those days!

"At this point something happened which changed the course of my life," Sinz related to the author. "I went looking for a job at the Brooks Household Art Company (later Rorimer-Brooks Co.) then located at the corner of Prospect Avenue and East 22nd Street—without success. Taking my leave, I boarded one of those open, summer streetcars Cleveland used to have and sat down next to a gentleman who was none other than Herman Matzen, head of the sculpture department at the Art School."

"Aren't you Walter Sinz?" Matzen asked. "What are you doing?" "Well, then, how about assisting me in my studio?" Thus commenced a 17 year association spanning the years 1907-1924. Herman Matzen was, at this time, the leading and most respected sculptor in Cleveland.

"I learned formulas from him," Sinz related. "How to make an eye, how to contour a hand. He was a great teacher."

In addition to his teaching chores at the Art School, Matzen worked closely with Cleveland architects, Hubbell & Benes, designers of The Cleveland Museum of Art, the Citizens Building, the West Side Market, the Bell Telephone Building and St. Luke's Hospital among others. Walter Sinz, as his associate, had a great deal to do with the design and execution of the ornamental elements which grace these buildings.

"The next time you are in the vicinity of the West Side Market take note of the granite cartouche of an eagle with outstretched wings above cornucopias overflowing with fruits and vegetables," he counselled. The bronze doors of The Cleveland Museum of Art (Fig. 76) (1916) were cast from models made by Sinz; the granite statue of *St. Luke Reading the Gospel* (Fig. 74) before St. Luke's Hospital, Shaker Blvd., is entirely his work. This was carved by Gandola Brothers in 1929.[6]

Sinz actually commenced teaching at the Art School in 1911—an association which was to last until 1952 when he retired. However, this long stint was interrupted in 1924 to enable him to spend six months at the Academie Julien where he studied under Paul Landowski and taught simultaneously.

"What do you think are your best works?" I asked him. "Of what works are you most proud?"

"Well," he replied, "there's the *Thompson Aviation Trophy*—the design for which I won in competition; the original is in the Smithsonian; a duplicate is in the Thompson collection here. There is a bust of *Alexander Graham Bell* by me in the Smithsonian. Then, too, there are a series of portrait busts of the presidents of Mount Union College, Alliance, Ohio, which I was commissioned to do."

Among other works by Sinz are: a bust of *Admiral King* in Lorain High School; a portrait bust of *William Hunt Eisenman* at the Society for Metals, Novelty, Ohio; also portrait busts of *Archbishop James Hoban* (Hoban High Schools—Cleveland and Akron). Sinz designed the historic bronze plaque affixed to a large boulder above the Akron Children's Zoo which marks the portage used by Indians in bridging the water-shed between the Great Lakes, via the Cuyahoga River, to tributaries of the great Ohio River.

In his late years (early 1960's) Walter Sinz kept extremely busy, at home, designing relief portraits for commemorative coins. Many of these are quite beautiful. The process employed, as he described it, is as follows: working from a photograph or sketch, the subject is developed, in relief, in clay contained within a 9" diameter dished-out, plaster disc; when completed a plaster female is taken off the clay model. This negative is treated with green soap or stearic acid preparatory to taking a plaster positive from it—exactly duplicating the original clay model. In other hands this process is repeated to the end that a tough, hard plastic model is obtained. The surface of this is "traced" on a reducing machine so as to produce a steel die of the desired size (frequently 2⅞") for coining the medallions. At the time of my visit with him he was working on such a relief portrait of former President Herbert Hoover, who had recently passed away.[9]

The greatest tribute which can be paid to Walter Sinz is the affection in which his former students invariably held him. One told me:

"He was a dedicated teacher and one of the finest men I have ever known. He carefully observed and genuinely criticized the work of each student in a constructive way. He planted ideas in such a way that the student thought they were his own. He would stay at school far beyond his assigned hours to assist a student in making a cast. He was a kindly man."

74. St. Luke Reading the Gospel (1929) by Walter Sinz, carved in granite by Gandola Bros., before St. Lukes Hospital, Shaker Blvd. Cleveland, O. This expressive piece is a major, outdoor work of the sculptor. We see St. Luke, with the Gospel in hand, flanked on one side by mother and child, and on the other by a young nurse. St. Luke, a physician, was a friend of St. Paul and St. Mark.

75. St. Luke (detail) back-side of monument. The ox is a symbol of St. Luke whose sainthood is celebrated by an ox roast each October 28th.

64

76. Bronze doors—Cleveland Musuem of Art—modeled by Walter Sinz (1916).

Victor Schreckengost (1906-)

Victor Schreckengost has been a versatile artist on the Cleveland scene for over fifty years. His activities have included painting, sculpture, ceramics, stage design, graphics as well as designs for contemporary production china. Schreckengost was born in Sebring, Ohio, a pottery center, in 1906. It is not, therefore, surprising that his father was, indeed, a potter and that much of his own work has been in ceramics.

Following the completion of his studies at the Cleveland School of Art, the young artist went to Vienna where he studied pottery under the well-known Michael Powalny. Other continental centers were visited before he returned to the Cleveland School of Art as an instructor in 1931—an association, including his student years, which lasted for half a century.

In the realm of outdoor sculpture, with which we are herein concerned, Schreckengost did the colorful, 4' x 8' ceramic panels, featuring prehistoric birds, which decorate the *Bird Building Tower* at The Cleveland Zoo (Fig. 79, 1951). His huge relief sculptures of elephants on the Pachyderm Building (Fig. 77, 1956) are an even more impressive zoological commission. These are 13' high by 25' in length! In 1955 Schreckengost completed what has been described as the largest, ceramic sculpture of modern times—*Early Settler* (Fig. 78) suspended above the entrance to the Lakewood High School Civic Auditorium.

Because of the large size of the individual terra cotta pieces and the necessity for very high temperature firing to provide optimum moisture resistance, *Early Settler* was processed at the Perth Amboy (New Jersey) Kilns. This sculpture is not simply applied to the building, but is affixed to metal armatures which are an integral part of the load-bearing wall. It ought to have been noted, in connection with the Pachyderm Building wall reliefs, that the different colored clays were applied to the wall surface in the wet state.

For over forty years the versatile artist-sculptor-designer has resided on Stillman Road in Cleveland Heights, Ohio.

65

77. Pachyderms (1956) by Victor Schreckengost, fired terra cotta, 13' x 25', Pachyderm Building, Cleveland Zoo. Four different clays were employed in the production of this large wall sculpture so that, when fired, four distinct tones developed. Tiles affixed to the rear become an integral part of the load-bearing wall. Schreckengost's pachyderms have intrigued and delighted visitors to the Zoo for almost a quarter century.

78. Early Settler (or Johnny Appleseed)(1955) by Victor Schreckengost, v. high temperature fired ceramic, 18′ x 33′, facade of Lakewood High School. It is claimed that this is the largest sculpture of its type in modern times. The individual pieces of which it is made are attached to an armature which becomes an integral part of the wall on which it is mounted. This is a very colorful work in blues, yellows, and earth tones with red birds.

79. Bird Building Tower (1951) sculpture by Victor Schreckengost, fired terra cotta, Cleveland Zoo. The stone tower is decorated, at intervals, with 4' x 8' terra Cotta plaques representing from bottom to top: the archeoteryx, the hesperornis, the diatryma, the dodo and the American eagle. As is the case with other Schreckengost sculptures included herein, much is lost for want of color.

80. City Fettering Nature (c.1927), right, by Alexander Blazys (Russian-American, 1894–1963). Blazys came to Cleveland in 1925; this work was acquired by the Cleveland Museum of Art in 1927 and is seen here before the stunning, striped Marcel Breuer addition to the Museum. It was cast at Antioch College in Yellow Springs, Ohio. Shortly after Blazys' arrival in Cleveland, he became an instructor at The Cleveland School of Art. Ultimately, he was appointed head of its sculpture department, serving in this capacity until 1937.

Alexander Blazys (1894-1963)

Alexander Blazys was born in Poniewiesz, Lithuania in February of 1894. As a youth he studied sculpture under Russian masters between 1913 and 1917. Because of deference shown to artists, he was able to pursue his craft during the Revolution. He came to Cleveland in 1925 at the age of 31 and shortly thereafter became a member of the Cleveland School of Art faculty. Following Herman Matzen, he served as head of its sculpture department until 1937.

The only outdoor sculpture by Blazys, known to the author, is his monumental bronze *City Fettering Nature* which stands on the East side of The Cleveland Museum of Art (Fig. 80). It is 7' 9'' tall on a granite base 5' 6'' in height and was acquired in 1927. Another important work in the City for which he will be remembered is the uppermost, carved limewood panel of the reredos of The Church of the Covenant. Additionally, *Cleveland Topics* of May, 1928, tells of portrait busts of *Andrew Squire* (founding member of one of Cleveland's great law firms) and *Henry Keller* (noted Cleveland artist) recently completed by Blazys.

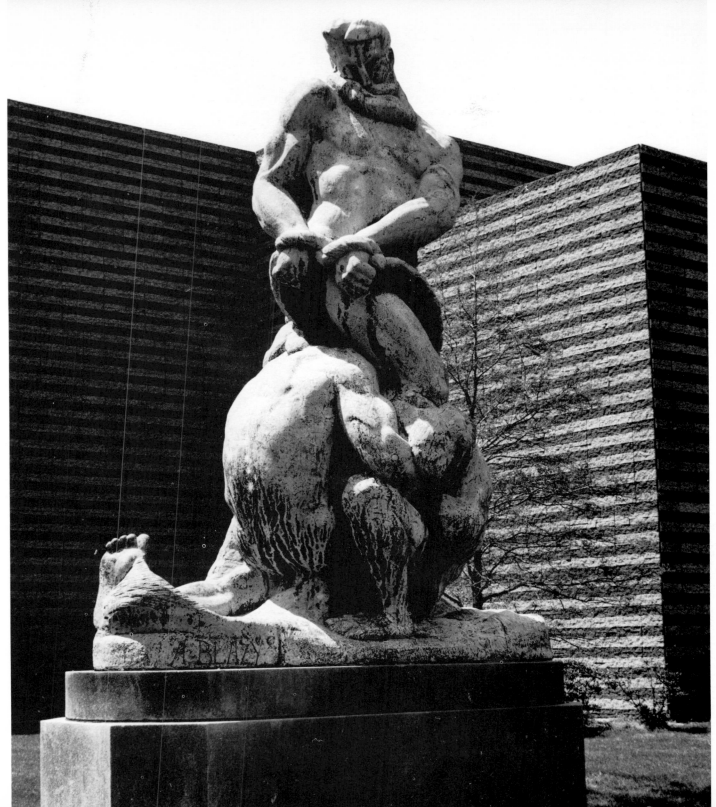

Max Kalish (1891-1945)

Max Kalish was born in Poland in 1891. He graduated from the Cleveland School of Art in 1910. Following graduation, he continued his studies at the National Academy of Design in New York under A. Stirling Calder (father of Alexander Calder); also in the studios of Isador Konti and C. S. Pietro (Pietro's work is represented in this volume by a handsome study of naturalist John Burroughs mounted on a boulder in the park-like setting before The Toledo Museum of Art (Fig. 77). Ultimately, he studied abroad with Paul Wayland Bartlett, a noted American ex-patriot sculptor who spent most of his life in France. He also attended the Academie Colorassi and finally L'Ecole des Beaux Arts while overseas.

Returning to America, well-trained Kalish joined the sculpture staff of The Panama-Pacific Exposition in San Francisco. There he did the *Spirit of Plenty* and other work within the Fine Arts Building.

The glorification of the American worker in bronze was a favorite theme of Max Kalish. These pieces, usually intended for indoor table display, have a masculine, muscular, robustness about them. They depict the worker, with sledge overhead, in the act of fracturing a large rock, or, perhaps, stripped to the waist puddling iron. He had a remarkable ability to reproduce the male human, with muscles taut, engaged in heavy labor.

His most notable work in Cleveland, and the only outdoor work with which we are familiar, is the heroic statue of *Abraham Lincoln* (Figs. 5, 81) which stands on the Mall before the Board of Education Building. It was executed in 1932 in bronze and is 12' in height. It depicts Lincoln in the act of delivering his immortal Gettysburg Address.

Funds for building and public sculpture dried up in America during the Great Depression and our preoccupation with surviving World War II—a period of fifteen years. With the advent of the post-War era (1946) not only the materials, but the subject matter of the sculptor and his treatment of it, all underwent a profound change. The hiatus was a water-shed which set the stage for a modern art, Ohio's participation in which we shall consider in the succeeding pages.

81. Abraham Lincoln (1932) by Max Kalish (American, 1891–1945), figure height-12'. The Kalish Lincoln, located on the Mall in downtown Cleveland, portrays the Great Emancipator in the act of delivering his Gettysburg address which is inscribed on the plinth below. This is Cleveland-reared Kalish's most prominent monument in the City and, to the best of our knowledge, the only one displayed out-of-doors. (Also cf. Fig. 5)

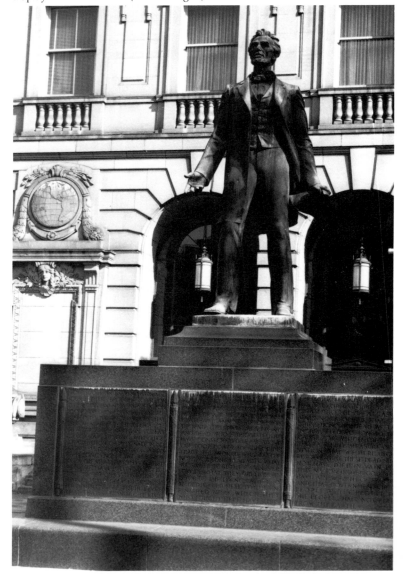

OHIO SCULPTURE IN THE POST WORLD WAR II ERA

Art historians concur that the seeds of modern, 20th century sculpture were sewn in Europe, particularly in Paris, prior to World War I. Wayne Craven writes in his *Sculpture in America* (Chapter 16, p. 614):

"Paris was the great gathering place of the men who were to create the initial stage of modern sculpture. To them fell the task of finding new forms of expression to replace eclectic tradition, the lifeless, romantic realism, and the diluted art of the academies. Picasso and Brancusi were in Paris, as were Gonzales, Modigliani and Zadkine; Nadelman and Csaky were there, Archipenko, Laurens, Pevsner, and occasionally Gabo; Boccioni, Lipschitz, Matisse and Duchamp-Villon as well. They had discovered new styles of art of the past which offered the inspiration that the Beaux Arts style no longer held for them and the domination of the classicism which had endured for five hundred years, since the beginning of the Renaissance, was brought to an end."

As Craven points out, "America was reluctant to participate in this revolution so that not until the post World War II era did America open its eyes to 'modern art'." Certainly the fact that many of the avant-garde artists listed above sought refuge in America from the Nazi holocaust had a great deal to do with the inception of our belated awakening. One of the most influential among these was Jacques Lipschitz, who was forced to leave Paris for Toulouse as the Nazi war machine advanced. Ultimately, in 1941, bereft of his art collection and other property, he was persuaded by friends to come to New York City. When he arrived, the combined resources of himself and his wife were $20. Even before the war and his coming to America, his works had been exhibited in New York. His *Mother and Daughter* (Fig. 82, 1929-30), displayed in the Sculpture Garden of The Cleveland Museum of Art, is considered to be representative of his developing talent at this earlier period. This is totally different, stylistically, from what Americans such as Paul Manship, Anna Hyatt Huntington, Herman Matzen, Seth Velsey or Max Kalish were doing at the time.

One of the few truly modern sculptors whose art developed on American soil during the '30's and the '40's was **David Smith** (1906-1965), who was born in Decatur, Indiana. Smith is generally considered to be the "father" of welded steel, abstract sculpture in America. He has an Ohio connection in that at age 18 he enrolled as an art major at Ohio University in Athens. Not satisfied with the art curiculum there, however, he left after a year and found employment with Studebaker (autos) in South Bend, Indiana, where he learned welding and riveting. The year 1927 found him enrolled at the Art Students League in New York City—the nation's most progressive school for aspiring artists—where he studied painting. Not until the early 1930's was he introduced to the welded metal sculpture of the Spaniards Gonzales, Gargallo and Picasso. Gargallo's work, in particular, greatly impressed him when exhibited at the Brummer Gallery in New York prior to 1935.

Inspired by the metal sculpture of these men, seen at first hand and in French art publications, Smith took the torch in his own hand and, to borrow Wayne Craven's words, "sensed at once that he had found his medium—thus welded metal sculpture in America had its beginning." At first Smith established his studio at the Terminal Iron Works on Brooklyn's waterfront where longshoremen viewed his work, in passing, with "incredulity." In 1940, determined to remove himself from "inhospitable New York," he bought some property at Bolton Landing on Lake George and built for himself a studio and house which he, of course, named "The Terminal Iron Works." Here he spent the rest of his life. His output of metal sculpture was prolific. Wayne Craven's description of the "Works" is interesting:

"The Terminal Iron Works looked more like a small-town machine shop than an artist's studio, with stacks of large sheets of stainless steel, piles of cast iron, strips and metal tubing, nuts and bolts, brass and copper, and aluminum; tools were strewn about on rusty workbenches and hoses ran from cylinders of gas to several types of torches. There were grinders and polishers, bottles of acid and cans of paint and waxes on steel shelving, as well as countless pieces of old metal, whose shapes were beyond description and whose original use defied explanation. These were gathered on trips throughout the area where dumps and junkyards were ransacked for the treasures they might yield to the sculptor's perceiving eye."

While we are not aware of a single piece of David Smith's metal sculpture out-of-doors in Ohio, without question his welded, abstract conceptions greatly influenced post World War II sculptors such as David E. Davis, John Clague, Don Drumm, Aka Pereyma, Ebb Haycock and others in the Buckeye State. The fact is that in America today steel and other metals, notably cast aluminum, have virtually displaced stone (and even bronze) as a medium, particularly in monumental, outdoor or environmental sculpture—even as synthetic resins and water have, to a marked degree, displaced the naturally occurring drying oils and solvents in many, modern paints. Furthermore, when working with steel— a material it had not even occurred to artists to employ early in this century—the sculptor by-passes the traditional, initial modeling-in-clay step for a direct attack upon his medium.

(text continued on page 79)

82. Mother and Daughter (1929/30) by Jacques Lipschitz, sculpture garden of The Cleveland Museum of Art. Lipschitz was one of the earliest precursors of the modern art movement in America. Consider what a radical departure from realism this represents when compared, for example, with Alex Blazys' traditional **City Fettering Nature**, also located on the Museum grounds and of precisely the same time. The accompanying text contains notes on Lipschitz's somewhat turbulent life.

83. Harvey Rice Monument (1899) by James G. C. Hamilton, bronze on a granite pedestal, 13½′ in height, Cleveland Museum of Art grounds. Harvey Rice (1800–1891) was, as the monument proclaims, educator, legislator and historian. The plaque held in the hand of the young lady states "Father of the common school system in Ohio." The monument is executed in the totally realistic manner of its time. Its subsidiary groupings are much more expressive than, for example, those seen in William Walcutt's Commodore Perry Monument (Fig. 3).

84/85. Harvey Rice Monument—details of the subsidiary groups at the base of the pedestal. The palm branch, extended by the young boy, is a symbol of esteem. In another, overleaf, an idealized teacher instructs a child.

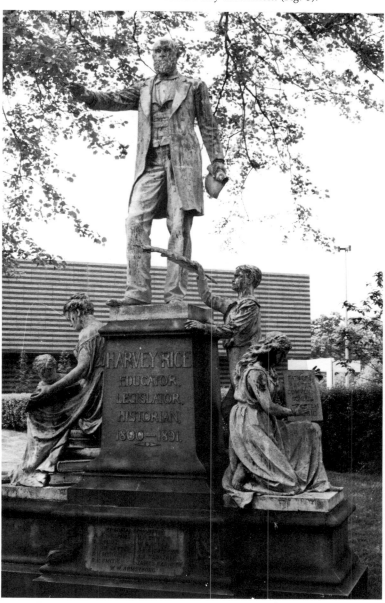

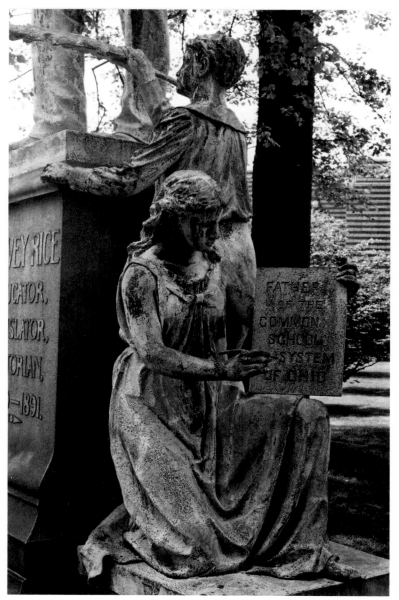

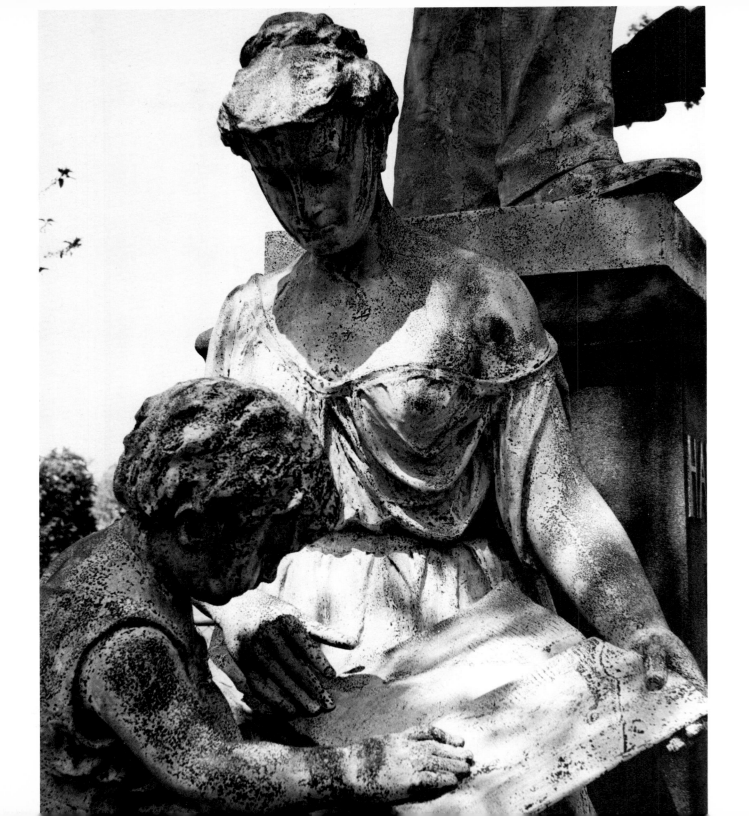

86. Gen. Moses Cleaveland (1888) by James G. C. Hamilton, bronze on a granite plinth, 12-15′ in height overall, Cleveland Public Square. Cleaveland (1754–1806) founder of the City in 1796 in behalf of the Connecticut Land Company of which he was an officer, is portrayed with the tools of the surveyor in his hands. Amzi Atwater, one among the 52 in the surveying party, described Cleaveland as having a broad face, dark complexion, very course features . . . slovenly of dress and vulgar in his conversation and manner.[23] Quite coincidentally, the camp cook bore the same name as Cleaveland's sculptor who executed the piece while under contract to the Smith Granite Co. of Westerly, R.I. which supplied the pedestal.

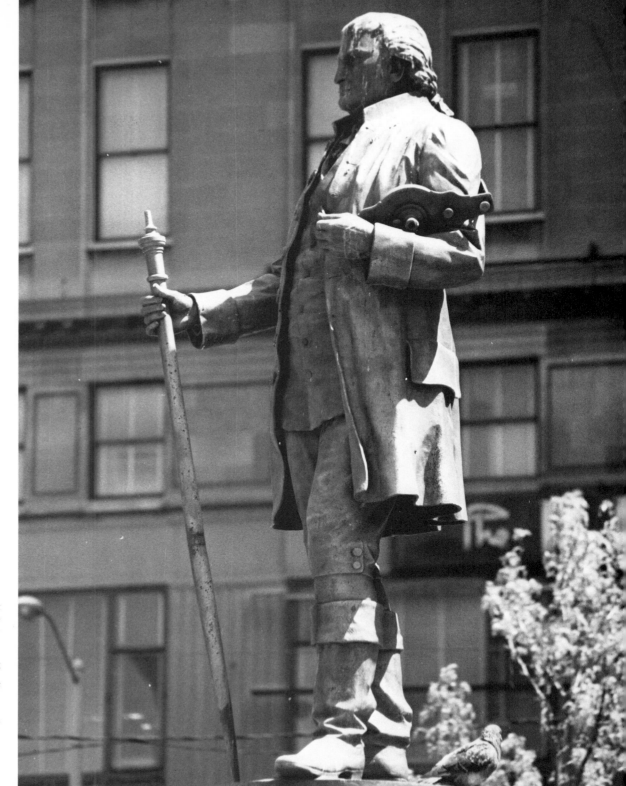

87. The Thinker by August Rodin (French 1840–1917) bronze on a granite base, located before the Cleveland Museum of Art. **The Thinker** of which this is one of several copies, is one of Rodin's most famous works. Here, the lower portion was bombed in an act of senseless vandalism circa 1970. Rodin, perhaps the greatest sculptor of our era, passed away about the time the Cleveland Museum came into being.

88. Fountain by Emilio Fiero, bronze, 36″ in height, Fine Arts Garden, University Circle. This lovely art nouveau drinking fountain is located near the former site of the Greater Cleveland Garden Center. Who could pass by without admiring the great blue heron in high relief on its side, or the frogs poised at the corners of its base? A thing of beauty is a joy forever!

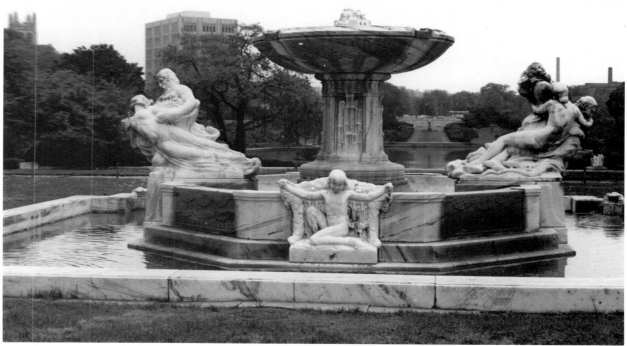

89. Fountain of the Rivers (1927) by Chester Beach of New York City, Frederick Law Olmsted-landscape design, before Cleveland Museum of Art. This lovely fountain was the gift of Mrs. Leonard C. Hanna to the City. **Cleveland Topics** (12/11/26) states '' . . . to be designed and modeled by Chester Beach of New York who conferred with Frederick Law Olmsted of Boston, designer of the complete scheme. The fountain consists of a large, flat bowl on a pedestal; flanking groups represent rivers flow-into the Great Lakes . . . 'children of the water' are represented close to the water groups . . . the fountain will be in the center of a 35' square pool . . . etc.''

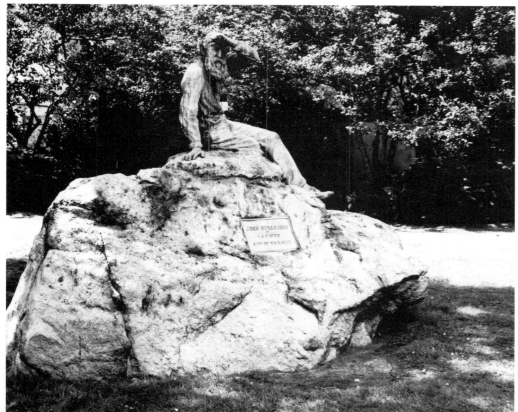

90. John Burroughs (1837–1921) by C. S. Pietro (1886–1918), bronze on a granite boulder, approximately life-size, Toledo Museum of Art (acquired 1918). This is one of two sculptures favored for location on the shaded lawn before the impressive, neo-classical facade of the Toledo Museum. Burroughs was an important American naturalist and author who ranged the hemisphere from his farm at Esopus, New York. The pale, green tint of the oxidized bronze contrasts nicely with the granite earth tones. Pietro came to the United State from Palermo, Sicily in 1911. William E. Bock, his patron and friend, gave the piece to Toledo.

the same style. Careful readers of this text will know that Milles' life touched and influenced a number of sculptors represented herein.

91. Fountain of the Rivers—details left: above—"children of the waters"; below-one of the river groupings.

92. Wings (1900) by Carl Milles (Swedish, 1875-1955), right, bronze on a granite base, 45" in height, gift to The Toledo Museum of Art by Mary Dunlap. Milles' conception, sharing the Toledo Museum's front lawn with the Burroughs, portrays the out-stretched hands of a man supporting an American eagle. Perhaps we are to interpret this as man's spirit being lifted to the heavens. Milles, born in Sweden, spent much of his life in America as teacher and sculptor in residence at Cranbrook Academy, Bloomfield Hills, Michigan, where a grand, canal-type fountain featuring many of his sculptural figures, is a feature of the landscape. His **Fountain of Faith** in the Washington, D.C. area is, not suprisingly, in very much

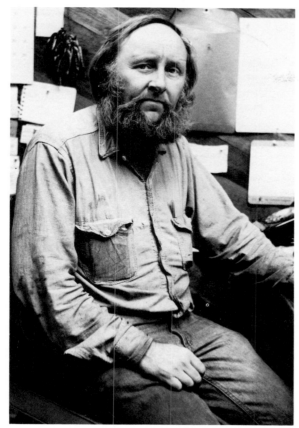

93. Don Drumm, sculptor, photographed by the author in the summer of 1979.

Don Drumm (1935-)

Don Drumm (Fig. 93) was born in Warren, Ohio, in 1935. His father was an auto mechanic. Don proudly declares, "I grew up as the son of a mechanic—a very darn good mechanic—and I acquired a lot of knowledge from living a part of my adolescence in a garage and working for my father on trucks and cars, working with welding equipment and being around nuts and bolts and the way things are put together. This has carried into my thinking today . . ."

Following graduation from high school, Don spent two years in a pre-med program at Hiram College (1952-54). He then transferred to Kent State University, for its broader curriculum, after having become "hooked" by a freshman art course. There he obtained both Bachelor and Master of Fine Arts Degrees. Following graduation he went to work for an industrial design company in Akron for a couple of years (1958-60), but left to start Don Drumm Studios in Akron. In 1965, at the age of thirty, Don was persuaded to interrupt his proprietary pursuits in the studio to accept a position as artist-in-residence at Bowling Green State University (Ohio). It was there that Don had his first opportunity to conceive and to execute environmental art on a grand scale. Enrollment had skyrocketed in the years preceding his six year stint at Bowling Green (1965-1971) with the result that the campus was in the midst of a great expansion of its facilities. The new buildings were of generally stark design. Dr. William T. Jerome, III, President of the University, realized that the campus could be enhanced by environmental sculpture. Working with Dr. Jerome and Richard Brown, the University architect, Drumm left a very considerable sculptural legacy to mark his years at Bowling Green.

Versatility is a key word descriptive of Don Drumm's output—an attribute of which he is most proud. He works in brick and/or concrete wall-relief, with aluminum casting or the shaping of wood as readily as with the cutting, shaping and welding of steel. This versatility is reflected in the work done at Bowling Green. His first and most obvious achievement on the campus is the mosaic effect created by his cut-concrete designs on the ten-story facade of the new library (Fig. 94) where black silicone stain is employed in designated areas for contrast and design recognition. Upon first viewing this work, one is immediately reminded of the colorful mosaics on the library facade at the University of Mexico. Perhaps this was his inspiration. The library's check-out desk, card catalogue and lounge are on a ground floor below the expansive plaza which offers no barrier to Drumm's sculptural wall. The latter plunges,

without interruption, to the building's foundation with a result that is particularly dramatic when viewed from within.

Elevated plazas flanking the library tower, which would otherwise be uninviting, barren spaces, derive considerable interest from the several judiciously positioned rectilinear shapes conceived by Drumm and formed of concrete with an overcoating of plaster, silicone stained (Figs. 95, 96). The tallest of these "monoliths" is approximately 18' in height. In addition to evoking an aesthetic experience, they serve as "benches" around which students may congregate. "In producing an interesting environmental experience," Drumm says, "we must be aware of how it relates to the immediate area. Indeed, an interesting environmental experience is the essence and intended direction of my work."

Elsewhere on the campus, adjacent to an old, landmark, country schoolhouse, Don executed a large Cor-ten "solar-totem" to the memory of the Kent State Four and the Jackson (Miss.) Two entitled *Bridge Over Troubled Water* (Fig. 98).[10] This is quite similar to his 25' high *Memorial to Richard Gosser*, a labor leader, which stands in a small, triangular park before the Health and Retirement Center on the fringe of downtown Toledo, Ohio (Fig. 97, 1966). Elsewhere on campus, an impressive 18' long cast aluminum wall sculpture confronts all who enter the Administration Building. Don says of his work at Bowling Green:

> "Bowling Green is a University rather than an art museum and our contributions are to the university campus in hopes that this is a stimulating environment in which to learn . . . I think that what I did on campus is educational, broadening, enriching and deepening to the lives of the students . . . "

Another of Don Drumm's so-called "solar totems" stands before Taylor Hall which houses the architecture department of his alma mater, Kent State University (Fig. 100, c.1964). This is fabricated of all-weathering steel and stands 14' tall. A similar totem is at Miami University at Oxford, Ohio. *Sky Notch* is the title of a

huge, 24' high Cor-ten sculpture on an elevated plaza beside Akron's John Morley Health Center, Broadway Avenue, behind the Summit County Courthouse (Fig. 102). His 18' high, and equally broad, fountain-sculpture of stainless-steel rod and cast aluminum panels, is the centerpiece of Akron's "Cascade Plaza"—showplace of the redeveloped central city (Fig. 101). When viewing this the author is reminded of the energy-collecting fins of a space ship. In a 36'-long panel before the Herbert Newman Housing Center for the Elderly in downtown Akron, Drumm inserts one of his characteristic all-weathering steel creations into a sculptured cement wall. Two of his most impressive "cut-stone" (actually sand-blasted brick) sculptures adorn the walls of a small utility building at the Akron's Children Zoo and at the Portage Path School. Appropriately, the former (Fig. 103) depicts highly stylized animals amidst sun bursts; equally appropriate is the huge head of an Indian deeply "etched" on the Portage Path School (Fig. 106), for less than two centuries ago, when the Ohio country was virgin territory, Indians, en route from the Great Lakes to the Ohio, portaged their canoes past this very site.

Don Drumm prides himself in being as much a craftsman as a creator. By virtue of his boyhood experience in his father's garage and subsequent work in industry, he is one of a comparatively few artists both able and equipped to conceive a sculptural design and to execute it whether this involve welding, casting or carving. His headquarters on Crouse Avenue in Akron, Ohio, are as much a foundy and metal-working shop as they are studio and showroom. Wayne Craven's description of David Smith's "Terminal Iron Works," quoted elsewhere, would serve as well to describe Drumm's establishment.

> "What is more real," Don asks, "than saying I am going to create an interesting object for the environment and I'm going to use the quality of steel and the contemporary techniques of welding to form, bend and create this work? You can't be more realistic than with that approach to creation . . .

"I keep coming back to Gestalt as an 'in' word, indicating a total relationship with the parts of a greater whole. In producing an interesting environmental experience, we must be aware of how it relates to the immediate area. This is why the majority of my work takes a non-objective direction. I am concerned with using the technology and materials of my society. That is my subject matter . . ."

The cement wall reliefs in the atrium at Orangewood Place, Chagrin Blvd. and I-271, Beachwood, Ohio, executed in 1975, are, Drumm believes, representative of his best work in this medium. Elsewhere in the Nation expansive examples of his cement wall-sculpture may be seen at Galleon Esplanade, a shopping complex at Nags Head, North Carolina. One piece at this location is two-stories high and 48' long. Numerous contemporary homes in Akron, Ohio, are embellished with interior wall-sculptures of wood and other materials, including decorative, aluminum door-handle escutcheons cast in his studio. In 1975 Drumm was called upon to design one of his 20' high "solar totems" as a memorial to *Martin Luther King* at the Hartford Heights Elementary School in Baltimore. In the same year he did a "totem" in Miami, Florida, which stands before a HUD apartment for the elderly. In 1969 The Citizens Savings and Loan Co., on the Central Plaza in Canton, Ohio, commissioned Drumm to design one of his more monumental wall sculptures in cast aluminum to embellish its main floor banking quarters.

(text continued on page 91)

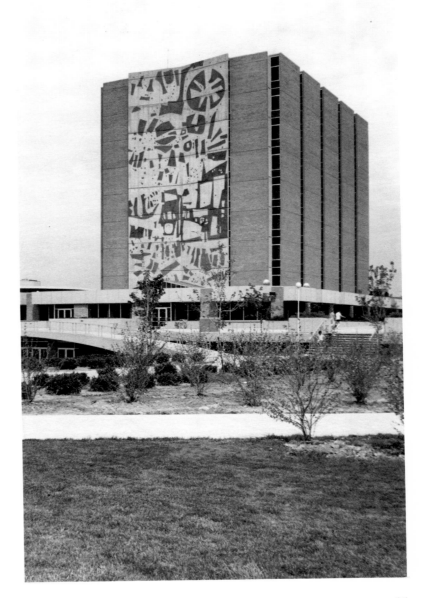

94. Library-Bowling Green State University (1967), cut concrete wall sculpture with silicone stain, 48' wide x 10 stories high. Don Drumm was sculptor in residence for six years commencing in 1965. A great building program was in progress at that time and Dr. William T. Jerome II, President, realized the need for art as a means of adding interest to the plain, utilitarian architecture. The relief mural, on the east and west facades of the college library, was Drumm's initial assignment. It plunges, uninterrupted, through ten stories, beyond the elevated terrace, to the ground-floor check-out room.

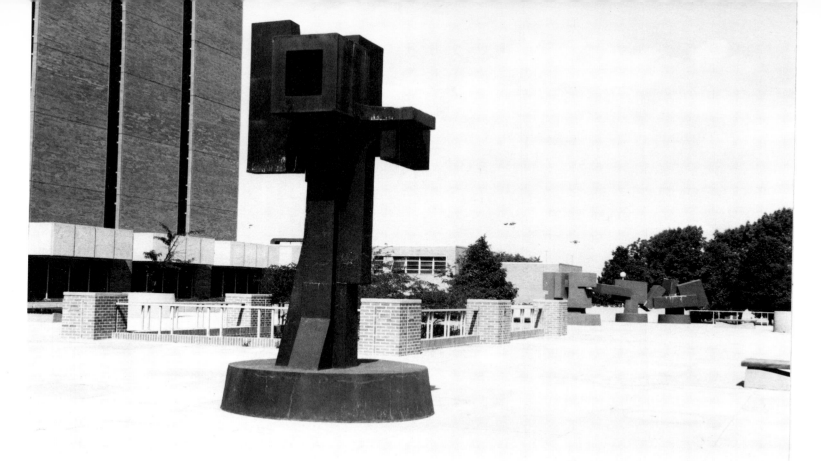

95,96. Monoliths (1967) by Don Drumm, concrete with plaster finish treated with silicone stain, tallest-18' in height, widest-20' x 10', Library Terrace, Bowling Green State University. The Library Terrace would be a rather sterile and forbidding space without these sculptural elements which also provide seating around which students may congregate. The cementitious surface of the terrace itself is patterned to complete the environmental design.

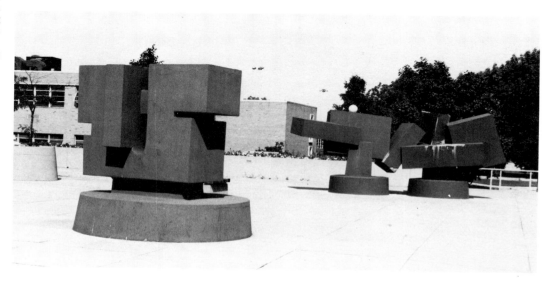

97. Richard Gosser Memorial (1964) by Don Drumm, Cor-ten steel, 25' in height, before the Toledo Health and Retirement Center. This **totem** is a memorial to a prominent Toledo labor leader. It is situated in a small, triangular park, before the Retirement Center, where one may contemplate it from adjacent benches.

98. Solar Totem to the "Kent State Four" and "The Jackson Two" (1970) by Don Drumm, Cor-ten steel, 14' in height, Bowling Green State University. This is one of a series by Drumm, known as "Solar Totems", of which the one at Kent State University is the earliest. This, at Bowling Green, is silhouetted before an early, one-room, schoolhouse museum on campus.

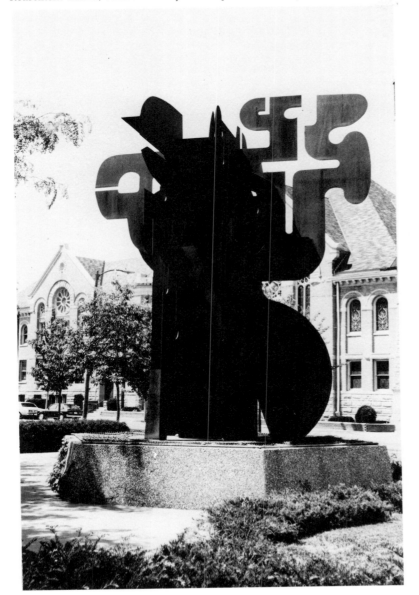

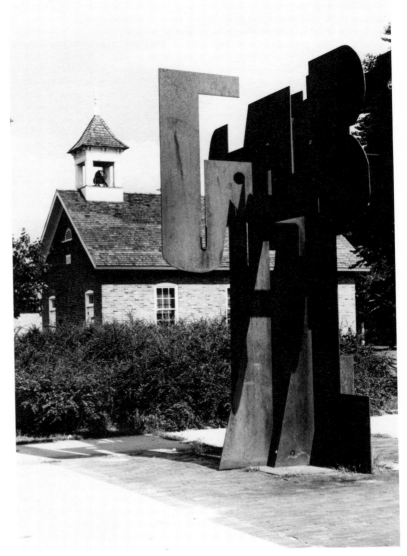

83

99. Don Drumm Studio and Gallery, cast aluminum. Drumm prides himself in being the operator of his own foundry (on these premises), a designer of sculpture for the environment as well as artistic, utilitarian objects for the household (door-handle escutcheons, candle-sticks etc.) in cast aluminum. His logo, the sunburst, is a favorite motif which appears frequently in his designs.

100. Solar Totem (1964) by Don Drumm, Cor-ten steel, 14' in height, before Taylor Hall, Kent State University. This, first of the 'solar Totems', was dented by a bullet in the course of the unfortunate student demonstrations during the Vietnam War. It blends well with the contemporary architecture of Taylor Hall (not shown). The reader should consult the text for details of Drumm's career.

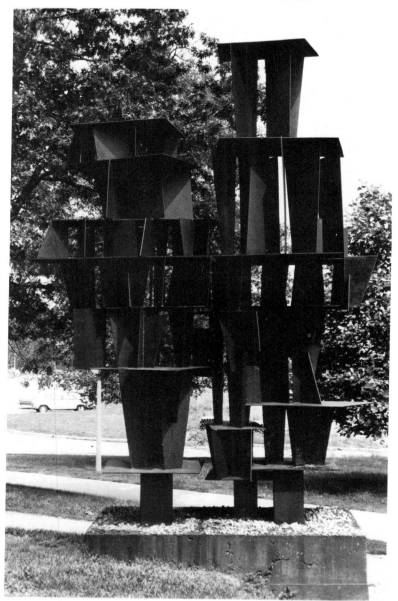

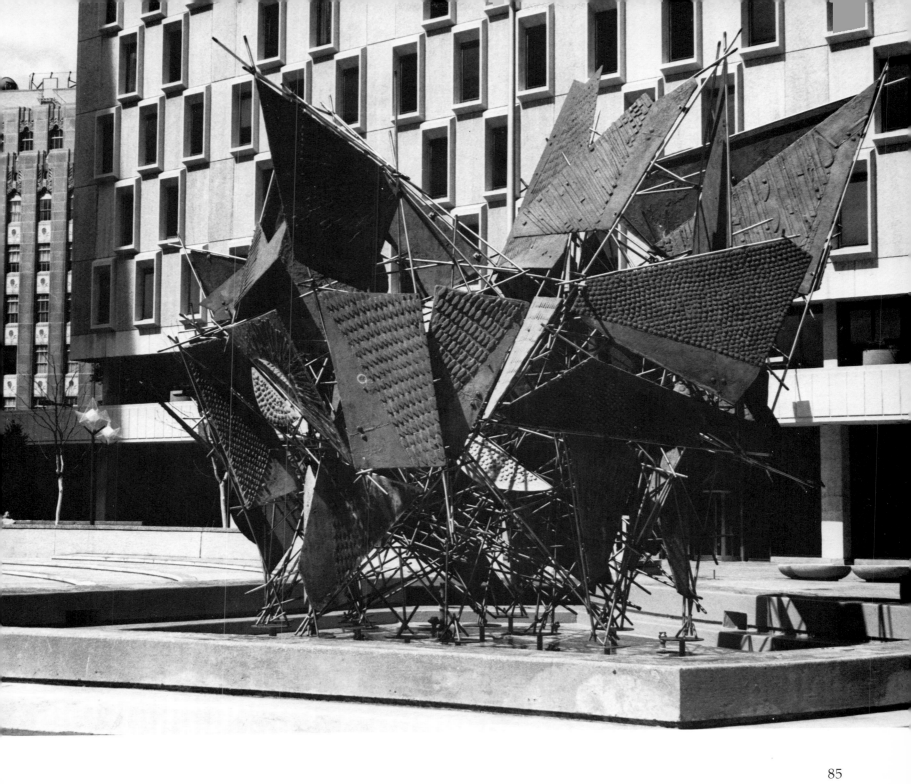

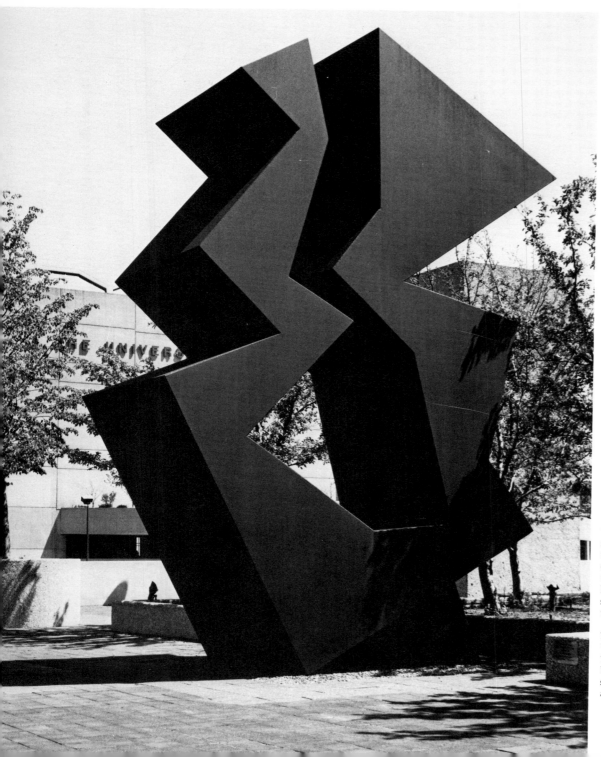

101. Cascade Plaza Fountain (1968) by Don Drumm, overleaf, stainless steel rods with anodized, cast aluminum panels, 15'Hx18'Wx15'. Drumm developed this fountain sculpture in association with Lawrence Halperin, planner of Akron's Cascade Plaza. Since there is commercial space and/or parking below, a primary requirement was that the sculpture not exceed two tons in weight. In developing the design, the execution of which required three years (1965–1968), a prime consideration was the aesthetics of the sculpture's comparatively dark color contrasting with the light color of the surrounding facades. It is only fully appreciated when the fountain is in action and the textured panels shimmer in the aqueous mist.

102. Sky Notch (1965) by Don Drumm, left, Cor-ten steel, 29' in height. This Drumm creation is located on the tiled terrace of the John Morley Health Center in downtown Akron, Ohio. It overlooks Akron University's Thomas Center for the Performing Arts and is so huge that a man may stand on the lower, horizontal surface of the 'notch'. "Sky Notch" is somewhat unique, considering the totality of the sculptor's work.

103. Akron Children's Zoo—right, Auxillary Building Wall by Don Drumm, relief sculpture in cut brick, 14'Hx28'. Drumm takes particular pride in his unique brick and concrete wall sculptures. This charming design enhances the environment and brings pleasure to all who view it.

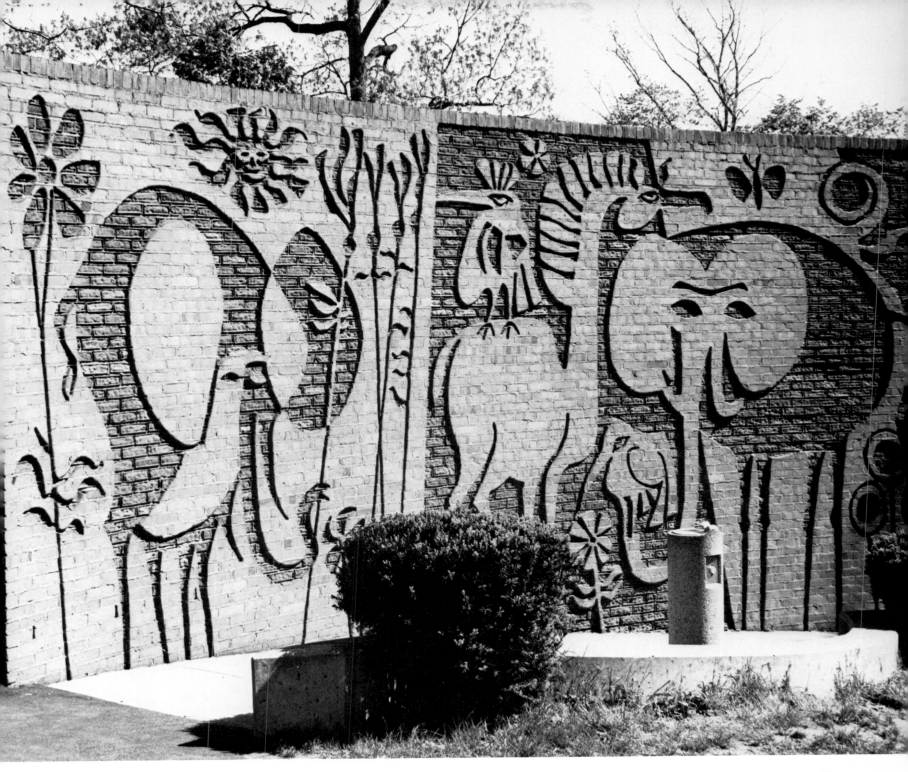

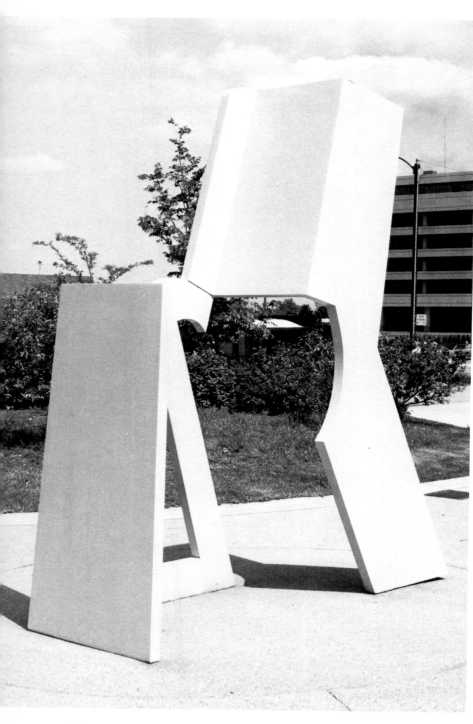

104. Roland (1976) by George Sugarman (b. 1912), height 10'-12', painted steel, located in a garden beside the Akron Public Library. George Sugarman studied sculpture in Paris between 1950–55. In the early '60's he became known for his ensembles of brightly painted jigsaw forms of carved and painted wood. Since the early 1970's he has been producing large, public sculptures of painted Cor-ten steel. Recent works, of which **Roland** is an example, deal with complex forms which define an internal space while retaining a sense of openness. The Columbus Museum sculpture garden includes a 1975–77 Sugarman entitled **Cade.**

105. Sculpture (1975–76) Theatre Arts Building, Akron University by Ray Jablonski, Cor-ten steel, 15' in height x 19' wide on a 20' square base. Thomas T. K. Zung, architect, commissioned Jablonski to design this companion-piece for his structure. Thirty-three years of age at the time, and holder of a Masters degree in Fine Arts from Kent State University, Ray Jablonski discarded the relative security of high school art teacher for an atelier in Cleveland's industrial "flats" circa 1975.

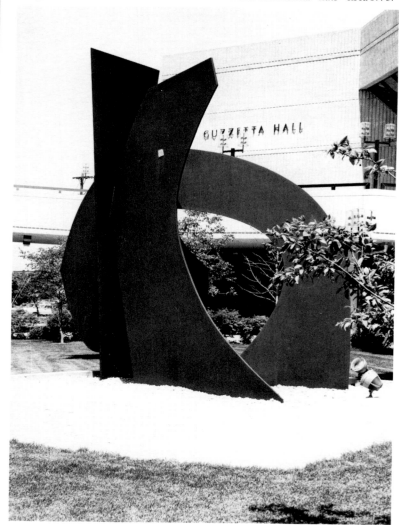

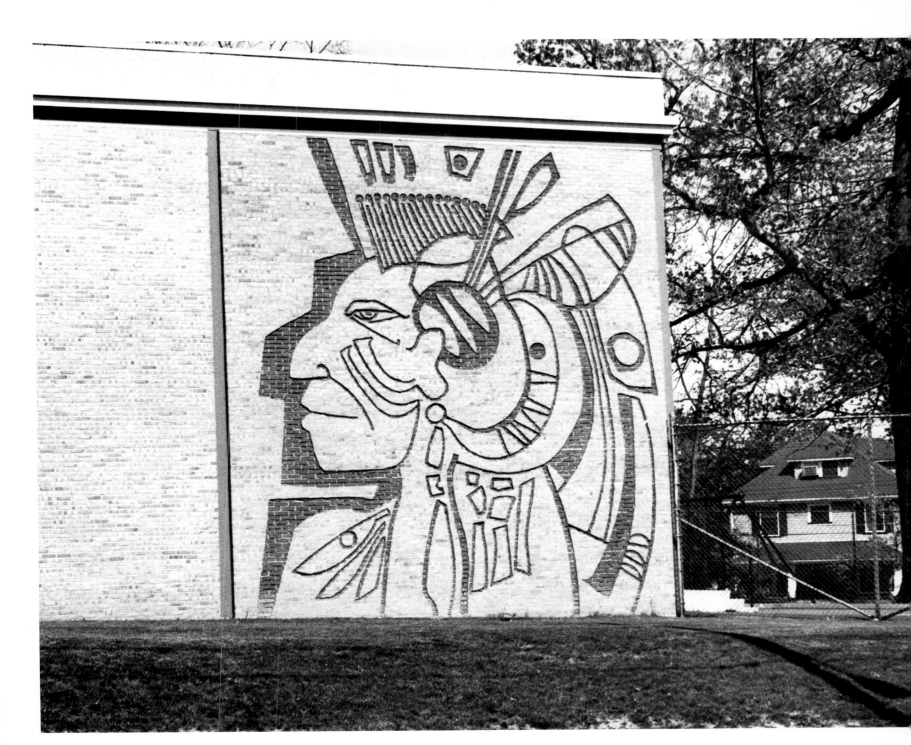

106. Indian Head, overleaf, Portage Path School, Akron, c.25'Hx20'W, cut brick. Our photograph is taken from the Portage Path, used by Indians 175 years ago in portaging from the headwaters of the Cuyahoga River overland to the Tuscarawas which, in turn, leads to the Muskingum and the great Ohio River at historic Marietta. Don Drumm is the sculptor.

108. Spirit of Doughboy (1924) by V. M. Viquesney of Spencer, Ind., bronze on a stone base, located before Armory, High Street, Akron. Each statue represented herein is interesting for what it reveals about the apparel of its time. Consider how differently this World War I "doughboy" is attired even when compared with Toledo's Spanish-American "rough-rider" (below) of 1898 (Fig. 107), not to mention the costume in which Moses Cleaveland appears on Cleveland's Public Square (Fig. 86). Here, in dichotomy, two institutions of man are represented—church and state.

90

John Rogers Clague (1928-)

John Rogers Clague was born in Cleveland, Ohio, on March 14, 1928. He received his Bachelor of Fine Arts from the Cleveland School of Art (now The Cleveland Art Institute) circa 1950. Over the years The Cleveland Museum of Art has acquired a number of Clague's pieces—mostly in metal; many of these having concurrently received awards in the Museum's annual May Shows. One of his earlier pieces entitled *Rebirth* (1961) may be seen in the entrance lobby of The Jewish Community Center in Cleveland Heights. At the heart of this open, egg-shaped abstract sculpture one observes the Ten Commandments. Lateral "pedals" forming the egg-shape symbolize, at the bottom, the flowering of ancient Israel and at the top, the unfinished "dome" of the faith.

In recent years John Clague has been absorbed with kinetic sculpture, at the frontiers of the art, which move and make "music." The raw material is mostly stainless steel rod, tube and sheet. One such, a model on display in his Gates Mills studio on the day that we visited, was called *One Man Band*. In this, thin vertical elements bearing gongs or "sounding balls" ring against burnished discs when the heavy brass base (the solid chord of a sphere) is set in motion (Fig. 109). Clague is also experimenting with fragments of stainless steel sheet embedded into a black matrix within rectangular frames. Burnished in different directions, these composites, bridging sculpture and painting, reflect light to provide unusual spacial effects.

Clague's production of outdoor, environmental sculpture has been sparse. However, the two major pieces of which we are aware are quite worthy of attention. The first of these, a kinetic known as *Auriculum I* (Fig. 110), stands 20' tall on the brick terrace before the contemporary library at Ashland College, Ashland, Ohio. It was commissioned in 1971 and installed in 1973. Mechanically, *Auriculum* involves a system of pendulums suspended from gimbals to achieve the movement that actuates its sound-aiming devices. Although it was primarily designed to require the physical participation of the viewer, on gusty days the sculpture is activated by the wind. When this happens a second, smaller pendulum in the upper reaches of the sculpture rocks in the opposite direction. This, in turn, causes strikers to ring against a conical spray of stainless steel rods. Leon F. Schenker, Professor of Art at Ashland College, quotes from an address to the faculty regarding *Auriculum I* as follows:

109. John Clague, sculptor (1928–)—photographed by the author in his Gates Mills studio. "One Man Brass Band" is seen on the black pedestal.

91

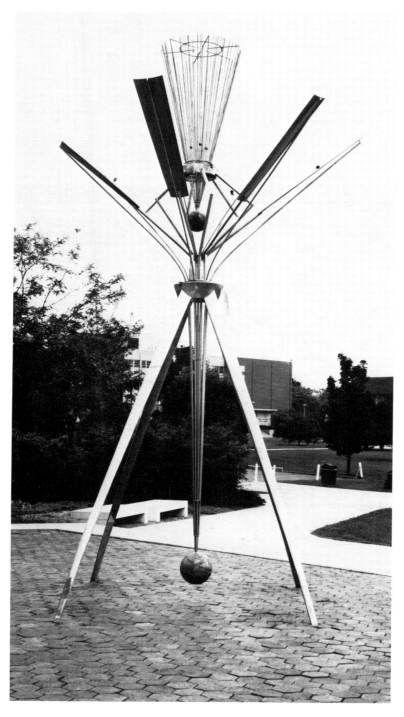

"Today . . . we are proud of that image (*Auriculum*). It represents the unique critical vision of one man and, in a larger sense, our acceptance of the uniqueness of every man and our desire, through education, to make that uniqueness critical . . . On this campus it may well be the most poignant symbolic evidence of our credo espousing belief in the individual." (cf. also Fig. 207)

The other, major Clague outdoor piece, completed in 1969, is the focal point of interest in the garden of a Shaker Heights, Ohio, residence (Fig. 111). Fabricated of mild steel *Overture*, as it is called, stands 8' tall and 10' wide, like some kind of giant arthropod. It is a composite of diverse metal shapes including spheres, cubes, wedges, bars and cymbal-like elements. It is, indeed, a source of wonderment and speculation to those who view it from the nearby patio-terrace and is not unlike certain pieces by David Smith as exemplified by his *Tanktotem V* (1955-56). (cf. *200 Years of American Sculpture* p. 179)

(text continued on page 95)

110. Auriculum I (1973) by John Clague, stainless steel, height-20', weight-2,300 lbs., located before the Ashland College Library. **Auriculum I** is a kinetic, sound-making sculpture. It involves a system of pendulums, suspended from gimbals, to achieve the movement which activates the soundmaking devices. It was designed to require the physical participation of the students; however, on gusty days, it is activated by the wind. The sway of the pendulums, upper and lower, causes strikers to ring against the conical spray of stainless steel rods. Its construction required two years of uninterrupted effort. Fig. 207 illustrates how well Auriculum interacts with the contemporary architecture of the library.

111. Overature (1969) by John Clague, all-weathering steel, height-8', located in a private Shaker Heights, O. garden. This interesting Clague creation stands like some kind of giant anthropod, or perhaps two strange creatures, shuffling cubes between themselves. It is, indeed, a source of wonderment and speculation for those who view it from the adjacent garden patio. John Clague received his education at the Cleveland Institute of Art; the Cleveland Museum has acquired a number of his prize-winning works.

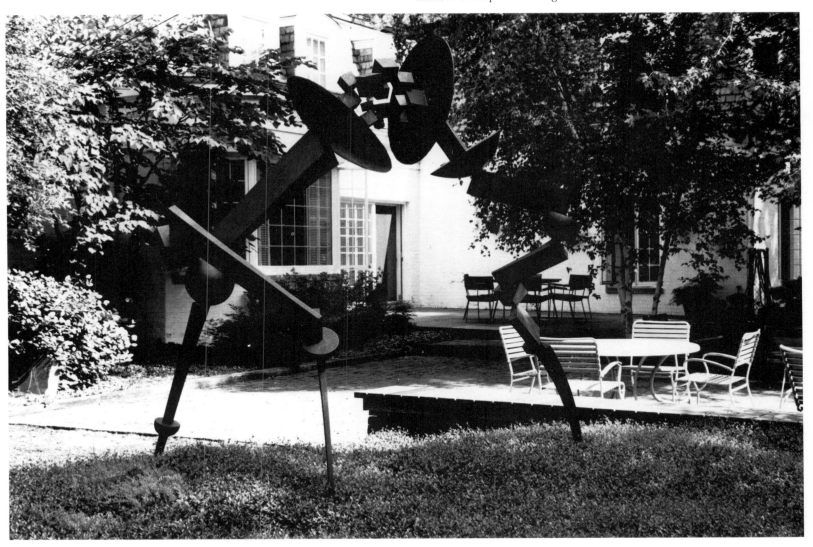

112. Eagle by June Shealor before Ashland College's Theatre for the Performing Arts, stainless steel, angle iron and concrete. This eagle, formed from several pieces of stainless steel sheet, struck us as being very successful.

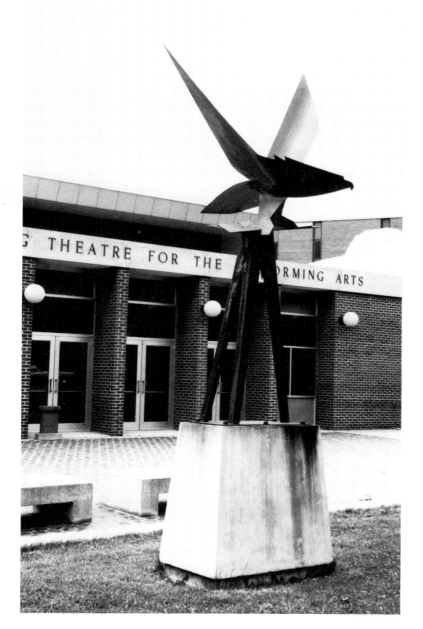

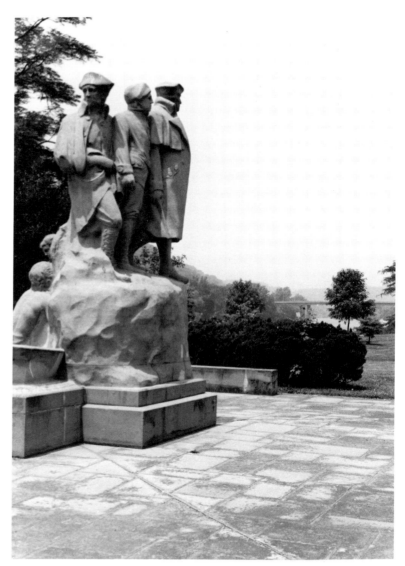

113. Start Westward Movement (1938) by Gutzon Borglum (American, 1871–1941), sandstone, height-22'. Anna Hyatt's one-time teacher is represented in Ohio by one major, outdoor work. He received the commission to do the **Start Westward Movement** in connection with the sesqui-centennial celebration of the establishment of the Northwest Territory (1787) of which Marietta was the first settlement. In the monument, located in a park beside the Muskingum River, two soldiers and a trapper survey the River, while several others (backside) unload a boat. Gutzon Borglum is, of course, best known for his Mt. Rushmore National Memorial in South Dakota containing the huge portraits of four presidents.

David E. Davis (1920-)

David E. Davis of Beachwood, Ohio, was born in Rona de Jos, Romania, in August of 1920. He studied at L'Ecole des Beaux Arts in 1945, then obtained a Bachelor of Fine Arts Degree from The Cleveland Institute of Art in 1948, to which he added a Masters Degree from Case Western Reserve University in 1961.

His principal contributions to Ohio's outdoor, sculptural scene to date are: *Walking Together* at Kent State University (1972); the *David Berger Memorial* before The Jewish Community Center, Cleveland Heights (1974); an untitled, painted steel piece before The Beck Center, Lakewood (1976); and finally *Harmonic Grid XX*, a painted aluminum abstract sculpture before the Progressive Insurance Company, Highland Heights (1978).

Walking Together (Fig. 117) was completed in 1972 for the Ohio Invitational Exhibition at Blossom Music Center. It was acquired for the Michener Collection in 1974 by Kent State University, where it stands on a rise before the Fine Arts Building. Fabricated mostly of wood with aluminum ''trim,'' it is suggestive of Mark di Suvero's *Hankchampion* (1960) in the collection of New York's Whitney Museum[11] which utilizes, basically, the same materials. Each would bring his own interpretation to this piece.

The *David Berger Monument* (Fig. 116) was commissioned in memory of the Israeli athlete, a former Clevelander, who was slain at the Munich Olympic Games in 1972. ''The Olympic emblem of five interlocking rings has been broken to symbolize the stopping of the 1972 Games; the ten semi-circles rest on eleven segments representing the eleven who died at Munich . . . one differing slightly to represent the unique events in David Berger's life . . .'' (from Jewish Community Center Bulletin). The monument is of Cor-ten steel.

In The Beck Center sculpture (Fig. 114) and that before the Progressive Insurance Company (Fig. 115), the former of painted steel (black and orange), the latter of painted aluminum (black and red), Davis seems to have hit upon a unique style. In both the sculptor introduces incised lines which add further interest to the rectangular and curvilinear shapes combined to form the whole. The introduction of color, also, is a great enhancer. Viewing these one is reminded that frequently Greek and Roman statues, and Greek Temples as well, were originally often vividly colored though, today, we see them stripped.

The Beck Center and Progressive Insurance Company sculptures are representative of the 'Harmonic Grid' series which has absorbed Davis's energy and explorations for most of the past five years. All of the geometric forms in these sculptures are derived from circular, triangular and right-angled shapes which it is possible to inscribe and cut from a rectangle in which the ratio of long to short side is 3:1. The pieces, so derived, have the same quantitative relationship within any particular member of the Harmonic Grid series. The system imposes a rigid discipline upon the sculptor. There is, therefore, a subtle, geometric relationship amongst all the disparate pieces of metal combined to form a Harmonic Grid—something not obvious to the casual viewer.

When last visited, Davis was having a difficult time unburdening himself from this long, self-imposed regimen for the pursuit of other sculptural directions.
(text continued on page 99)

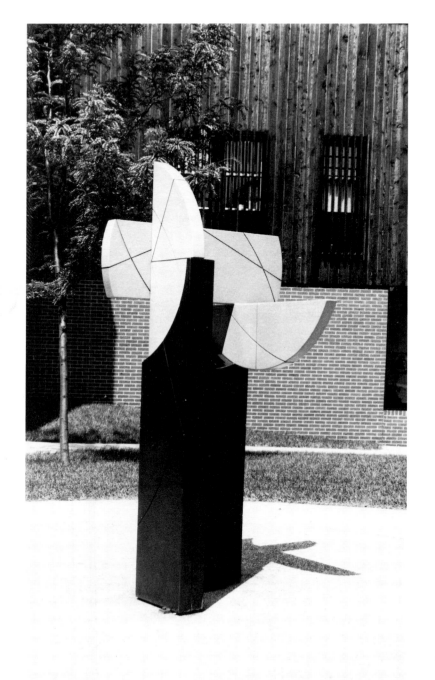

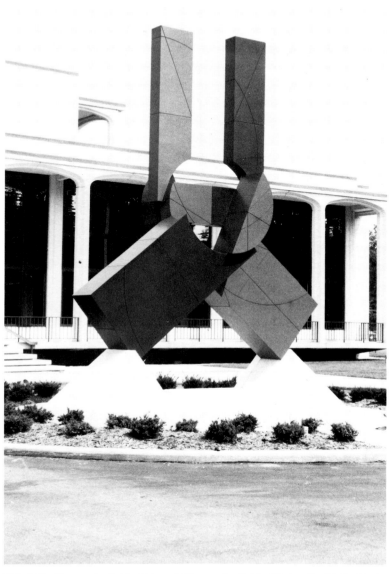

114, 115. Harmonic Grid #44 and Harmonic Grid #20 by David E. Davis. HG-44, executed in 1976, is fabricated of painted steel with dimensions 96" H x 78" dia. x 32". It is located before the Beck Center, Lakewood, O. HG-20 is fabricated of painted aluminum and stands 23' in height; it is located at the entrance to The Progressive Insurance Co., Highland Heights, O. Color is important to the fullest appreciation of these sculptures. In the harmonic grid series the sculptor has developed a unique program set forth in the accompanying text. The incised lines in those pictured, add interest to their rectangular and curvi-linear shapes.

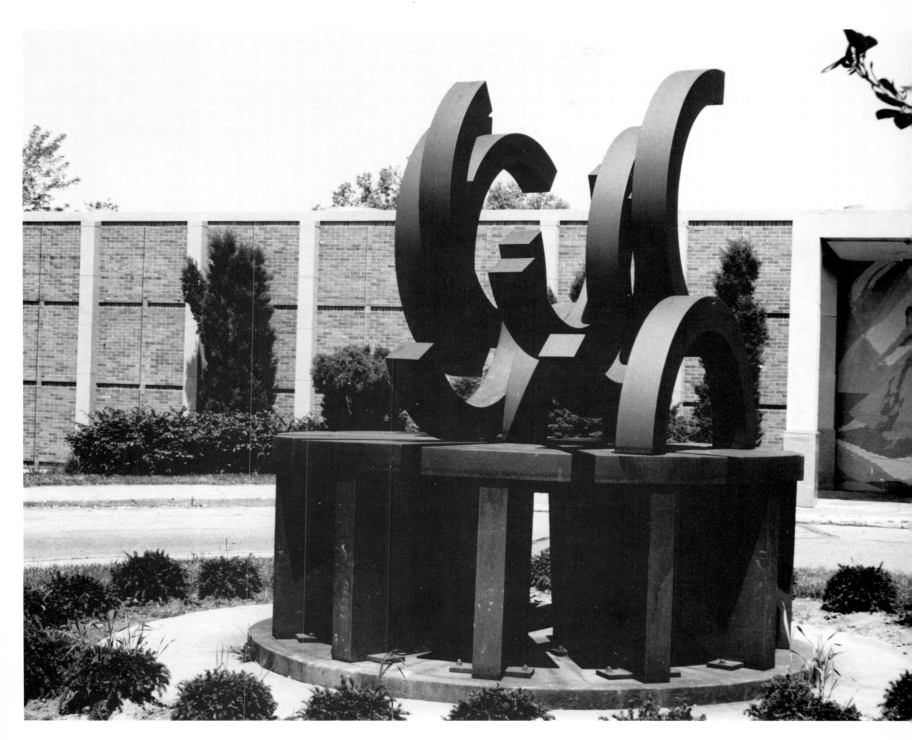

116. David Berger Monument (c.1973–74) by David E. Davis, overleaf, Cor-ten steel, 14′ in height x 11′ in diameter, Jewish Community Center, Cleveland Heights. This is an abstract memorial to the Cleveland-born, Israeli athlete who was murdered at the 1972 Munich Olympic games. The Olympic emblem of five inter-locking rings has been broken to symbolize the stopping of the games. The ten semi-circles thus formed rest on eleven segments representing the eleven who died at Munich. This monument was designated a Historic Landmark by the City of Cleveland Heights in the autumn of 1979.

117. Walking Together (1972) by David E. Davis, wood and aluminum, 22′ in height. This work was created for the Ohio Invitational Exhibition held at Blossom Music Center in 1972; it was acquired by Kent State University for the Michner Collection in 1974. The piece suggests forward movement; it is not unlike Mark di Suvero's Hankchampion (1960) in the collection of New York's Whitney Museum.

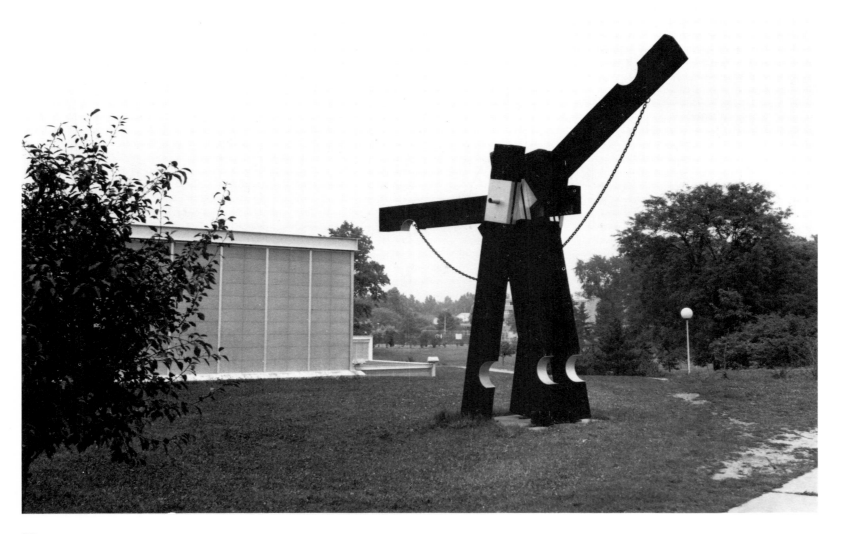

Aka Pereyma (1927)

Aka Pereyma was born in the Russian Ukraine in 1927 of a family noted for its Easter egg decoration, a native art. Circa 1950 Aka married a surgeon and moved with him to America where he had the opportunity to further his studies. Impressed with designs which Aka "doodled," he encouraged her to study ceramics at the Brooklyn Museum where she shortly discovered that her previous experience with Easter egg design was most helpful.

When the couple's children were of school age, by which time they had settled in Troy, Ohio, Aka continued her art studies at The Dayton Art Institute. Impressed with her ability, personnel there encouraged her to further her studies at The Chicago Art Institute. At her husband's insistence, though there were teenagers in the house, she went to Chicago where she attended the Institute day and night for a year. Back in Troy, she continued studies at The Dayton Art Institute from which she received a degree in sculpture in 1965.

At about this time, Glen Williams of the Hobart Brothers Technical Center in Troy presented Aka with a small welding unit as a Christmas present. Metal sculpture was a totally new and foreign art to her, but again her husband shaped her career by putting her in contact with a welding instructor. She attended one of the earliest summer programs for artists sponsored by Hobart Brothers in the '60s. One thing led to another and today Aka Pereyma, having found her medium, is Program Director of Hobart's month-long, summer program known as "Welding for Artists." With her persistence and total dedication to art and the work at hand, it is not surprising that Aka Pereyma excels in this art form.

The spacious grounds before the Hobart Brothers Technical Center are greatly beautified by the welded metal sculpture of graduates of this summer program. Three major pieces are the work of Aka Pereyma. The one which first catches the visitor's eye upon approaching the Center, is *Jacob's Ladder* (Fig. 118). This combines welded aluminum sheet over a Cor-ten steel base. The combination provides an interesting color contrast since the metallic aluminum might easily be taken for lustrous stainless steel, while the base is in the dull, reddish, chocolate-brown of corroded Cor-ten. *Jacob's Ladder* is 15' high x 6' deep x 4' wide. Aka says of it, "It is, in a way, a religious piece for it makes one look up to Heaven, or it could make you feel like you want to climb higher." A news release of The Contemporary Arts Center, Cincinnati, which sponsored an exhibit of Ms. Pereyma's work during November of 1976, comments as follows: "Her working process stems from folk art in that her approach is one of intuition rather than intellectual calculation. The color, composition and content are resolved through purely emotional methods."

At the left of the entrance to the Technical Center the visitor confronts another striking piece by Aka Pereyma (Fig. 119). It is also fabricated of Cor-ten steel, painted white, and was initially intended as a grave-marker for Glen Williams, the man who started her in the direction of welded, metal sculpture; however, environmental regulations at the cemetery precluded its intended use. Aka observes, "In Europe, one of the places where environmental sculpture is concentrated is in cemeteries. Starting with the small village cemetery and ending in cemeteries of statesmen, soldiers and artists; it was like going to a sculpture exhibit where all the tastes in art could find satisfaction." She deplores the fact that today families spend a considerable amount of money on a drab piece of granite when, by consulting with an artist, they might have a piece of art.

The third piece by Aka Pereyma, located under the recessed entrance to the welding school, bears the title *The Shield*. It, too, is made of Cor-ten and has the dimensions 5'x3'x2'. A giant wrench is suggested by its "head" and gear-like serrations (Fig. 120). Aka Pereyma's work, a striking revelation to the author, has been widely exhibited—particularly in southwest Ohio.

Also on the Technical Center grounds, one may observe Cor-ten sculptures executed by Mike McDonald (Fig. 121) and Charles Ginnever, (Fig. 122) well-known New York State artists. McDonald's piece—three cubes

118. Jacob's Ladder by Aka Pereyma, aluminum on a Cor-ten steel base, 15' H x 6' x 4', located in a sculpture park before the Hobart Bros. Technical Center, Troy, O. Aka Pereyma came to the United States from the Ukraine in 1950. She attended the Chicago Art Institute and in 1965 received a degree in sculpture from the Dayton Art Institute. Currently, she serves as Program Coordinator for the summer "Welding for Artist's Workshops" at the Technical Center. Of **Jacob's Ladder** she says, "It is, in a way, a religious piece. It makes you look up to heaven, or it should make you feel like you want to climb higher. It also could be a grave-marker—mine!"

stacked one atop the other—suggests David Smith's famous *Cubi I* (1963) featured on the jacket of *200 Years of American Sculpture*. Ginnever's work suggests a teeter-totter. An additional sculpture which we noted when visiting the Hobart campus (Fig. 123) suggests *Flight*. Missile-shaped members which appear to be made of glass-reinforced plastic "fly" through a block-shaped "A" fabricated of Cor-ten steel. The great fountain before the Technical Center may be seen in the background of this photo.

(text continued on page 103)

119. Glen Williams Memorial, left, by Aka Pereyma, Cor-ten steel painted white, located on the grounds of Hobart Bros. Technical Center, Troy, O. A dozen or so years ago Glen Williams of Hobart Bros. gave Ms. Pereyma a small welding set for Christmas—a present which sparked her interest in welded steel sculpture. This piece was created, in gratitude, as a grave-marker for Mr. Williams, however, cemetery regulations prevented its intended use. "In Europe," Ms. Pereyma says, "environmental sculpture was concentrated in cemeteries . . . it was like going to a sculpture exhibit where all the tastes in art could be satisfied".

121. Cubes by Michael McDonald, Cor-ten steel, c. 10′ in height, Hobart Technical Center, Troy, O. This highly interesting composition is quite reminiscent of David Smith's **Cubi I**. Smith, who pioneered in welded steel sculpture in the late 1930's, is considered to be the "father" of this art form in America (cf. text).

123. Flight (author's designation), right, by Robert Gaston, steel and resin reinforced fiberglass, Hobart Bros. Technical Center, Troy, O. Gaston is also the creator of **Guardians of the Path** (1976), a monumental concrete sculpture at the entrance to Miami University's Middletown, O. campus. The latter consumed 102 tons of steel reinforced concrete in shaping eight vertical forms—the tallest of which is 18'.

122. Teeter-Totter (author's designation) by Charles Ginnever (1931-), Hobart Bros. Technical Center. It may be presumed that Ginnever, a respected California-born, Vermont sculptor, created this piece while enrolled in Hobart's Welding for Artists Workshop. **Cubes** may be seen in the background.

Robert Charles Koepnick (1907–)

Robert Charles Koepnick is the Dean of contemporary sculptors practicing in the Miami Valley (SW Ohio). Born in Dayton in July of 1907, he first studied at the Dayton Art Institute, then at the Cranbrook Academy of Art, Bloomfield Hills, Michigan, with Carl Milles. For 40 years, between 1934 and 1974, he taught art at the Dayton Art Institute. Koepnick's works have been exhibited at The Pennsylvania Academy of Fine Art, Philadelphia; at the Art Institute, Chicago; at the Metropolitan Museum of Art, New York; also at the National Academy of Design, New York. Today, he maintains a studio near Lebanon, O.

Koepnick's most visible outdoor sculptures in Dayton are the cast aluminum panels on both the facade of the Dayton Public Library (Fig. 124) and on the entrance gate-posts to the Montgomery County Fair Grounds (Figs. 125, 126). The Library panel depicts men, women, and children with books in hand, standing over a background of open books. Completed in 1960, it is 21' high x 6' wide. One of the Fair Ground panels depicts mother and daughter before an appropriate background of cattle, fruit and roosters (Fig. 126); while the other portrays a father and son with harness-racing, sheep and hogs represented in the background. Having seen these, one could not mistake the identity of Koepnick's contemporary style wherever encountered.

While surveying the lovely courthouse square in Sidney, O., prior to our familiarity with Koepnick's work, we noted an eye-catching, cast aluminum panel across the facade of the contemporary First National Exchange Bank (Fig. 127). It did not surprise us later to learn that it, too, is the work of Robert Charles Koepnick. This assemblage, weighing 2,000 pounds, is 24' long x 8' in height. It was cast by the Ross Aluminum Foundries of Sidney. The panel, as described in the Bank's literature, is a "sculptural commentary on life in the Sidney community. . . ." It is "directed towards portraying, in some tangible form, the role of the Bank in the community while at the same time incorporating some outstanding landmarks in the latter's history." Also in Sidney, Koepnick designed a particularly effective panel-sculpture, entitled *Futural,* for the facade of the Ross Foundry, which has participated in the production of much of his work (Fig. 129).

Several Koepnick sculptures are owned by St. Peter in Chains Cathedral in Cincinnati including a bronze figure of *St. Peter* affixed to an exterior wall. A 13' bronze *Johnny Appleseed,* completed by him in 1967, is the focal point of a newly developed section of Spring Grove Cemetery in the "Queen City." A 1973 commission resulted in an 8' tall abstract, aluminum sculpture for the facade of the DeMarco Office Building in Vandalia, Ohio.

Additionally, Robert Koepnick's sculptural output includes numerous religious pieces among which are a 32' aluminum sculpture of *St. Michael* at Houston, Texas; an aluminum bas-relief in St. Rita's Church, Dayton; and an 8' *Crucifix* at St. Francis of Assisi Church in his hometown of Centerville, Ohio.

During the summer of 1979 The Dayton Art Institute featured an exhibit of recent sculpture by **John Koepnick**, son of Robert, and **James Nestor** in its sculpture garden. Both men are Ohioans now living in Pittsburgh. The younger Koepnick received his MFA from Carnegie-Mellon University and has been a teaching assistant at this institution. Fig. 134 provides a general view of the Dayton Art Institute exhibit. John Koepnick's pieces are: in the foreground, right; at the rear-center and the middle piece at the left. He says of his work: "I attempt to deal with what I believe to be the core issues of sculpture; that is weight, scale and mass . . . the intent here is to develop works of restraint in which the placement of things and the manipulation of volumes is all important."[12] This is a far cry from what was in the mind of Charles Henry Niehaus when he did his *Garfield* in Cincinnati or Max Kalish when he did his *Lincoln* on Cleveland's Mall!

One of the prized contemporary, abstract sculptures owned by The Dayton Art Institute is *Firmament* by Alexander Liberman (Fig. 133). (The setting for this may be better appreciated in Fig. 134 where it may be seen on the elevated "deck".) The piece was acquired by Dayton Art Institute in 1977.[13] Its dimensions are 7'4'' high x 26' x 28'. The cadmium red coating over the steel, a favorite color of Liberman, is particularly effective and makes an eye-stopper of it.

Before leaving Dayton we note the cast stone *John F. Kennedy* which stands before Kennedy Center at The University of Dayton and the Kiser High *Panther*. The former was sculpted by **William J. Thompson** of Ohio State University's Art Department and stands approximately 7' tall (Fig. 135). To a greater degree than in Anna Hyatt Huntington's *Lion* at The Dayton Art Institute, we sense the power, the speed and the stealthiness of a *Panther* in the design of **Eva Walters**

(continued on page 108)

104

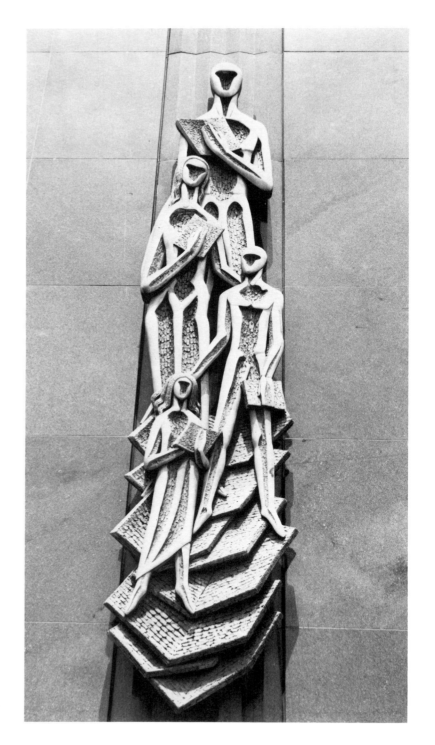

124. Panel-Dayton Public Library (1960), left, by Robert Koepnick (1907–), cast aluminum, 21'x6', cast by Valentine Matchplate Co. Robert Koepnick is the acknowledged dean of sculptors in southwest Ohio. He first studied art at the Dayton Art Institute and then at Cranbrook Academy under Carl Milles. He taught sculpture at the Dayton Art Institute for forty years commencing in 1934. In addition to works illustrated herein, one of his 12' panels graces the auditorium facade at Mount St. Joseph College in Cincinnati; his figure of **St. Peter-in-Chains** (bronze) presides over the north entrance to Cincinnati's Cathedral of this name. Koepnick maintains a studio in the vicinity of Lebanon, Ohio.

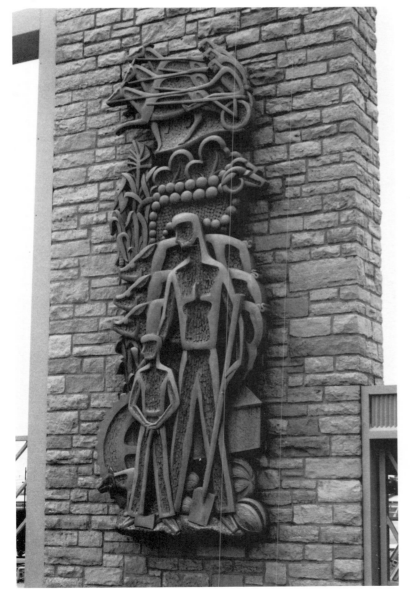

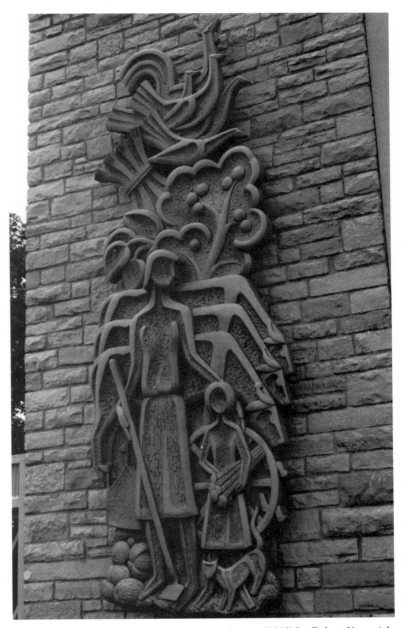

125, 126. Fairground panels—Montgomery County (1960) by Robert Koepnick, cast aluminum, 12' in height, Dayton, O. Farm and fairgound activities provide the theme for these companion panels; one featuring mother and daughter, the other father and son. Koepnick's style, as evident in these panels, is quite individual—leading one to confidently feel that he could recognize the artist's work wherever encountered. This, however, is equally true of the works of Clement Meadmore, Henry Moore, Louise Nevelson and others.

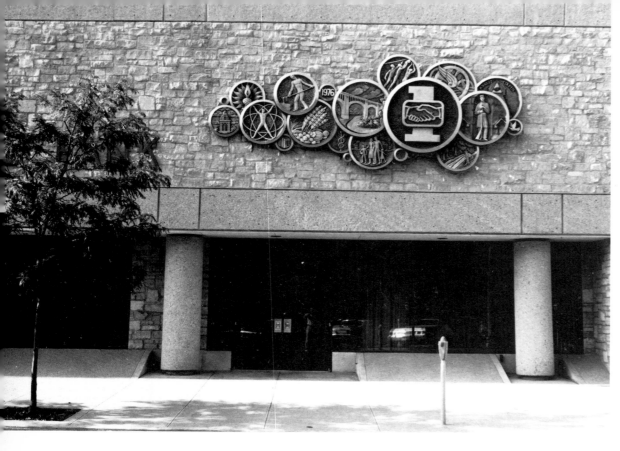

127, 128. Logo-First National Exchange Bank (1976) by Robert Koepnick, cast aluminum, 24'x8', Sidney, Ohio (cast by Ross Aluminum Foundries of Sidney). The composite of discs centers around the historical growth and modern development of the community. Pictorially represented are: the nearby New York Central RR. bridge, the courthouse tower, the lamp of knowledge, wheels of commerce and industry, a Civil War soldier, farm products, etc. A supplementary photo (Fig. 128) shows the installation of the piece in 1976.

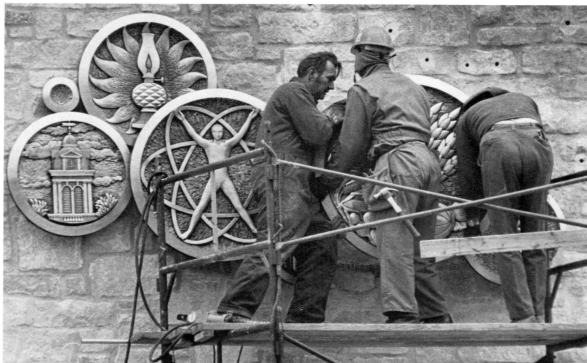

129. Futural (1970) by Robert Koepnick, cast aluminum by Ross Aluminum Foundry, 13′ in height, located on the foundry facade, N. Oak Ave. Sidney, Ohio. Futural is a grouping of 24 individual aluminum castings, presenting different surface treatments in varying orientations and levels. It is, in the author's opinion, a tremendously impressive piece of work. Sculptor Koepnick has worked closely on a number of projects with William A. Ross, President of the Foundry, who takes great pride in the results of their collaboration. (Photo courtesy Ross Foundry)

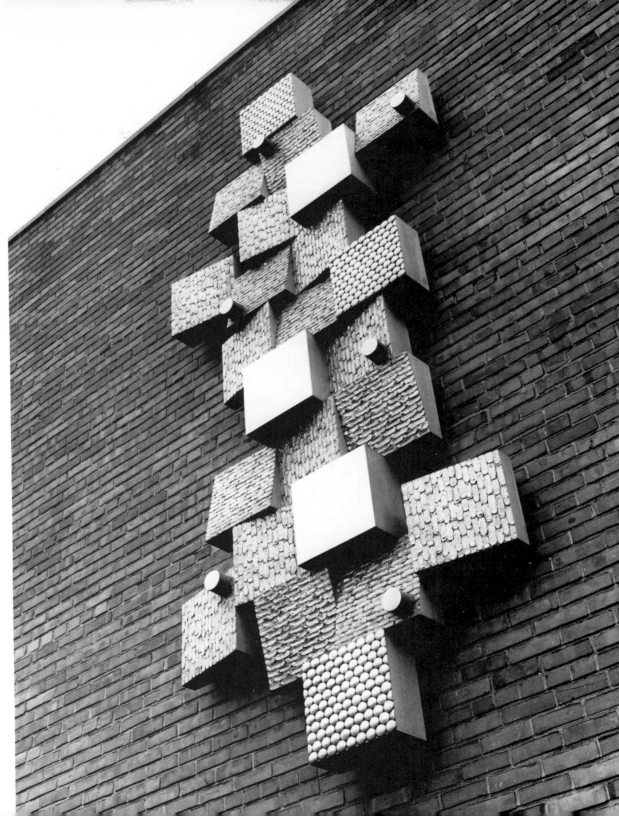

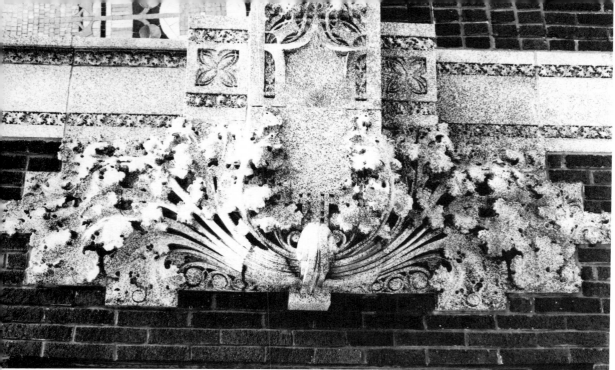

130. **Peoples Federal Savings and Loan** (1917), below, Louis Sullivan, architect, Sidney, O. This is the major, surviving structure in Ohio by the famous Chicago architect, Louis Sullivan (1856–1924) for whom Frank Lloyd Wright worked in the 1890's. The Sidney Bank is typical of a number of similar buildings designed late in his career. Sullivan is noted for the intricate, sculptural detail which he introduced into his designs. The Carson, Pirie, Scott store in Chicago is representative of his most florid style.

131. **Peoples Federal Savings and Loan**, left, a detail of the decorative element at semi-circle base. Architectural ornament reached its zenith in America in the work of Louis Sullivan which is nowhere better illustrated than in this comparatively small Ohio commission.

132. **Peoples Federal Savings and Loan,** Sidney, O., opposite, Photo at left illustrates the entire entrance ensemble. The semi-circle embraces a very colorful mosaic in which blue is the predominant hue. Photo at the right is a closeup of one of the stylized, shield-bearing lions which guards the entrance.

(Zaidon), which stands on a granite plinth before Kiser High School (Fig. 136). Reportedly,[14] it was sculptured in Italy of a black, Finnish granite. Eva Walters was a 1947 graduate of Kiser, which acquired the work in 1960.

The *John H. Patterson Memorial* (Figs. 138-140) located in Hills and Dales Park south of the city, is one of the more impressive monuments in the state. It is an equestrian, in high relief, in which the philanthropist and founder of The National Cash Register Co., astride his horse "Spinner", surveys the 325-acre property over which he rode so often and eventually gave to the City of Dayton as a park. The mounted figure of Patterson stands out from the granite base which attains an overall height of 35'. Large, supplementary, bronze composite sculptures (Fig. 140), occupying lateral extensions of this base suggest the benefits of labor and learning on the left and the abundance of the earth combined with the aspirations of man on the right. The monument was commissioned in April of 1925 and dedicated in May of 1928. It is the work of **G. Moretti**, an American. The situation of the Patterson Memorial, on a height of land with the vast open space falling away before it, adds immeasurably to its imposing character.

(continued on page 114)

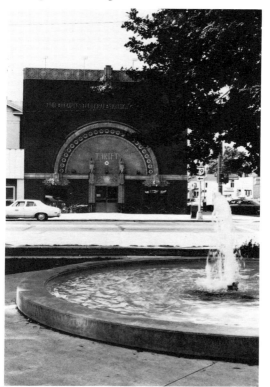

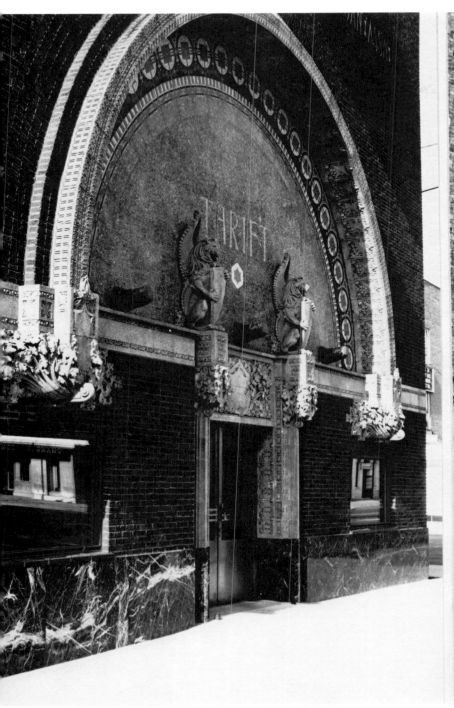
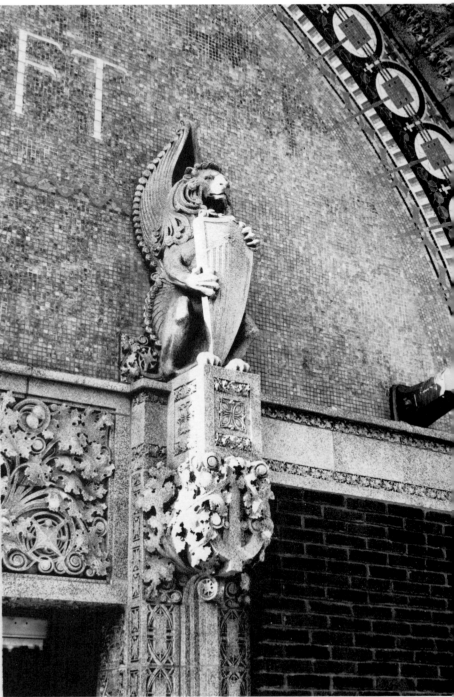

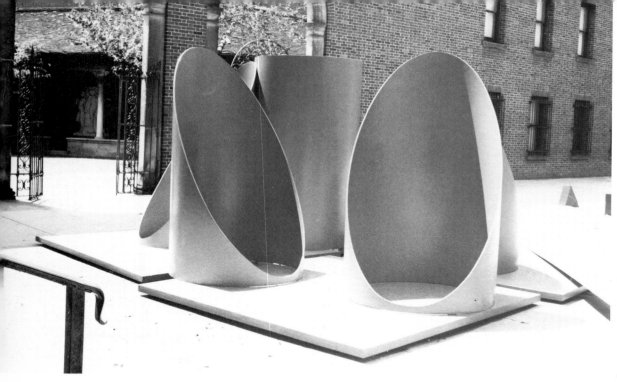

133. Firmament (1970) by Alexander Liberman, painted steel, 7'4"Hx26'x28', Sculpture Garden, Dayton Art Institute (cf. Note 13). Born in Russia in 1912, Liberman received his advanced art education in France, particularly at L'Ecole Speciale d'Architecture and L'Ecole des Beaux Arts. He was able to escape Europe during World War II—arriving in New York City in 1941, where, for the better part of the next two decades, he was involved with painting and publishing. He learned how to weld during a trip to France in 1959 with the result that metal sculpture has been his consuming interest ever since. He has been particularly concerned with the circle, the cube, the triangle and the fluid spaces around them. Since 1966 he has colored his creations with brilliant, cadmium-red paints which impart added dramatic impact. **Firmament**, acquired by the Dayton Art Institute in 1976, became the first, contemporary, abstract sculpture in the City.

134. Koepnick-Nestor Sculpture Exhibit (summer 1979) Dayton Art Institute. John Koepnick, son of well-known Robert, received his MFA degree from Carnegie-Mellon University. His pieces in our photo are: "Build-up" (lower right), "Twist" (middle left), and 'PGH' (background center). James Nestor, a native of Youngstown and holder of a Master's degree from Kent State University, executed the other pieces. The work of both men is very contemporary employing steel, aluminum and wood as their medium.

136. The Kiser Panther (1960), right, design by Eva Walters (Zaidon), sculpted by an unknown Italian; polished, black, Finnish granite on a granite plinth. This was a gift of the "Class of 1961" to Kiser High School (Dayton) of which Eva Walters was a 1947 graduate. Here, we sense the speed, the stealthiness and the power of the panther to a far greater degree than in Anna Hyatt Huntington's **Lion** at the Dayton Art Institute.

135. John F. Kennedy by William J. Thompson, approx. 8' in height, located before the Kennedy Center at the University of Dayton. Here, Prof. Thompson, formerly associated with the Ohio State University Department of Art, appears to compromise between traditional, representational sculpture (for the head) and abstract expressionism (for the body)—a reasonable solution to his assignment.

Floating Garden (1978–79), Downtown Dayton Kiwanis contribution to the River Corridor Project, Loren Minnick, coordinator. It is not always easy in 1980, to know what passes for sculpture. If the reader doubts this, refer to the important Robert Smithson project on the Kent State University campus, to the skeet-shooting conceptual "sculpture" by Dennis Oppenheim exhibited at the Cleveland Orchestra's Blossom Music Center August-September 1979, or to Mary Miss's **Staged Gates**, included herein.

111

141. Staged Gates (1979) by Mary Miss, Wolmanized Douglas Fir, Paw Paw Camp, Hills and Dales Park, Dayton. Following formal studies in art at the University of California, Santa Barbara (1962–66), Ms. Miss came in contact with, and befriended, a number of notable, western sculptors. Her first, large scale, outdoor structures, using the open landscape, date to 1967 when she lived in Colorado Springs. She has traveled widely and currently teaches at Sarah Lawrence College. (photo by Susan Zurcher)

138/139/140. John Henry Patterson Memorial (1928) by G. Moretti, Hills and Dales Park, Dayton, O., 35' in height overall, bronze with granite base. In this monument, John H. Patterson (1844–1922), founder of The National Cash Register Co., is portrayed in high relief mounted on his favorite horse "Spinner" with whom, daily, he rode over the lovely, rolling landscape he now surveys in frozen perpetuity. Upon his death these 325 acres were deeded to the city of Dayton in a generous philanthropic gesture. Moretti, an Italian-American sculptor, captures the aristocratic character of his subject in the dominating, central portion; subsidiary figures on lesser, lateral pedestals portray the creativity and industry of man.

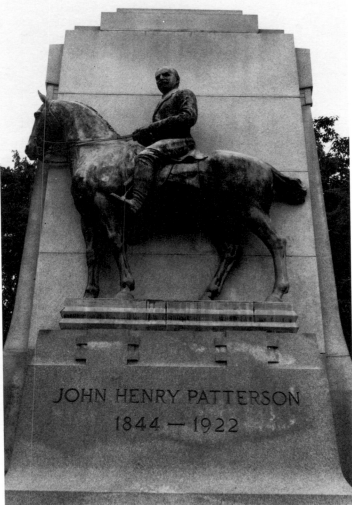
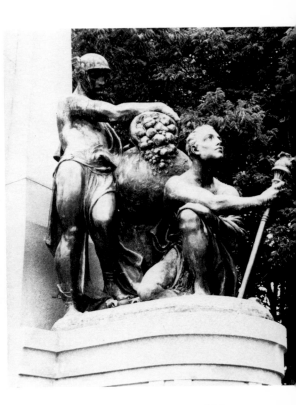

JOHN HENRY PATTERSON
1844 — 1922

The final Dayton 'sculpture' included herein is Mary Miss's *Staged Gates* installed in Hills and Dales Park at Paw Paw Camp in the summer of 1979 on the initiative of The City Beautiful Council. (Fig. 141) It is fashioned of Wolmanized Douglas Fir. This is one of those conceptual pieces in that middle ground between architecture and sculpture. Born in New York City in 1944, Mary Miss studied art at the University of California at Santa Barbara. Summers in Colorado brought her in contact with Herman Snyder and Bruce Colvin. She did her first large scale, outdoor structures using the open landscape while living in Colorado in 1967. Additionally, she has a number of outdoor installations in New York and New Jersey. The list of exhibitions in which she has participated is impressive, indeed.

It is not always easy, in 1980, to know what passes for sculpture. When the question was posed to **Dennis Oppenheim,**[15] a participant in the Blossom-Kent Summer Art Program (1979), he inferred that the word no longer has meaning; "Sculpture," he stated, "is any art-form which is not painting!" (Which we assume would include prints, lithographs and other art processes on a flat surface.) By his definition the combination floating garden and windmill called *Monument to Volunteerism* in the Miami River at the heart of Dayton, is a sculpture. It is the result of a three-year collaboration between government, business and labor under the direction of Loren Minnick (Fig. 137).

There are several, noteworthy, outdoor sculptures extant in Springfield, Ohio, and an additional piece planned for the impressive City Hall Plaza now nearing completion.

Anthropomorphic Observation is the title of **Jon Fordyce's** intriguing, abstract piece on the grounds of The Springfield Art Center on Cliff Road adjacent to Buck Creek, (Fig. 142). The work was completed by Fordyce in 1976 and given to The Art Association in 1978 by Robbins and Myers Inc. to commemorate the first century of the firm's founding in Springfield. It is a collection of interesting shapes, fabricated of weather-resisting steel, in an intriguing spacial arrangement over a concrete base. Fordyce, who was born (1943) in Cambridge,

Ohio, now lives in New Carlisle, Ohio. He did graduate work in art at The Dayton Art Institute and was a candidate for an MFA degree at Ohio State University in 1969. His work has been widely exhibited.

A second abstract sculpture, entitled *Flipover* (1975), by **David Evans Black** stands before the contemporary headquarters building of the Credit Life Insurance Company (Skidmore, Owings & Merrill, architects), forming a part of the city's re-developed core (Fig. 144). Novel in design, it is fabricated of stainless steel combined with tinted Lexan plastic and is approximately 15-16' in height. David Black was born in Gloucester, Mass., in May of 1928. He obtained an AB degree from Wesleyan University in 1950 and attended Indiana University in 1953 where he studied with Karl Martz and George Rickey. Having become associated with Ohio State University in 1954, he is now rounding out a quarter of a century tenure there as Professor of Sculpture—interrupted only by a Fulbright Grant to Italy (1962-63).

Another sculpture by Black occupies a central position on the Miami University campus at Middletown, Ohio. Ceramic reliefs executed by him (1959) appear on the facade of an apartment building at Neil and Lane Avenues in Columbus; also at the Hardesty Village Center (1965) in southwest Columbus. The huge stainless steel Seal of Ohio (1974), 8.5' in diameter x 3' deep, in the lobby of the new State Office Building, 30 E. Broad Street, is his conception (replica in the Supreme Court).

Back in Springfield, **Helen Morgan (Wagstaf)** (1902-) designed a geometric piece in stainless steel positioned at the entrance to Wittenberg University's Science Building (Fig. 143). It is entitled "Interaction" and is 7½' in height. Her bronze *Dulcinea* (Fig. 145), inspired by Cervantes character, as interpreted in "The Man from LaMancha," languishes atop a stone base, surfacing from a pond, in Snyder Park, Springfield. A Springfield native, Helen Morgan's works have been widely exhibited in Ohio museums and galleries.
(continued on page 119)

143. Interaction, below, by Helen Bosart Morgan (1902–), stainless steel on a granite base, c. 8' in height, located before the Science Building at Wittenberg University, Springfield. Helen Morgan, a Springfield native, studied art at Wittenberg University and sculpture at The Dayton Art Institute, also the Chicago Art Institute (1951–52). She taught art at the Springfield Art Center (1953–58); had a one man show there in '72, has long been active with the Art Center and has exhibited widely in Ohio and beyond. Her works are in the collections of the Cincinnati Museum, the Butler Institute, and, of course, the Springfield Art Center. She has worked in a variety of media including limestone, marble, terra cotta, iron, bronze, wood and aluminum. Her **Dulcinea** (fig. 145) in Snyder Park, Springfield, was inspired by the female character in 'The Man from LaMancha'.

144. Flipover (1977) by David E. Black, stainless steel and Lexan plastic, commissioned by The Credit Life Insurance Co., Springfield, Ohio. David Black is the senior member of the Ohio State University's sculpture section, having joined the faculty as an instructor after studies with George Rickey at Indiana University (MA degree 1954). The combination of stainless steel with transparent plastic is one that Black has used frequently in his most recent works, several of which are importantly displayed in Berlin, Germany. His **Skylink** (1977) on the Middletown campus of Miami University, is also such a work. **Skypiece**, in Berlin, is particularly effective as the center-piece of a long, formal pond or fountain.

115

146. Madonna of the Trail (July 4, 1928), right, by August Limbach (German sculptor who came to St. Louis in 1910), cast Algonite stone, National Pike, Springfield, Ohio. The Madonna of the Trail idea was initiated by Mrs. John Trigg Moss of St. Louis whose sketches were executed by Limbach (cf. note #2) Twelve of these were cast from Algonite stone, a poured mass of which Missouri granite is the principal aggregate, and erected along the National Pike (US Route 40) between Baltimore and California under the auspices of the DAR. This, on the western fringe of Springfield, was the first to be dedicated. They are six feet in height without the base.

147. George Rogers Clark Memorial (1924), far right, by Charles Keck of New York City, 34'H, carved in stone to commemorate the Battle of Piqua fought on this very spot, a mile or two west of Springfield, Ohio. Clark (1752–1818), a General in the American Revolution, was conqueror of the old Northwest Territory and of Vincennes from the British in 1779. His brother, William, was a leader in the Lewis and Clark Expedition. The back-side of the monument has an interesting portrait, in low relief, of an Indian warrior instructing a youth in the handling of the bow and arrow.

145. Dulcinea by Helen Bosart Morgan, bronze, is a second work by this leading local sculptress located out-of-doors in Springfield's Snyder Park. It was inspired by the leading female character in "The Man from LaMancha". For almost three decades Helen Morgan has been a leading protagonist of the arts in her native city. (photo courtesy of the artist)

116

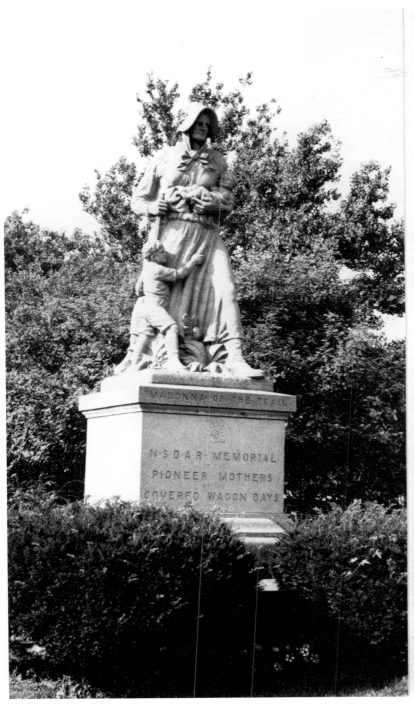

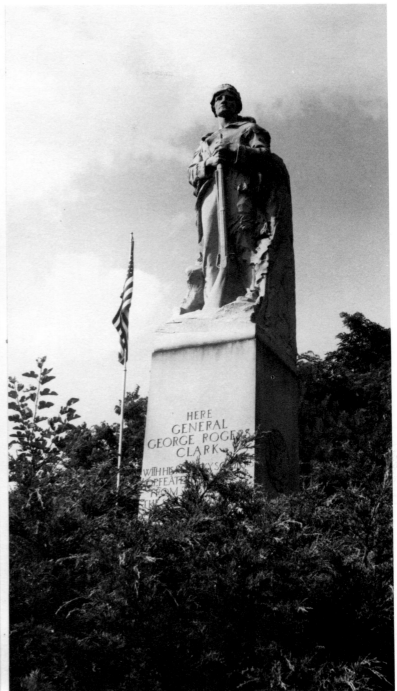

149. Ebb Haycock-sculpture, right, born Newark, N.J., educated at Columbia University and the State College at Kutztown, Pa, member of the Fine Arts faculty at Ohio Wesleyan University since 1949. Photographed in the Art Building at Ohio Wesleyan in the summer of 1979.

148. Eminent Sound (1973) by Ebb Haycock, bronze, 9' in width, located in a courtyard of the Marconi Building, Long and Marconi Streets, Columbus. "Yes" says sculptor Haycock, "I do mean to suggest radio waves vibrating from a central point. It is designed so that vertical jets of water, from the pond 17" below, plume or bathe the sculpture and become an integral part of it." Six wall reliefs, also by Haycock, relating to the invention of the radio, line the brick enclosure. The ambience here is particularly attractive.

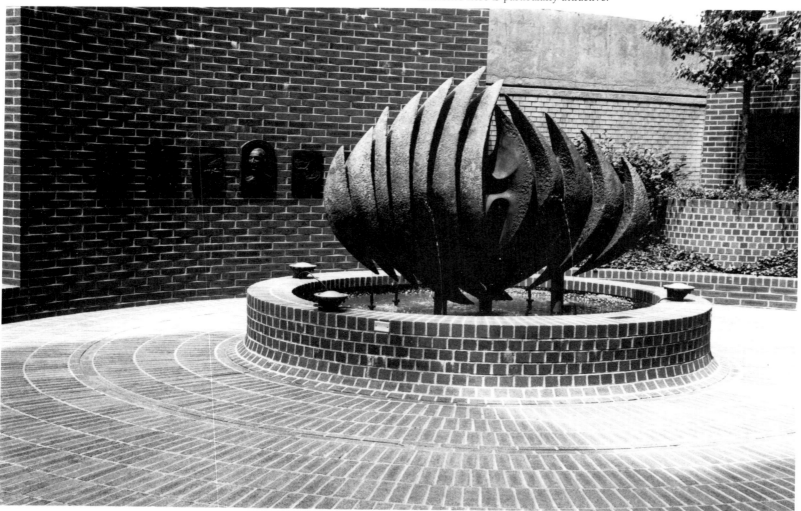

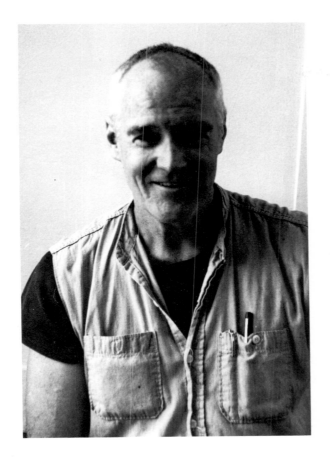

Ebb Haycock

Ebb Haycock is a name not to be ignored in any consideration of sculpture in Ohio. For the past twenty years, since 1949, he has been associated with the Art Department at Ohio Wesleyan University in Delaware, Ohio. His academic background includes undergraduate work at the Newark School of Fine and Industrial Arts, and graduate studies at Columbia University, the State College at Kutztown, Pa., and the University of Iowa. Prior to coming to Ohio, Mr. Haycock taught at Leheigh University, Bethlehem, Pa. The list of exhibitions in which he has participated and galleries where his work has been featured is prodigious. In the past decade alone, he has won a 1st prize in sculpture at a Liturgical

Art Show, Capitol University, Columbus (1969); Best-in-Show (steel sculpture), Columbus Art League (1971); 2nd prize (sculpture), All Ohio Painting and Sculpture Show, Canton Art Institute (1972); Award of The Ohio Arts Council in Ohio Liturgical Arts (1973).

Ebb Haycock has done several bronze busts, including that of *Bishop Herbert Welch*, President of Ohio Wesleyan between 1905 and 1916, displayed in the Beeghley Library; and a 1½ times, life-size likeness of *Branch Rickey* in the Branch Rickey Field House at Ohio Wesleyan (1967). *Trio* is the title of his 8′ wide polished aluminum wall relief commissioned by The Huntington Bank in the Nationwide Building, Columbus (1977). *Buckeye Bone* is a welded steel wall relief, 10′ tall in the lobby of the Buckeye Federal Savings and Loan Building, Columbus (1973). However, it is his outdoor sculpture which is our principal concern herein.

Earliest of these is his 6′-tall bronze *Mother and Child* (Fig. 150, 1965), focal point of a pleasant, little garden before The Bexley Public Library, Main Street, Bexley, Ohio (suburban Columbus). This work has a feeling not unlike Jacques Lipshitz's *Mother and Daughter* (Fig. 82) in the Cleveland Museum's Sculpture Garden; it is also reminiscent of some better known works by Saul Baizerman (cf. page 139, *200 Years of American Sculpture*). His style had greatly evolved by 1973 when he did *Eminent Sound,* a 9′ wide bronze sculpture in the garden-plaza of Columbus' Marconi Building at Long and Marconi Streets (Fig. 148). This fountain-piece is meant to suggest radio waves vibrating from a central point. As planned, the sculpture envisioned vertical jets of water pluming on either side of the bronze elements. The water plumes, not always operative, were to be an integral part of the design.

More recently Haycock did a 7′ high bronze *Bone* (1976) for an outdoor courtyard beside The Academy for Contemporary Problems, Columbus (Fig. 151). Mr. Haycock says of it, "This sculpture refers only to bones from which I draw and gain ideas. Also, I felt that the severe architectural planes and angles of the building and courtyard design needed a central sculpture with

curves and contours which could play against the mechanics of its immediate environment. Furthermore, I wanted the sculptural forms to invite contemplation."

In 1977 Haycock did three life-size figures in steel and glass-reinforced plastic for the lobby of the Ruscilli Construction Co. of Columbus. They are symbolic of the workers who built the business and represent an engineer, an iron worker and a carpenter. Other pieces by Haycock are a *Lion of Judah* (1975, 3½' tall on pedestal) exhibited in the Jewish Section of Grand Prairie Cemetery, Marion, Ohio; *Tall Trojan* (Fig. 152), a welded composite of chrome-plated, auto-bumpers is in the courtyard of "Club North"—an apartment complex located on Morse Road near Cleveland Avenue, Columbus.

The campus of Ohio State University has two highly visible sculptures: one in bronze of classical design, dedicated in 1930, which stands on a flagstone terrace before the east facade of the University Library (Fig. 153), commemorates the 26-year presidency (1899-1925) of William Oxley Thompson; the other a contemporary abstract *Soliloquy*, 25"+ in height, stands beside the Electrical Engineering Building on Neil Avenue. (Fig. 154) This is the work of **Eugene Friley** of the University's Art Department. Professor Friley received his BFA degree from Ohio State University in 1947 and his M.A. in 1950. He has been an Instructor in the School of Fine and Applied Arts (ceramic art area) from 1947 to the present, except for a hiatus of three years military service during World War II. The reader will have his own opinion about which of these will endure.

(text continued on page 123)

150. **Mother and Child** (1965) by Ebb Haycock, bronze, 6' in height, located at the Bexley Public Library, Bexley, O. This early work by Ebb Haycock has something of the feeling of Jacques Lipschitz's **Mother and Daughter** in the garden court of the Cleveland Museum of Art. His style developed in the direction of abstract expressionism by 1973 when he executed **Eminent Sound** for Columbus' Marconi Building.

151. Bone (c. 1976) by Ebb Haycock, bronze, 6'6'' in height, located in a garden court beside the Academy for Contemporary Problems, Columbus. ''This sculpture refers only to bones from which I draw and gain ideas. Also, I felt that the severe architectural planes and angles of the building design called for a sculpture with curves and ontours which could play upon the immediate environment. I wanted the sculptural forms to invite contemplation.''—Ebb Haycock.

153. William Oxley Thompson (1930) by Erwin F. Frey (1892–1967), bronze, 10′ in height, Ohio State University campus. As the base proclaims, William Oxley Thompson was President of the University for a quarter century between 1899 and 1925. He is here portrayed in the robes of an academician standing on the flagstone terrace before the University Library—a perfect classical foil for sculptor Frey's traditional treatment of his subject. Prof. Frey, long associated with the University's Department of Fine Arts, is also represented herein by his very appealing **Christ After the Resurrection** located in Franklin Commons Park, Columbus.

152. Tall Trojan (1971) by Ebb Haycock, welded steel (chrome plated), 10′ tall, Club North Apartment complex, Morse Rd. near Cleveland Ave., Columbus. In Tall Trojan sculptor Haycock has converted the massive, discarded autobumpers of the 1960's into a thing of beauty and interest. A three sectional wall relief entitled **Trio** (1977) of polished aluminum, 8′ in width, within the Nationwide Plaza office of the Huntington Bank, is one of the artist's most recent projects.

154. **Silioquy** by Eugene Brooks Friley (1921–), cement/sand/fiberglass/plastic over a steel armature, overall height c. 25', before Electrical Engineering Building, Ohio State University campus. Dr. Friley received both BFA and MFA degrees from Ohio State University and has been a member of its art faculty for over 30 years (ceramic art area). He says "this is basically a figurative piece to me it represents a water-borne nymph-like creature, frozen in mid gesture, as though freshly emerged from the morning mists of the nearby Olentangy River."

COLUMBUS, THE CITY BEAUTIFUL

Within the last couple of years two of Ohio's most interesting sculpture gardens have been established in Columbus. The most recent of these, dedicated (though unfinished) on the evening of June 23, 1979, is that associated with The Columbus Museum of Art; the other, Franklin Commons Park, is located just north of the County Administration Building on the South High Street site of the demolished, Second Empire, Franklin County Courthouse.

The Museum Garden extends from an oval at the institution's SW corner, featuring an important **George Rickey** (Fig. 156, *Two Lines Up Excentric Variation VI*, 1976), thence across the Broad Street facade and for the total depth of its east facade. Among the important acquisitions unveiled at the June 23rd reception was **Henry Moore's** *Three Piece Figure, Draped,* a 16' long 1975 work by the renowned British sculptor (Fig. 155). This occupies a central position at the head of the steps before the Museum and is as fine as any Henry Moore we have seen. Also unveiled was **Clement Meadmore's** *One Out Of Three* (Fig. 157), a 16' long, looped, rectangular form in aluminum completed in 1974. Anyone familiar with Meadmore's work would immediately recognize its authorship. Elsewhere within this garden one finds **Alexander Calder's** *Intermediate Model for the Arch*, an 11' high 'stabile' of black-painted steel-plate executed in 1975 (on loan, Fig. 159); a 10' high **Louise Nevelson** constructed of Cor-ten steel (on loan) (Fig. 163, 1970); a charming 63'' high, bronze **Georg Erlich** entitled *Singing Girls* (1949); *Wasahaban* (Fig. 161) a monumental, vividly green-painted aluminum sculpture by the Canadian, **Robert Murray**; and *Working,* (Fig. 158) a 1958 work of the important Russian-born **Alexander Archipenko.** This garden adds immeasurably to the external beauty and interest of the Columbus Museum.

The sculpture garden north of the County Administration Building, known as Franklin Commons Park, is the conception of landscape designers Prindle and Patrick of Columbus. The focal point of the garden is a gargantuan Henry Moore entitled, *Large Oval with Points* which sits atop a truncated, masonry pyramid arising from a step-down basin (Fig. 167). The bronze work, completed in 1970 (though the sculpture garden is more recent), is "a gift of the Lazarus family to the Columbus Gallery of Fine Arts for the People of Franklin County, Ohio." Like all other sculpture in this municipal "garden," it is on loan to Franklin County from the Columbus Museum. It is impressive, indeed, silhouetted against its backdrop of contemporary architecture.[16] To the north of the Henry Moore there is a particularly charming, demure, attenuated young woman in bronze whose gown clings tightly to her inanimate figure. Her name is *Eve* and she was conceived by the American, **Lewis Iselin** in 1959. *Eve*, perhaps a dancer, stands on her toes with head lowered, hands together below her left hip, poised to take several steps to her right into the waiting arms of her partner. (Fig. 165). Iselin was born in June, 1913. He studied at the Art Student's League, New York, under Mahonri Young. Other of his works are in the collections of Harvard's Fogg Museum, as well as art galleries at Colby College, Yale University and the Whitney Museum.

Christ After The Resurrection is the title of a limestone sculpture located close to the north wall of the County Administration Building (Fig. 169). This is the work of **Erwin F. Frey** (1892-1967) whose *William Oxley Thompson* on the Ohio State University campus we have already noted. Here Christ stands, chin out, head high, before humanity—symbolized by a young man and woman. It was executed between 1945 and 1955. The sculptor has cleverly worked out the grouping-of-three emerging from the virgin block of limestone.

Elsewhere on the grounds there is a steel piece by **David Hayes** entitled *Centaur* (1973). But for its upper, outstretched "wings", it slightly resembles an Alexander Calder stabile. Hayes, born in Hartford, Conn., in March of 1931, received his AB degree from Notre Dame

University; an MFA from Indiana University and, subsequently, studied at the Ogunquit Art School. His work may also been seen at New York's Modern Art and Guggenheim Museums.

Opposite the aforementioned sculptures, on the west side of High Street in a garden partially enclosed by two sides of the contemporary Franklin County Courthouse, one observes a fine likeness of *Benjamin Franklin*, the county's namesake (Fig. 170). This is the work of **James P. Anderson**, Professor and Chairman of Muskingum College's Art Department between 1966 and 1974; since, he has held the same position at the University of Northern Arizona, Flagstaff. The bronze *Franklin*, 12' in height, was cast in 18 separate pieces from Professor Anderson's maquette in Pietrasanta, Italy. It says something about the sculpture of our time that Dr. Anderson felt compelled to say, "Of course, the academic crowd will abhor the whole thought of Ben Franklin instead of a modern piece."[17]

Professor Anderson has one other outdoor sculpture in Ohio; namely *Urschleim XIV* (1970), an abstract bronze, 6' x 3' x 4', which stands on the Quadrangle of Muskingum College at New Concord (Fig. 171). This was inspired by the old theory of the Urschleim, fascinating to the artist, which contended that all life sprang from a primordial slime. Anderson's former residence property in New Concord contains a highly interesting wall sculpture (Fig. 172), by John Spofforth of Athens, Ohio. Spofforth received a $5,000 Grant from the Ohio Arts Council in 1978 "for transforming the common materials of brick and mortar into a new aesthetic medium."

Earlier in this discussion we touched upon what might be thought of as a third sculpture garden in Ohio's Capitol City; namely, the Statehouse grounds. Herman Atkins MacNeil's *William McKinley Monument* of 1906 (Fig. 38) marks the formal entrance to the fine Greek Revival Capitol. McKinley, it will be recalled, had been assassinated just five years earlier (September 6, 1901), following his election to a second term in the Presidency, while attending the Pan-American Exhibition in Buffalo, New York. The Spanish-American War, a principal event of his Presidency, resulted in our

155. Three Piece Figure, Draped (1975) by Henry Moore, bronze on a bronze base, 16′ in length, Columbus Museum of Art. This 1975 creation of the renouned English sculptor was given to the Columbus Museum (1979) by Richard and Elizabeth Ross and family. Befitting its importance, it occupies the position of honor at the Broad Street entrance to the Museum, asserting the compatability of modern art and neo-classical architecture.

156. Two Lines Up, Eccentric Variation VI (1976), overleaf, by George Rickey (1907–), stainless steel blades mounted on a stainless steel support. (Gift of the Albert Fullerton Miller family to the Columbus Museum). Hoosier-born Rickey, one of the great names in American, contemporary sculpture, studied at Oxford, Paris and New York. His kinetic sculptures, initially inspired by Calder's **mobiles**, often take the form of tapered, triangular wands which are activated by air currents. These are so designed that they never engage one another and are far more exciting to watch in action than in a static photograph. Ohio acquired its second 'Rickey' in September of 1979 with the installation of his largest work, to that date, before Cincinnati's Central Trust Co. at the corner of Fifth and Main Streets. (cf. Fig. 197)

assuming a degree of U.S. sovereignty over the Phillipine Islands; also our annexation of the Hawaiian Islands. The broad pedestal supporting the bronze likeness of the martyred President bears the quotation:

> "Let us ever remember that our interest is in concord, not conflict and that our real eminence rests in the victories of peace not those of war"

No figure in the political life of Ohio has been immortalized in bronze to the extent that has McKinley, neither in scope nor in number. The *National McKinley Birthplace Memorial* at Niles (Figs. 32, 34, 1917) and the *McKinley Memorial* at Canton (Figs. 35, 36, 1907) are among the grandest in the State. His effigy, standing on a high pedestal, presides over the principal entrance to Toledo's Lucas County Courthouse (Fig. 39).

We have previously noted Levi Schofield's *These Are My Jewels* (Fig. 17) and Bruce Saville's *Peace* (Fig. 31), both of which occupy positions at the northern extremity of Statehouse Square; balancing these at its southern extremity, one notes the bronze, life-size figure of *Christopher Columbus* with globe in hand, testifying to the spherical nature of the earth. With the sculpture gardens cited, namely: Franklin Commons Park, Statehouse Square and that, newly constituted, at the Museum of Art, Columbus is well on its way to becoming the City Beautiful. *(continued on page 141)*

The Sculpture Garden is a comparatively new innovation of our time. There may have been a single sculpture as the center-piece of the Roman, residential atrium; to be sure the Boboli Gardens in Renaissance Florence featured some sculpture. But certainly few, if any, counterparts to the mass assemblage of important sculpture in a garden setting, as exemplified by New York's Museum of Modern Art or Washington's Hirschorn Museum, existed prior to this century. We are now, happily, witnessing a proliferation of such gardens. By mid-twentieth century sculpture had come down, off the building, and into the environmental landscape. It has become accepted practice, when funds permit, to accent a building or compliment an adjoining plaza with sculpture. This practice has caught on in public and private places in Ohio. The City of Columbus, in particular, in fortunate in that two such impressive gardens have come into being within the past couple of years, namely, Franklin Commons Park, adjacent to the County Administration Building and the recently dedicated (June 23, 1979) Sculpture Garden at the Columbus Museum of Art. We highlight here some of the pieces on display at both locations. (It should be noted that all sculpture currently exhibited in Franklin Commons Park is owned by the Columbus Museum)

157. Out of There (1974) by Clement Meadmore (1929–), looped rectangular form in aluminum, painted black, 16' in length (Gift of the Ashland Oil Company to the Columbus Museum of Art). It is interesting to observe how contemporary sculptors "do-their-particular-thing". For a decade Australian-born Meadmore has been experimenting with variations of convoluted forms having a square cross-section. Once one is familiar with his work, one could not fail to recognize it wherever seen. His characteristic creations are installed in important places nationally and internationally. (As this book goes to press, a second, Ohio Meadmore is being installed in association with the new office headquarters of Developers Diversified in the Cleveland area) cf. Fig. 214, page 175.

158. Working (1958) by Alexander Archipenko (1887–1964), bronze, circa 4' in height, Sculpture Garden of the Columbus Museum of Art. Archipenko, an artist of international stature, studied and taught in Moscow, Paris, Berlin and finally (1923) in the United States. His revolutionary method of opening up the sculptural form with holes and his emphasis on the concave surface, rather than the traditional convex, created a new idiom in modern sculpture. These features make his work easily recognizable.

159. Intermediate Model for the Arch (1975) by Alexander Calder (1898–1976), steel plate painted black, c. 11' in height. This late model **stabile** by Alexander Calder, quite typical of many other similar shapes for which he is noted, is on loan to the Columbus Museum, but it is quite likely that some loyal Museum benefactor will provide the funds for its permanent acquisition in which eventuality it will become the first of its type in the State. Calder's **mobiles** and **stabiles** have been very influential in the development of modern sculpture.

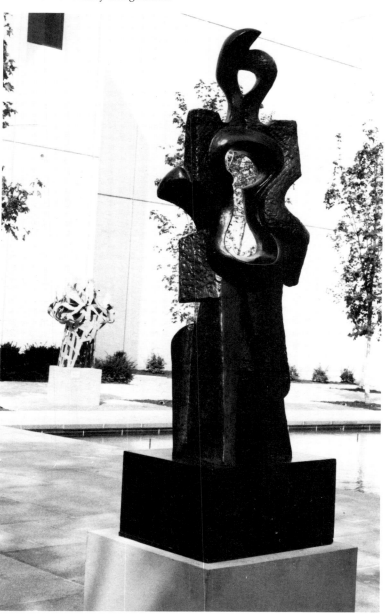

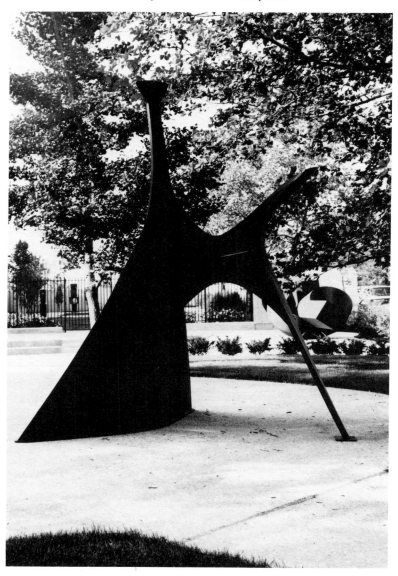

128

160. Ancestor II (1970), left, by Barbara Hepworth (1903–1975), bronze, height-c.8'. At the time of the sculpture garden dedication (June 1979), this piece by the famed English sculptress, was on loan from New York's Marlborough Gallery. Hopefully, the Columbus Museum will be enabled to take permanent possession of it. Like Henry Moore, her works explore the relationship between solid and void. Many of her figures, this one included, are vertical forms representing "the transition of my feeling toward the human being standing in the landscape."

161. Wasahaban (1978) by Robert Murray (Canadian, 1936–), painted aluminum, 7'6" in height x 6'. Wasahaban, a 1979 acquisition for the Columbus Museum's sculpture garden, is quite typical of Canadian-born Murray's contemporary work. Painted a vivid blue-green, it is highly visible in its special position. The cutting and folding of the metal was carried out by Lippincott, Inc. of North Haven, Conn. whose artisans specialize in working with metal sculptors. The Metropolitan Museum, New York, the University of Massachusetts at Amherst and Honeywell, Inc., Minneapolis are among the numerous institutions owning a Robert Murray. The Dayton Art Institute's exhibition catalogue **Robert Murray**, published in 1979, is an excellent source for more definitive information about the artist and his works.

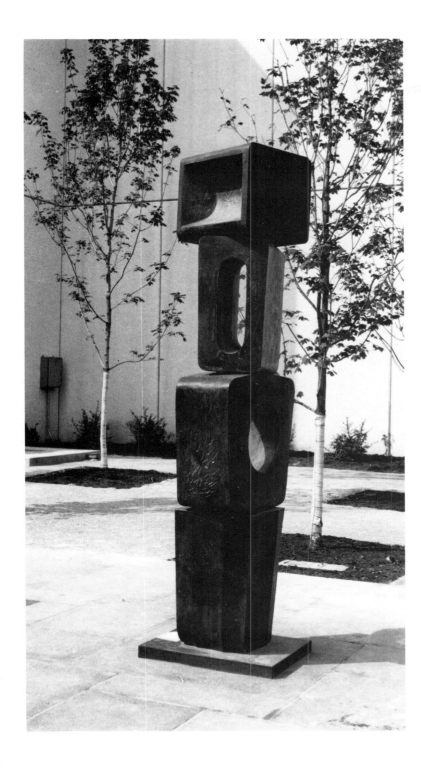

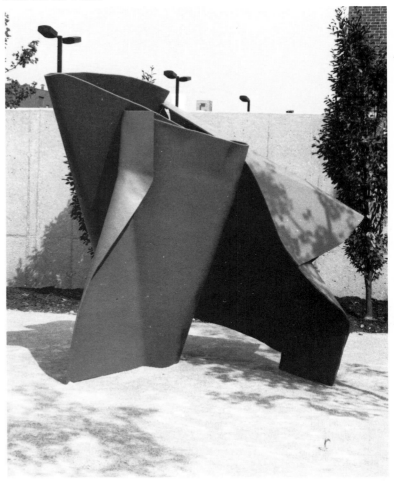

162. Sensenbrenner Park/Old Union Station vestige (1897) Daniel H. Burnham, arch't. Columbus' Union Station was demolished in the mid 1970's to make way for a Convention Center, The City, however, exercised the good judgement to save a principal element of its Beaux Arts entrance which now becomes the centerpiece of a newly established Park in the vicinity of the Nationwide Building complex. Thus an architectural remnant becomes a piece of environmental sculpture! The terra cotta medallions which formerly served as metopes in the frieze above the arch, are incorporated in the brick wall bordering the Park (cf. Fig. 166).

163. Atmosphere and Environment (1970) by Louise Nevelson (1899–) Cor-ten steel, 10' in height (on loan to the Columbus Museum of Art). Russian-born Louise Nevelson commenced combining miscellaneous scrap, wooden shapes into 'breakfronts', or entire wall panels, in the mid 1950's. The charm of this particular piece, executed in steel for exterior display, is its relative transparency. Even as Clement Meadmore, George Rickey, Alexander Calder and others, have achieved fame doing 'their thing', so has Louise Nevelson with her intricate arrangements within boxes or rectangular forms. **Sky Landscape II** by Ms. Nevelson was dedicated in Cincinnati January 22, 1980.

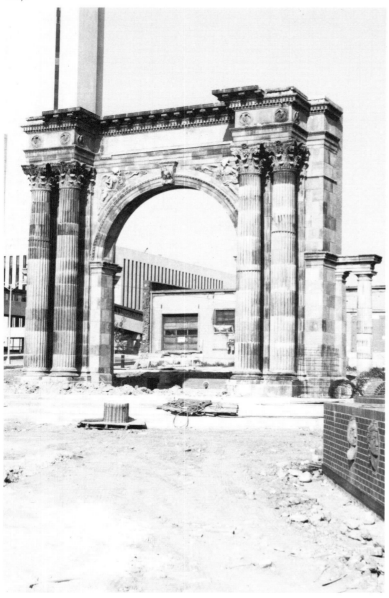

130

164. Alpha (1975) by Beverly Pepper (American, b. 1924), Cor-ten steel painted orange, total length-40'. This massive piece (on loan to the Columbus Museum of Art during 1979) takes the form of two pairs of tent-like shapes. Pepper, a native of Brooklyn, N.Y. has resided in Italy since 1951. Originally a painter, she commenced sculpting in 1961 and is now acknowledged to be a leading creator of monumental works of which this, in Columbus, is quite typical. Her pyramidal shapes suggest unexpected relationships between interior and exterior forms, openness and mass.

131

166. Christopher Columbus—one of the metopes from the frieze above the Union Station arch.

165. Eve by Lewis Iselin (1913–), bronze, 5-6' in height, Franklin Commons Park. Eve is a beautiful thing! Iselin's attenuated treatment of her reminds one of the Mannerist style of the late Renaissance as exemplified in the paintings of El Greco. The sculptor, born in New Rochelle, N.Y., studied at the Art Student's League (NYC) under Mahonri Young. Other specimen's of his work may be seen in the collections of Harvard's Fogg Museum and museums at Yale and Colby College; also at New York's Whitney Museum of American Art.

167. Large Oval with Points (1970) by Henry Moore, bronze, monumental in size, located in Franklin Commons Park, S. High Street, Columbus. The City of Columbus has created a welcome urban space on the former site of its demolished, Second Empire Courthouse. It is a good trade-off—thanks to the planning of Prindle and Patrick, architects, and the generosity of the Lazarus family which marks 125 years of its presence in Columbus with the gift of this huge Henry Moore. The author was somewhat stunned to encounter a duplicate of this sculpture, effectively installed without base, on the wooded campus of Princeton University. Franklin Commons Park is the kind of place which beckons the office worker, with bagged lunch, to comtemplate this enigmatic shape and the other fine sculptures present, during spring, summer and autumn.

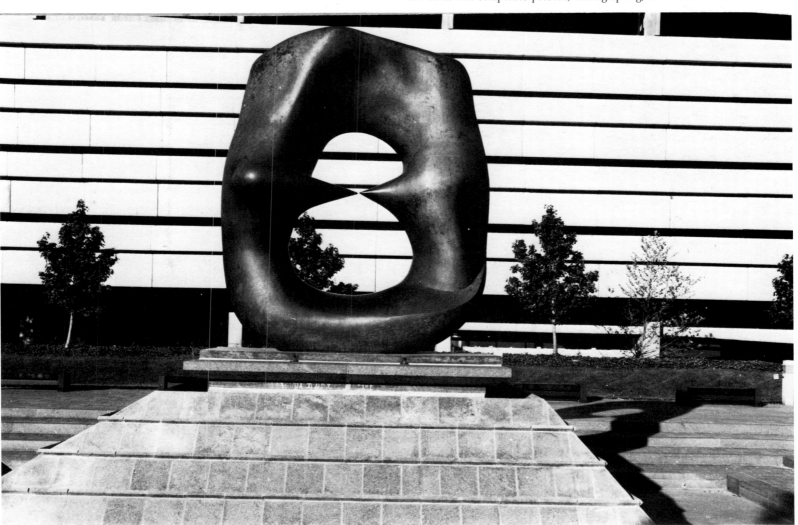

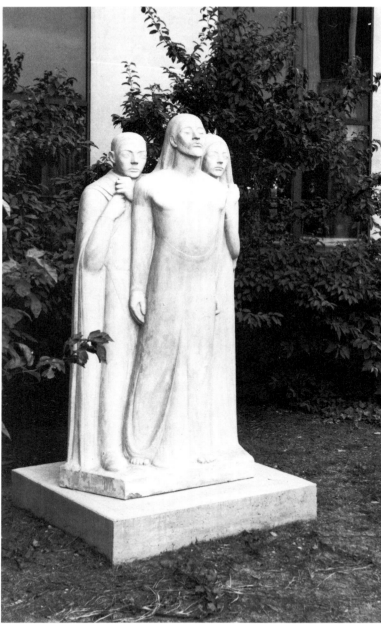

169. Christ After the Resurrection (1955) by Erwin Frey (1892–1967), limestone, Franklin Commons Park, Columbus. Prof. Frey worked on this sculpture for ten years. Christ stands chin out, head high, before humanity symbolized by the young man and woman. Like Seth Velsey's **Man and Dog** in Dayton, this later Frey piece represents a departure from the strict realism of earlier decades, and, in particular, the sculptor's **William Oxley Thompson** also included in this volume.

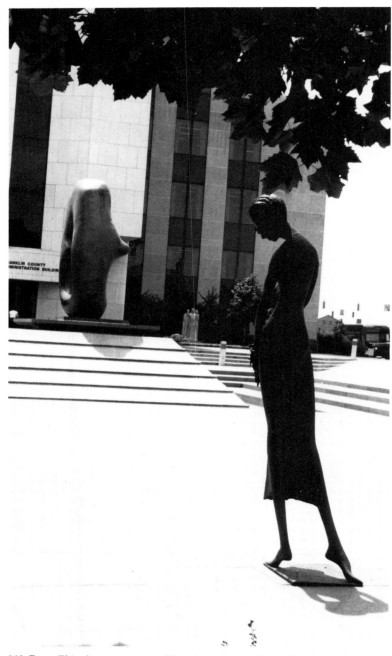

168. Eve—This alternate aspect of Eve shows her in relation to other sculptures in Franklin Commons Park. Henry Moore's **Large Oval with Points** rests hugely on its truncated pyramid while, in the distance between the two, one glimpses Erwin Frey's **Christ After the Resurrection.**

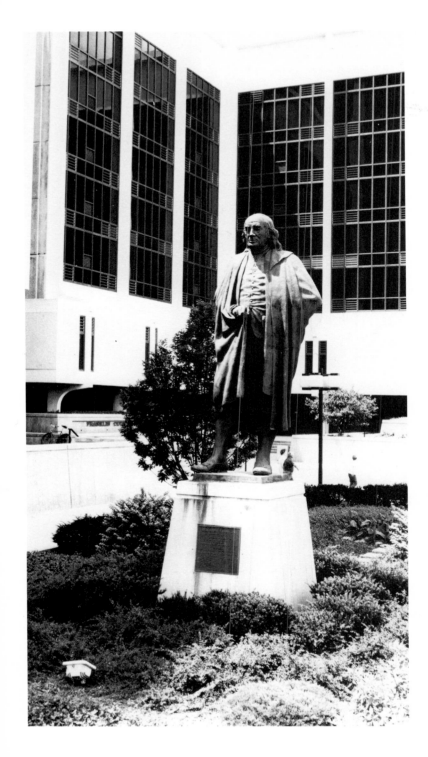

170. Benjamin Franklin (1974) by James P. Anderson (1929–), bronze, 12′ in height (cast at the Tommasi Fonderia, Pietrasanta, Italy), located across High Street from Franklin Commons Park, Columbus. Enroute to Italy, where the final modeling of this sculpture took place, the sculptor sought out the two best likenesses of Franklin—one by Houdon, another by Jean Jacques Cassieri in the Bibliotheque Mazarin, Paris. It says something about the sculpture of our time that Prof. Anderson felt compelled to say, "Of course the academic crowd will abhor the whole thought of Ben Franklin instead of a contemporary piece."

171. Urschleim XIV (1970) by James P. Anderson, bronze, 6′x4′x3′, Science Building, Muskingum College, New Concord, Ohio. This abstract work by Prof. Anderson, at the time Chairman of Muskingum's Art Department, was inspired by the old theory of the Urschleim which contended that all life sprang from primordial ooze, or slime—long since discredited by modern science. Dr. Anderson's works are in collections in Ohio, Arizona, the West Coast and beyond. (Photo-courtesy Muskingum College)

172. Brick Wall (early 1970's) by John Spofforth, located at the former residence of Prof. James P. Anderson, New Concord, Ohio. "My work," says Spofforth, "which has received a $5,000 Fellowship Grant in 1978 from The Ohio Arts Council, is concerned with transforming the common materials of brick and mortar into a new aesthetic medium. It is located mostly in Athens, O." Prof. Anderson says (letter September 1979) "I had to sell the property where this wall is. The piece is worth more than I received for the entire property."

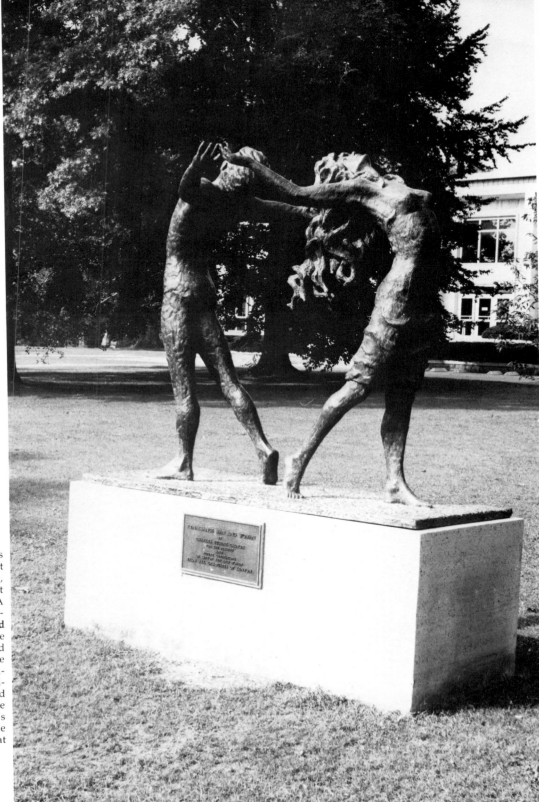

173. Renaissance Man and Woman (1973) by Charles Eugene Gagnon (1934–), bronze, c. 8' in height overall, located before the Kenyon College Library, Gambier, O. Gagnon is a Minnesotan who studied at The Minneapolis School of Art and received his MA degree from the University of Minnesota. The program for the unveiling of **Renaissance Man and Woman** reads (June 2, 1973) "The statue which we unveil today is more than a carefully conceived and painstakingly crafted sculpture dedicated to the human spirit. It represents an effort to turn our attention away from our sterile and self-defeating materialism towards the spiritual rebirth of all men and women everywhere." Among Gagnon's notable works are: **St. Francis and the Birds** at St. Mary's Hospital, Rochester, Minn., **Dancer Stretching** for the Mayo Clinic; also a portrait bust of **Conrad Hilton** at the Clinic.

174. Cloud Arch (1979) by Barry L. Gunderson, steel painted a vivid royal blue with a 'cast shadow' of white terrazzo, 29' long x 12' tall, located in the Downtown Plaza, Portsmouth, Ohio. "Because I was so struck by the rigid perpendicularity of the surrounding architecture, I wanted to submit a piece that offered a distinct contrast in form . . . the planar, upright form of its cast oblique 'shadow' effectively makes use of the restricted space" Currently, Prof. Gunderson is working on an outdoor piece to be installed in Crosby Gardens, Toledo, O.

175. Rake Curls (1977) by Barry L. Gunderson, fiberglas over plywood with Cor-ten steel troughs set in the ground, Bexley Hall, Kenyon College, Gambier, Ohio. 45' long x 11' tall. **Rake Curls**, finished in a vivid red color, suggests earth as if gouged by a giant rake; also the gouges made by the rake (Unseen in our photo). "The parellel lines produced by a rake can be very artistic," says the 34 year old Prof. of Art who obtained his MFA degree from the University of Colorado.

176. Hermae-sculptor unknown, flanking the principal entrance to the Second Empire Wayne County Courthouse, Wooster, Ohio (1878), Thomas Boyd, architect. These herm figures, facing Wooster's town square, are among the more interesting architectural sculptures in the State.

177. Civil War Monument (1892) sculpted by Alcock and Dorald, Town Square, Wooster, Ohio. One could fill a small volume with the Civil War sculptures which exist in most Ohio Communities. This one, dedicated May 5, 1892, particularly caught the author's eye because of its relative approachability and the architectural interest of its base.

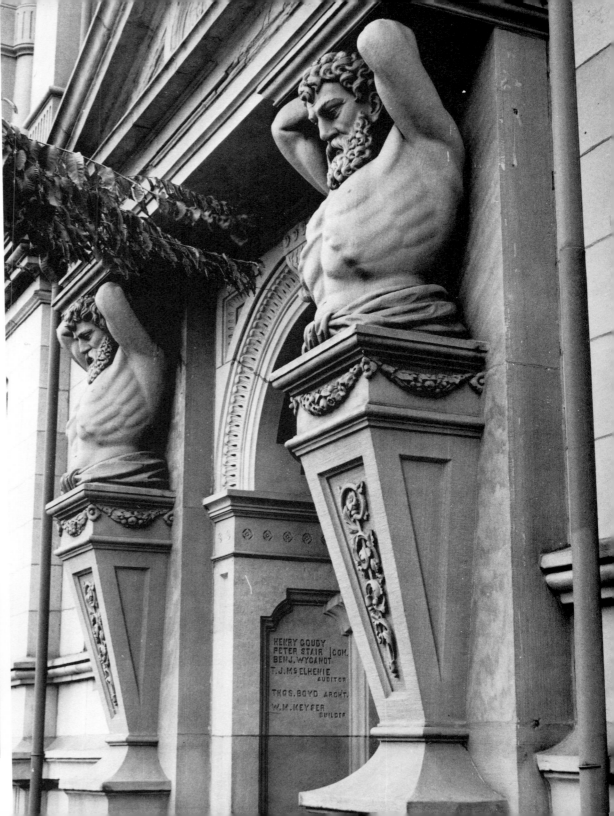

178. Tension Arches (1976) by Athena Tacha, 12' in height x 24' in length, fabricated from a single sheet of stainless steel painted green on one side, red on the other, Euclid Avenue at Huron Road Mall, Cleveland. If you asked its meaning, the sculptress would respond, ''Aren't the arches graceful? Have you noticed how nicely the color changes when one walks by? Is it not enough that it greatly enhances the urban space?''[18] Ms. Tacha, Associate Professor of Art History at Oberlin since 1973, is a hybrid architect-sculptor many of whose creations are to be lived with and sat upon, like civic furniture.

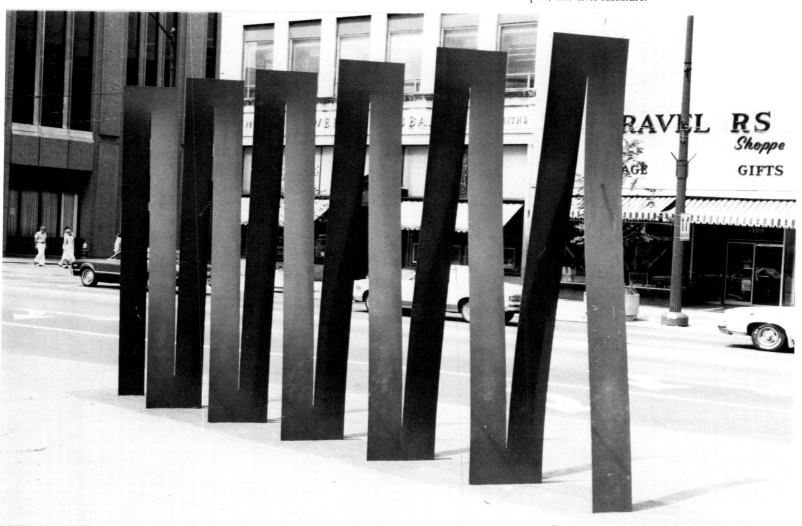

Athena Tacha (1936-)

Athena Tacha, born in Larissa, Greece in 1936, has for some years been living in Oberlin, Ohio, where her husband, Richard E. Spear, is Professor of Art History and Director of the Allen Memorial Art Museum. Ms. Tacha obtained her M.A. degree in sculpture from the National Academy of Fine Arts, Athens, in 1959 and an M.A. degree in Art History from Oberlin College in 1962. She also holds a doctorate in aesthetics from the Sorbonne University, Paris, 1963.

Fate seems to have brought her to Oberlin in 1963 where, for the next ten years (1963-1973) she served as the curator of modern art at the College's Allen Memorial Museum. Since, she has been teaching sculpture at Oberlin.

Two works by the artist are represented in this publication: *Tension Arches* at the Euclid Avenue entrance to Cleveland's Huron Road Mall (Fig. 178) and *Streams*, a series of variegated steps—a kind of outdoor theatre—on the bank of Plum Creek, adjacent to Vine Street Park in Oberlin (Fig. 179). The former was fabricated from a single sheet of stainless steel—painted olive-green on one side and Tuscan red on the other. One might imagine that it represents a kind of robot-man walking or, perhaps, a series of wish-bones. Commenting on it, Ms. Tacha asks rhetorically, "Aren't the arches graceful? Have you noticed how nicely the color changes when one walks by?"[18] One does not have to understand *Tension Arches*; one has only to recognize that it adds interest to Playhouse Square where it is passed by thousands daily. It is, indeed, a unique sculpture!

As suggested in an earlier paragraph, it is not always easy today, as we enter the final two decades of the twentieth century, to know what is architecture and what is sculpture. Athena Tacha's *Streams* suggests that we explore the differentiation. Is the Eiffel Tower, which was built as an engineering feat for the Paris Exposition of 1889, architecture or sculpture? If the realm of the architect is the design and construction of buildings having habitable space, there is some question as to whether the tower is, in fact, architecture. It could easily, today, be considered a huge piece of sculpture. The same question might be asked about the *Gateway Arch* in St. Louis, designed by Eero Saarinen. It is certainly as much a monument (or piece of sculpture) as it is a building. When, in the summer of 1979, we asked Clement Meadmore with what the sculptor is concerned, he hesitated momentarily and responded, "With aesthetic experience; certainly, the third dimension is vital to sculpture."[19]

Streams, executed in 1976, represents a kind of architecture-sculpture which is unique to Athena Tacha. It is, essentially, a linear, outdoor theatre consisting of meandering steps or seats, randomly separated by mini-rock gardens. The rocks in this particular instance are pink Utah Pumice, chosen both for its color and light weight. *Streams* suggests the ampitheatres of antiquity in Ms. Tacha's homeland. "Public art should not just sit there," she says, "it should serve society." *Streams* serves as a place for an older couple to sit and enjoy a summer evening while Plum Brook quietly shimmers below, or as a place for two young students to rendezvous and discuss their future lives together. It fulfills Meadmore's criteria in that it evokes an aesthetic experience; and it has a third dimension. "While it isn't sculpture for monuments or representing the human form, it is sculpture for architectural spaces, for urban spaces,"[20] she suggests.

Ms. Tacha was the winner of a contest sponsored by the New York Arts Council to do a similar kind of thing in Smithtown, L.I., New York, called *Tide* which was dedicated in June of 1977. Other projects of this type have been planned, but not executed *33 Rhythms— Homage to the Cyclades* by Athena Tacha won 1st Prize in sculpture in the prestigious May Show of The Cleveland Museum of Art (1979). This complex, stepped design suggests a Mayan Temple, or the approach to a Greek propylaeum. The Mixtec Indians, who built Monte Alban (Oaxaca, Mexico) hundreds of years ago, might have borrowed Ms. Tacha's concept; they most certainly would have found in it ideas for

179. Streams (1976) by Athena Tacha, cement block covered with Ohio sandstone plus Utah pink pumice, Oberlin, Ohio. **Streams** represents a kind of architectural sculpture which is unique to Greek-born Athena Tacha. It is essentially a linear, outdoor theatre consisting of meandering steps or seats, randomly separated by mini-rock gardens. **Streams** suggests the amphitheatres of antiquity in Ms. Tacha's homeland. It is a place to relax, to commune with nature, or to court one's fiancée on a mild, late spring evening.

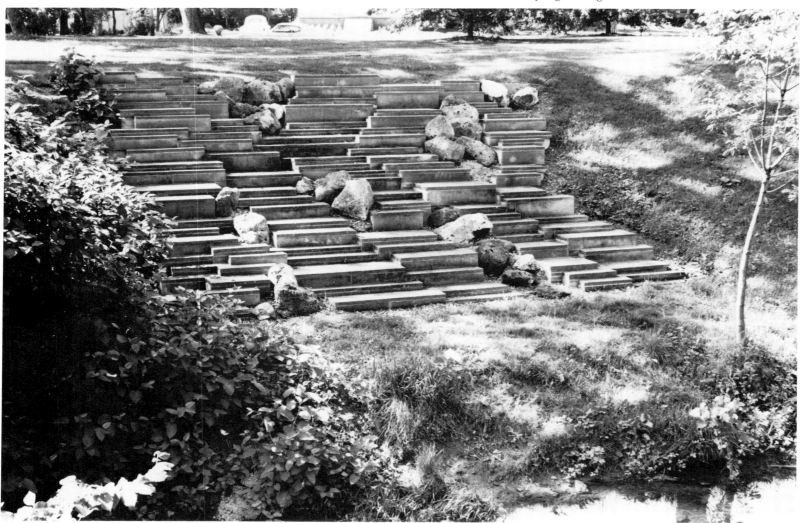

emulation. The May Show Bulletin says of this work that "it demonstrates her full development as an important artist."[21]

Before leaving Oberlin and Athena Tacha we must walk to the east end of Tappan Square where, between The Allen Memorial Museum and Sophronia Hall Auditorium, there is *Electric Plug* (Fig. 181) by **Claes Oldenburg.** This is a hugely, magnified image, in steel and brass, of a common electric receptacle. Wayne Anderson in *American Sculpture in Process 1930-1970* (p. 197) says in connection with Oldenburg: that he "creates parody by juxtaposing the commonplace with his fantastic vision of it." Oldenburg was born in Stockholm, Sweden, in 1929. His father was a diplomat with the result that his childhood was spent variously in Oslo, New York State and Chicago. He graduated from Yale University in 1951 and became, in the early 1960's, one of the principal practitioners of Pop Art in America. *Underground Railroad*, (Fig. 180) is, perhaps, a more appropriate "sculpture" on the Oberlin campus since the community was an active center for the surreptitious transmission of slaves across the Mason-Dixon Line to Canada in the mid-19th century. Some may scoff at *Underground Railroad*, others may feel that it drew upon as much genius as Oldenburg's *Electric Plug*.

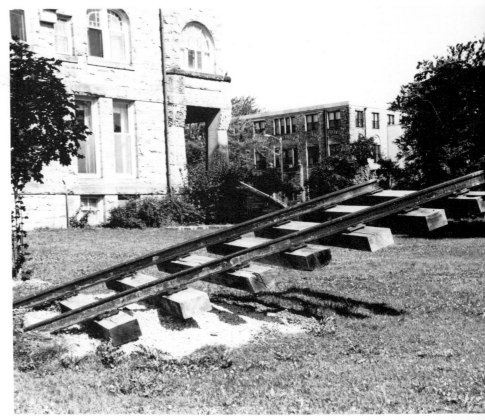

180. Underground Railroad, sculptor unknown, Steel rails and wooden ties, Oberlin. Oberlin, Ohio was an active transfer point on the "Underground Railroad" used to effect the surreptitious transmission of slaves to freedom in Canada prior to the Civil War. Who is to say that this symbolic piece of track, emerging from the ground, is less art than a magnified electric plug?

181. Electric Plug by Claes Oldenburg (1929–), iron and brass, c.100 times life-size, Oberlin College campus. Although born in Stockholm, since his father was a diplomat, young Oldenburg spent much of his youth in America. He received his first formal art education at Yale University from which he graduated in the Class of 1951. His first Pop Art, a movement of which he has been a leading exponent, appeared in 1960. What can one say about this gargantuan electric plug?

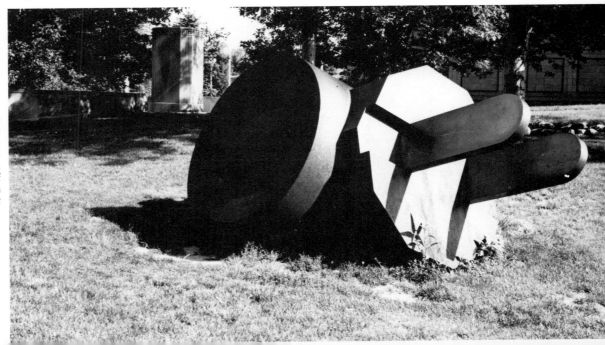

CONTEMPORARY DEVELOPMENTS IN CINCINNATI, CLEVELAND AND ENVIRONS

If one follows Route 10 eastward from Oberlin it will lead him into downtown Cleveland where, before the new Justice Center stands Isamu Noguchi's *Portal* (Fig. 182), a giant, convoluted, painted-steel, tubular construction. *Portal*, 36' in height, was fabricated by the Patterson-Leitch Company of Cleveland and erected in the bicentennial year 1976. Its presence in the City was at first greeted by some with derision; they cynically interpreted it as "justice going down the drain." On the other hand, professionals such as John Clague, whose outdoor works are represented in this book, have had nothing but praise for it and Clement Meadmore, when specifically questioned, expressed the opinion that it was Noguchi's best work. These professional reactions confirm the wisdom of the Fine Arts Advisory Committee which invited Noguchi to Cleveland and approved his model. It is certainly true that its curving lines are a calculated contrast to the rectilinear design of the Center which it is intended to complement. However, the piece is interesting to this author for the architectural vistas which it frames as one moves about it. It ought be mentioned that *Portal* ultimately became a gift to the City by the George Gund Foundation.

Isamu Noguchi was born in Los Angeles in November of 1904. In 1906 the family moved to Japan where he spent his childhood attending Japanese and western schools. In 1918 he returned to America where he attended the Interlaken School in Indiana until it closed, after which he attended public high school. In 1922, at the age of 18, he apprenticed briefly with Gutzon Borglum (cf. *Start Westward*, Fig. 113), who discouraged him from pursuing a career in sculpture. Accordingly, in 1923 he enrolled as a pre-medical student at Columbia University; however, 1924 finds him studying sculpture, once again, under Onorio Ruotolo at the Leonardo da Vinci School. In 1927 he won a Guggenheim Fellowship and went to Paris for

two years where he met Alexander Calder and became an assistant to Brancusi. Following travels in China and Japan between 1930-32, Noguchi returned to New York which has been his operational base since. He is noted for his "space-creating" sculptures and environmental designs including the Unesco Gardens in Paris (1956-58) and the Chase-Manhattan Bank Plaza, New York (1961-64).

In an interview with Rena Blumberg aired in the late summer of 1979 over WDOK Radio, Cleveland, Noguchi said:

> "I am interested in the process of discovery . . . Each situation calls for an entirely different approach; realizability comes from place; place tells you what can be done . . . Portal is exceptionally large (dictated) by its particular spot . . . gigantism, by itself, is not the point . . . my concern is to make a place meaningful . . . What is an artist but somebody with an antenna, somebody who gets vibrations . . . All any artist can do is to make people more aware . . .that's all he can do . . . "

182. Portal (1976), left, by Isamu Noguchi, steel-painted black, 36' in height, located before the Justice Center, Cleveland (fabricated at the Patterson-Leitch Co. Cleveland, under the direction of David E. Davis) Although initially accepted with mixed feelings, this huge conception by the famed Japanese-American sculptor is gradually winning its way into the hearts of Clevelanders. It is particularly interesting for the architectural vistas which it frames as one moves about it: of the Cuyahoga County Courthouse to the north and of the new, East 9th Street Federal Building to the East. (Confer also Frontispiece)

183. Global Flight (1976), overleaf, by Clarence E. VanDuzer, stainless steel, c. 50' in height, installed at Cleveland Hopkins Airport to commemorate the 50th anniversary of the establishment of the facility. The especially restricted location of VanDuzer's conception certainly does not add to its fullest appreciation. The sculptor received his MFA degree from Yale University. Following teaching positions at the University of Denver and the Flint (Mich.) Institute of Art, he became, in 1957, sculptor and instructor at the Cleveland Institute of Art—a position he has held ever since. His works include fountains at Euclid Square Mall, Belden Village Mall, Richland Mall (Mansfield) and Westland Mall Shopping Center (Columbus).

145

Close by *Portal*, in a southern segment of Cleveland's Mall, one encounters **Marshall Fredericks'** *War Memorial Fountain: Peace Arising from the Flames of War* (Fig. 184). Clevelander Fredericks was commissioned to do the project in 1946, shortly after World War II. However, it was not realized until dedicated on Memorial Day in 1964. Humanity, symbolized by the bronze figure of a man, is portrayed reaching for the firmament while the flames of war, emanating from the earthly sphere, threaten to engulf him. Four, massive, subordinate sculptures, executed in charcoal-green granite, symbolize the civilizations on the inhabitable continents of the earth (Fig. 185-186). These elements, as well as the filigreed bronze sphere, are inundated with spray when the fountain is activated. Marshall Fredericks (1908-), the sculptor, was raised in Cleveland and attended the Cleveland School of Art (now the Cleveland Institute of Art). A travelling fellowship enabled him to tour Europe where he studied under Carl Milles in Stockholm. He followed Milles to Cranbrook Academy at Bloomfield Hills, Michigan, where he became his assistant and an instructor. Elsewhere, Marshall Fredericks did *The Expanding Universe* sculpture at The Department of State in Washington. Today, his studio is located at Royal Oak, Michigan.

Four miles east of the Mall, before Strosacker Auditorium on the campus of Case Western Reserve University, there is an abstract sculpture by **Tony Peter Smith** known as *Spitball*—a strange appellation for so linear a creation (Fig. 187). It is one of three made to this design, a duplicate being at Rice University and a third privately owned. *Spitball* was designed in 1961, but not installed on the Case campus until 1972 to commemorate the career of Kent Smith, longtime trustee and once acting President of Case Institute of Technology. It is 11½' in height x 14' x 14' in steel, painted black. The piece is almost a theorem in plane and analytical geometry, quite suitable for the grounds of this engineering institution where, unfortunately, it sometimes serves as a bulletin board (white blotches on our photo are remnants of masking tape). Smith was

born in South Orange, New Jersey, in 1912. He studied at the Art Student's League in New York, 1934-35; then transferred to The New Bauhaus in Chicago where he studied architecture, 1937-38. He was apprenticed to Frank Lloyd Wright between 1938-40. Since 1964 his sculpture has been exhibited in a number of prestigious eastern museums. A second Tony Smith sculpture is being installed before Cleveland's new State Office Building at year end 1979.

Nearby, on the Case Western Reserve University campus, a fountain from which a tall, lustrous, stainless steel cylinder rises to a height of 40', commemorates the important Michaelson-Morley experiment of 1889 in which the speed of light (in water) was first determined. The *Michelson-Morley Fountain* was designed by William A. Behnke in collaboration with Prof. Robert Shankland of the University's Physics Department. It brings to mind the sculptural, cylindrical columns of Antonio Pomodaro, one of which occupies a central position in the Great Hall of the Columbus Museum of Art.

(text continued on page 151)

184. War Memorial Fountain: Peace Arising from the Flames of War (1964) by Marshall Fredericks, bronze with granite base, 45'5" in height, located on the Cleveland Mall. Humanity, symbolized by the tall, bronze figure of a man, is portrayed reaching for the firmament while flames of war, eminating from the earthly sphere, threaten to engulf him. Four, massive, subordinate sculptures, carved in charcoal-green granite, symbolize the civilizations of the inhabitable continents of the earth.

185. War Memorial Fountain—Cleveland Mall (detail) overleaf. The tall, male figure was cast in Oslo, Norway; the bronze sphere-filigreed with signs of the Zodiac—in Brooklyn, N.Y. Fredericks commenced work on this monumental piece in June of 1945 so that almost twenty years were consumed in its realization. This figural grouping, with an alligator, would seem to represent central or south America.

186. War Memorial Fountain—Cleveland Mall (detail) far overleaf. The young woman in this granite grouping appears to have a Caucasian physiognomy. Sculptor Fredericks attended the John Huntington Polytechnic Institute in Cleveland and graduated from The Cleveland School of Art, Class of '30. The monument, conceived at the conclusion of World War II, is more a product of the preceding, representational era than of post-war, abstract expressionism.

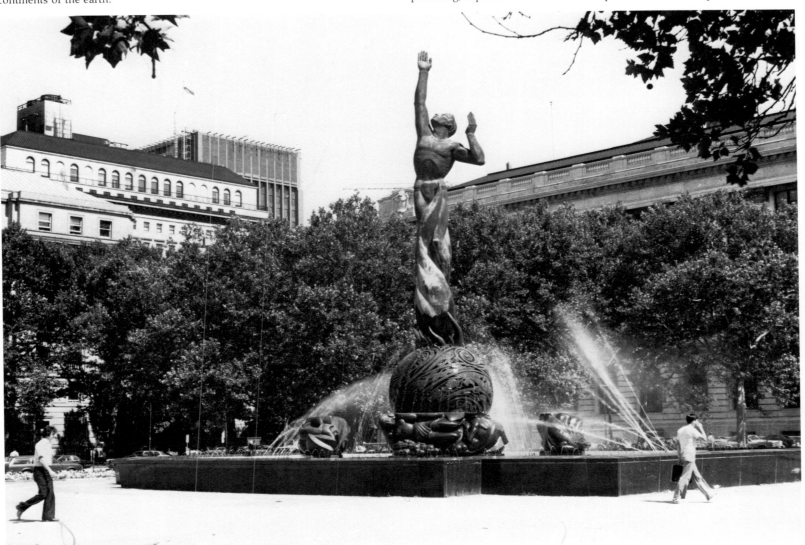

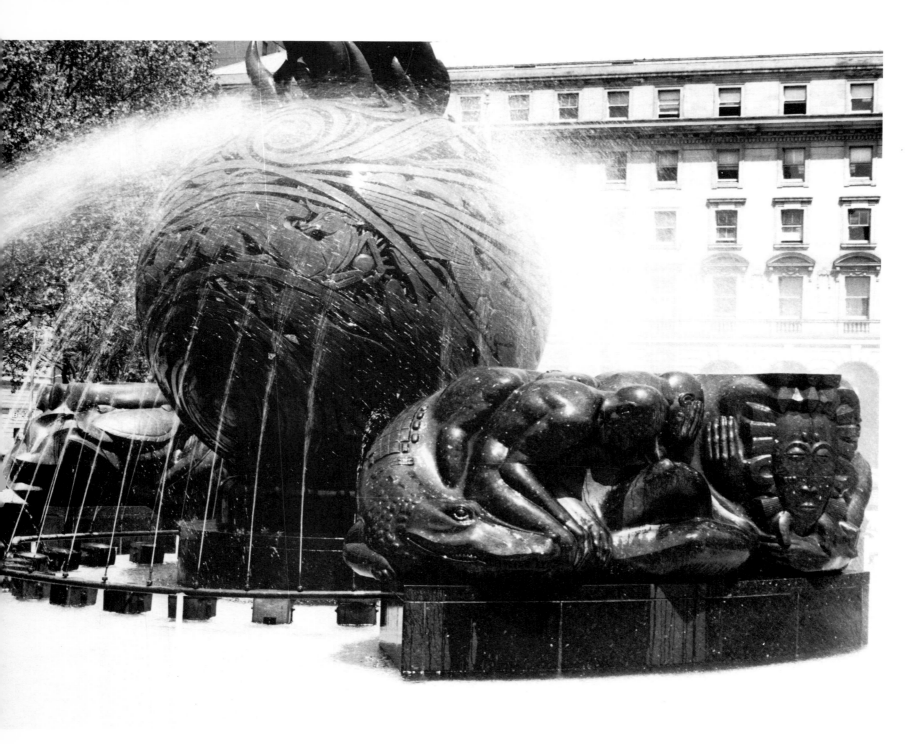

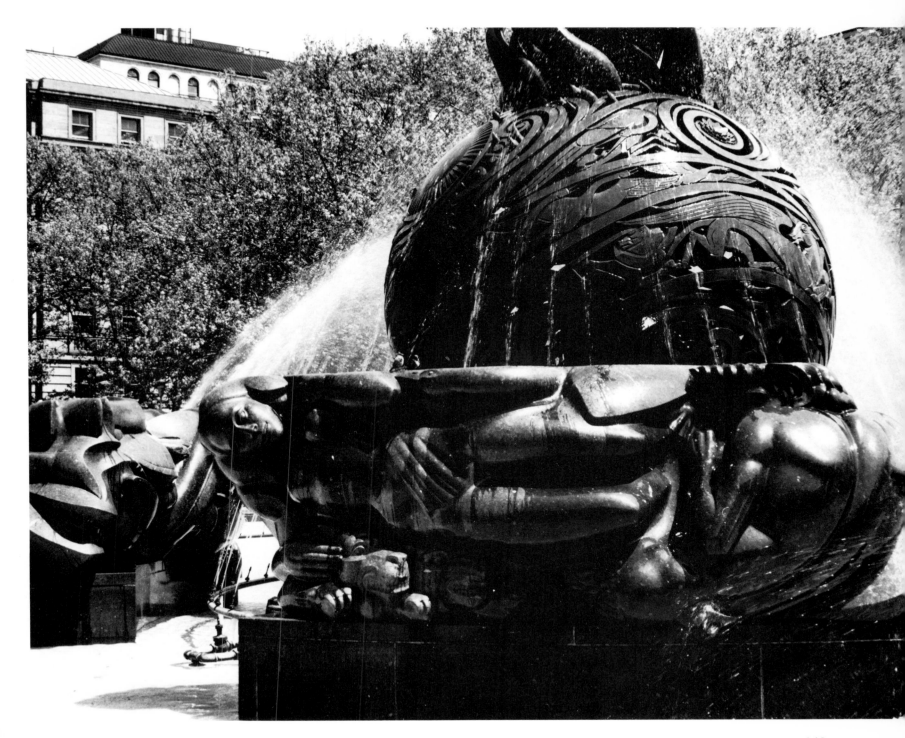

187. Spitball (1961) by Tony Smith, left, painted steel, 11½' in height x 14'x14', installed on the Case-Western Reserve campus in 1972. Tony Smith is an architect turned sculptor. Following education at New York's Art Students League, he was, for two years, associated with Frank Lloyd Wright. One of his major commissions was **Grasshopper** (1972), a massive 27-ton sculpture-big as a two story house-completed for the north lawn of the Detroit Institute of Art. As this book is in preparation, Smith is completing **Last**, a welded steel sculpture to be placed at the entrance to the new Ohio State Office Building in downtown Cleveland. William Germain Dooley equates Smith's creations with **Minimalist** art which "as in today's architecture, (employs) modular units that are interchangeable. At other times output seems to be assemblies of varying shapes of cubistic origin in random, but mechanized designs."

188. Desire to Heal by Michael Tradowsky, fiberglas reinforced plastic over a cementitious base. Dental School-Case-Western Reserve University.

Yetta Rosenberg (1905-)

The artist, a native New Yorker who adopted Cleveland as her home and studied at The Cleveland Institute of Art, has sculpted two of the larger, outdoor, contemporary, abstract, bronze pieces in the Cleveland area, both cast locally by The Studio Foundry. The first of these, a memorial popularly known as the "Flame," was unveiled August 6, 1976 (Fig. 191). It is on the grounds of The Temple located on Shaker Blvd., just east of Richmond Road. It would seem to symbolize life as a flame which may burn brightly, but which, at the same time, is extinguishable. We have noted a similarity between Ms. Rosenberg's flame and a much earlier wood sculpture by Robert Laurent (1917) in the collection of New York's Whitney Museum of Contemporary Art (illustrated in *200 Years of American Sculpture*).

The other Yetta Rosenberg sculpture stands before The Suburban Temple on Chagrin Blvd., Beachwood, west of Green Road (Fig. 189). Here an abstract arm and outstretched hand reaches 12½' to the heavens. An inscription, derived from a Robert Browning poem, etched directly upon it reads, "Man's reach should exceed his grasp or what's a heaven for?". Ms. Rosenberg states that she started out to be a painter, but gravitated into sculpture. Readers of this text will know that such deviations are not an unusual occurrence. Prior to 1975 her medium was marble or alabaster. These creations won coveted places for her in the prestigious Cleveland Museum of Art May Show; also in the Butler Museum of American Art, Youngstown; the Canton Museum and regional college exhibits.

Man, Woman and Earth is the title of a 1972 sculpture at Mayfield High School in Mayfield Heights, Ohio (Fig. 190). This is the work of **Wayne Trapp** (1940–), a native of northwest Ohio and one-time instructor in sculpture at Ohio State University. The project was made possible by a grant of government money combined with a private gift of the Cor-ten steel of which it is fabricated. In addition to this metal sculpture, Trapp has done several astonishing "sculptural houses"

151

189. Man's Reach (1978) by Yetta Rosenberg, bronze, 12′ in height, located at the Suburban Temple, Beachwood, O. Says the sculptress, "I was inspired by a Robert Browning poem which was repeated to me many times in my youth, viz., "Man's reach should not exceed his grasp, or what's a heaven for? . . . I inscribed this line on the base." Ms. Rosenberg's works have been displayed at the Butler, Canton, Toledo and Cleveland Museums; also in numerous galleries.

190. Man, Woman and Earth (1972) by Wayne Trapp, Cor-ten steel, c. 15′ in height, located at Mayfield High School, Mayfield Heights, Ohio. Trapp, a native of northwest Ohio and one-time instructor in sculpture at Ohio State University, now lives in New England. "He is a person," says Willoughby artist Louis Penfield, "who relates well to earth and the environment."

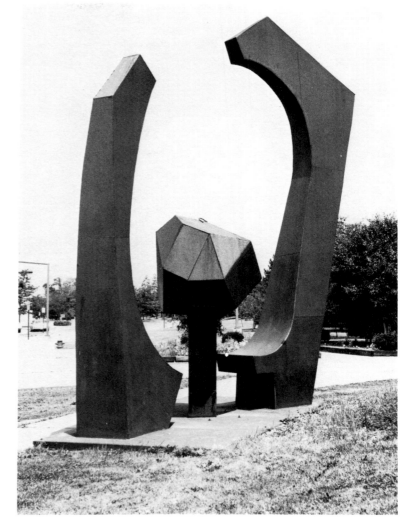

191. Flame (1976) by Yetta Rosenberg, bronze, 13' in height, The Temple Branch, Shaker Blvd. Pepper Pike, O. New York-born, Cleveland educated Yetta Rosenberg worked mainly in ceramics, until 1966 and, for the next decade, primarily with stone. **Flame** and **Man's Reach**, large bronze commissions of the late 1970's, were enlarged from the model and cast under the direction of Ron Dewey at The Studio Foundry, Cleveland. **Flame** would seem to symbolize life which burns brightly in its prime, but the ultimate fate of which is extinguishment.

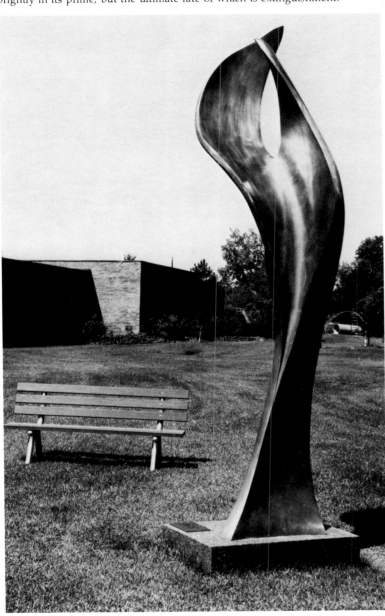

in the area, one of which is located on Cascade Road in Lake County; another in Medina. The materials employed are rebar wire and cement. Trapp now lives on a farm in New England where he continues to sculpt and build his unique "sculptural houses". "He is a person," says Willoughby artist Louis Penfield, "who relates well to earth and the environment."

Robert Fillous (1913-)

Over the principal entrance to Berea High School, southwest of Cleveland, there is a monumental, cast aluminum sculpture 10' wide x 15' high, designed and excuted by Robert Fillous (1913-) in 1967 (Fig. 192). At the base of this sculpture, a tree-of-knowledge symbolizes the disciplines to which the pupil is exposed; namely, the sciences, history, geography, economics, art, etc.; above, the Rocky River, which bisects Berea, is shown flowing northward between the Cleveland Hopkins International Airport and N.A.S.A. Laboratories. Small amounts of color and studied variations in texture, add form and interest to the whole.

Robert Fillous is the son of James Fillous (1889-1979)*, an important wood carver, who came to Cleveland from Bohemia in 1900 at the age of eleven. In 1904 he apprenticed himself to Rorimer & Hays (later Rorimer & Brooks) as a wood carver. Today he is the last survivor of the hundreds of carvers active in Cleveland at the turn of the century and, notably, the only one who could faithfully emulate the style of Grindling Gibbons. Artisans like the elder Fillous found work in studios such as Brooks, Rorimer, and Bonhard which fashioned custom furniture for Cleveland's first families; also with

*James Fillous passed away on Sunday, December 2nd, as this manuscript went to press.

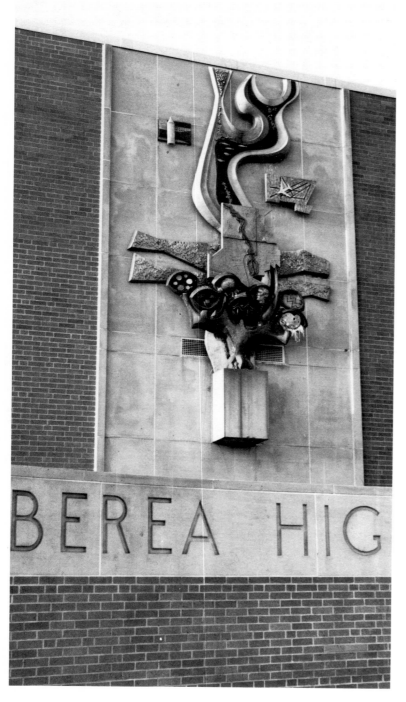

architects, notably Charles Schweinfurth, who designed homes incorporating elaborately carved mantel-pieces, linen-fold panelling, etc. for the same clientele.

Robert Fillous attended the Cleveland School of Art where he studied sculpture under Alex Blazys and Walter Sinz. He fondly remembers Sinz as the finest teacher he ever knew—a dedicated man—one thoroughly versed in casting procedures and an exceptional wood carver as well. Sinz, he related, gave unstintingly of his time to advance the work of his students; it was commonplace for him to stay well beyond classroom hours to assist a student with a casting. For a number of years the younger Fillous has been associated with the firm of Fillous & Ruppel, founded by his father, in Cleveland. In addition to the Berea High School sculpture, he has completed a similar project for the Woodland Hills Elementary School at East 93rd Street and Union Avenue in Cleveland; his *Justice* accents the facade of the Erie County Courthouse in Sandusky, Ohio, and his cut-stone sculpture embellishes the Timken Vocational School in Canton. Elsewhere, at Mystic, Connecticut, his *Birth of a Whale* is the central element of a fountain before the Mystic Aquarium. Robert Fillous also did the three leaping dolphins at the Niagara Falls Aquarium. "Did you know," he declares, "that the whale is the only mammal whose head is born last?—that an attending female is present at every whale birth?"

192. Berea High (1967) by Robert Fillous (1913–), polychrome cast aluminum, height-c.15', facade of Berea High School, Berea, Ohio. At the base a free-standing tree of knowledge portrays various branches of the school's programs: science, history, geography, the arts, etc. In the background, a free-flowing form indicates Rocky River flowing north to Lake Erie which, while enroute, crosses other forms recalling the trees of Metropolitan Park. Superimposed upon this is a conventionalized map of Berea. Further north the River flows between the National Aeronautical and Space Laboratories and Cleveland Hopkins Airport. Robert Fillous is the son of the renowned wood-carver, James Fillous. (1889–1979)

193. Moses, right, by Ivan Mestrovic (1883-1965), bronze, 2'x3', acquired 1966 by The Temple, Shaker Blvd., Pepper Pike, O. from Olga Mestrovic, the sculptor's widow. Mestrovic, a Yugoslav sculptor, spent his post World War II years in America. First, as Professor of Fine Arts at Syracuse University (1947–55), then at Notre Dame University (1955–1965). The bronze **Moses** is one of two cast from the same plaster mold—long since destroyed. His conception of Moses is compelling, monumental in spirit, if not in size. Mestrovic's **Jeremiah**, a 1952 work, is displayed in the lobby of The Jewish Community Center, Euclid Ave. at E. 18th Street, Cleveland.

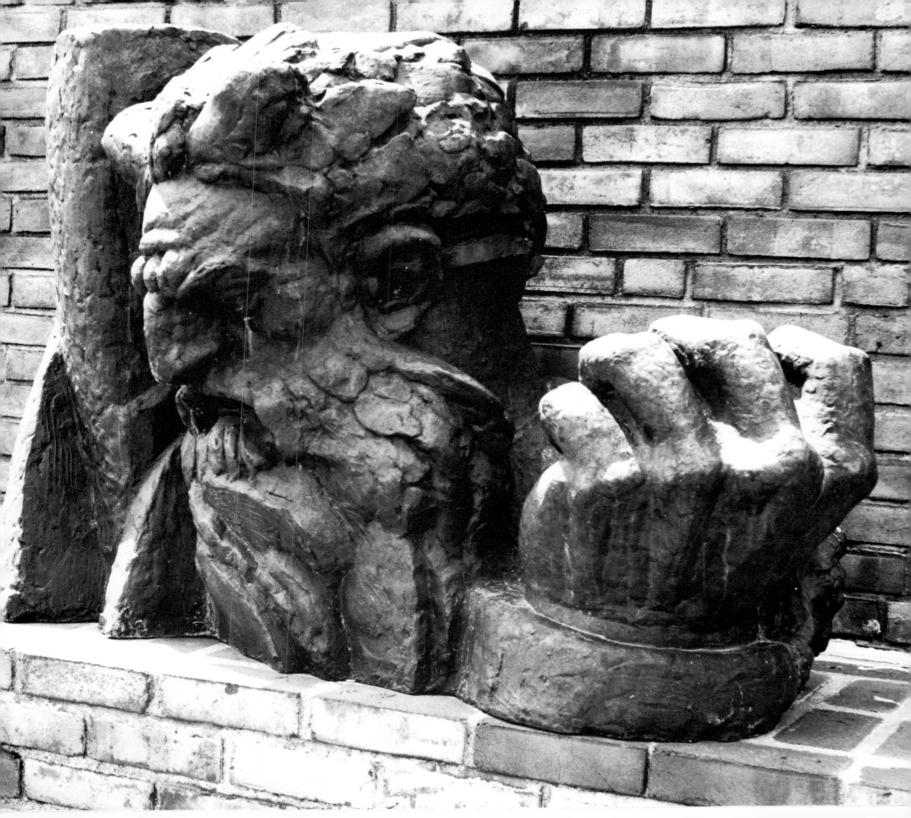

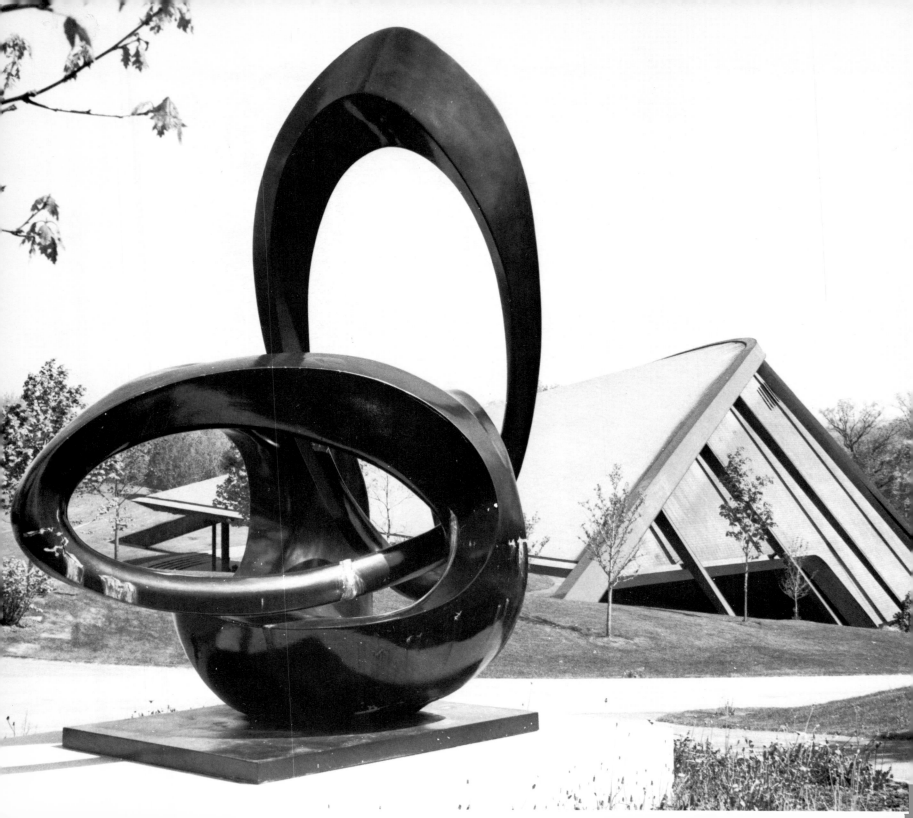

Blossom Music Center

There are, at the present time, two sculptures at Blossom Music Center in Northampton Township between Akron and Peninsula. One of these, known as *Kulas Cleff,* is the work of **William McVey** (Fig. 195);[22] the other, much more imposing and of greater mass, is *Genesis XI,* a creation of the Spanish-Canadian sculptor, **Keiff** (Fig. 194). This piece, 14' in height and weighing three tons, was given by Mr. & Mrs. C. Bingham Blossom in honor of Mrs. Dudley S. Blossom, Jr. It was cast in Kieff's Montreal studio and dedicated at Blossom, where it stands on a 13 ton granite base, in September of 1974. The elliptical forms of the sculpture are an ideal foil before the parabolic arch of the Music Center.

Notes from the catalogue of a Kieff exhibition at Brainard Place in Lyndhurst (Ohio), October 17, 1974, say of this piece:

> "In this variation Kieff seems to have a greater sense of mass defined by lines moving in space. The great loops of bronze, rather than being graceful drawings in air, seem here to encompass the space."

(text continued on page 165)

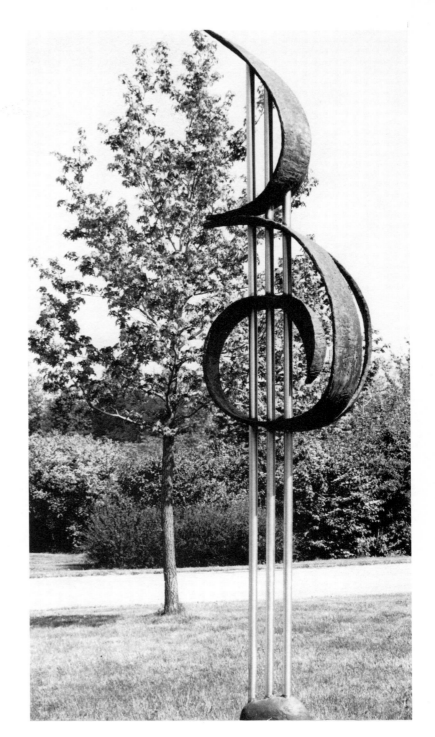

195. Kulas Cleff (1973) by William McVey, bronze and stainless steel, 11' in height, located at Blossom Music Center, Northampton Twnshp., Summit County, O. This huge musical symbol not only sets the tone for all who enter the precincts of the Music Center, but also honors the Blossom family whose philanthropy made the cultural facility possible.

194. Genesis XI (1974) by Kieff, left, (Spanish-Canadian, (1936–), bronze, 14' in height on a 13-ton granite base, located at Blossom Music Center. Kieff, born in Madrid, studied art, music and architecture in Madrid, Buenois Aires and Vienna. Genesis XI was cast in his Montreal studio in the early 1970's and given to the Music Center by Mr. and Mrs. Bingham Blossom in honor of Mrs. Dudley S. Blossom Jr. The metal casting, exclusive of the base, weighs three tons. When exhibited at Brainard Place in Lyndhurst in 1974, a catalogue description noted that " . . . In this variation Kieff seems to have a greater sense of mass defined by lines moving in space. The great loops of bronze, rather than being graceful drawings in air, seem here to encompass the space". It is, it might be added, a marvelous foil for the curvi-linear form of the Center itself.

196. Law and Society (1972) by Barna von Sartory, 32-ton block of Indiana limestone on a stainless steel base, Fountain Square, Cincinnati. Donated by Charles Sawyer in celebration of, the 100th anniversary of the Cincinnati Bar Association. The author considers this originally controversial piece to be an entirely suitable symbol of the solid, basically immutable body of law which governs the land. Nearby, in the Federal Reserve Bank Park at 5th and Main Streets, there is a very contemporary stainless steel **Fountain Sculpture** (1972) by Oliver Andrews. In it water cascades down and over two geometric shapes contained within a reflecting pond; the tallest is 12' in height, the other, a prismatic shape, is 16' in length. This stunning ensemble adds greatly to the redeveloped Fountain Square/Government Square sector of the City.

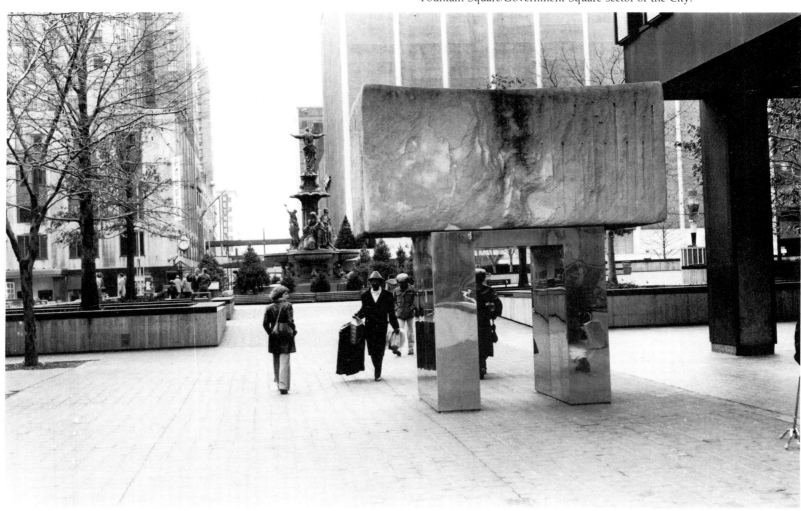

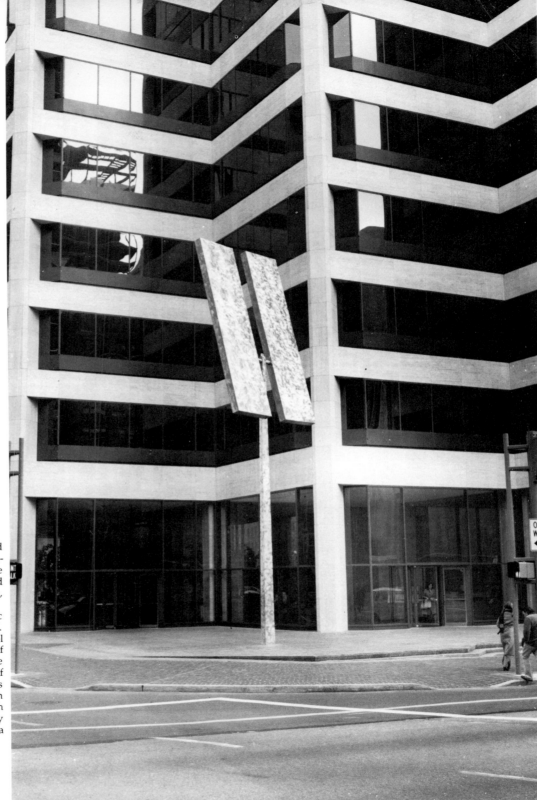

197. Two Rectangles Vertical Gyratory IV (installed September, 1979) by George Rickey (1907–), stainless steel, 44' in height x 12' in width. The mobile rectangles have the dimensions 20'x5'x10''. Located before the Central Trust Co., Government Square, Cincinnati, Ohio.

George Rickey, one of America's foremost kinetic sculptors, was born in South Bend, Indiana in 1907. He studied at Trinity College-Scotland and Balliol College-Oxford; also at the Ruskin School of Drawing-Oxford as well as at the Academie Aude L'Hote in Paris. His works are in the collections of Buffalo's Knox-Albright Museum, the Smithsonian's Hirschorn Museum, New York's Museum of Modern Art — to mention but a few. It is fascinating to watch the stainless steel panels "swing and sway" as they react to whatever breeze is available. (cf. Fig. 156 for a variation of Rickey's "theme")

199. Helios Guardian (1964) by Michael D. Bigger, Cor-ten steel, 24' in height, located at the Cincinnati Zoo. Bigger, an Illinoian, received his BFA degree in Architecture from Miami University of Ohio and an MFA in Sculpture from the Rhode Island School of Design. He is currently Chairman of the Sculpture Department at the University of Manitoba (1975–). **Helios Guardian** occupies a mound at the southeast extremity of the zoological gardens. Did the sculptor wish us to conjure visions of shield-bearing Greek hoplites guarding the sun-god (Helios)? This monumental piece was the first abstract sculpture, on so large a scale, to be installed in the "Queen City."

200. Fountain Sculpture (1970's) by Antonio Pomodaro, Skywalk-downtown Cincinnati

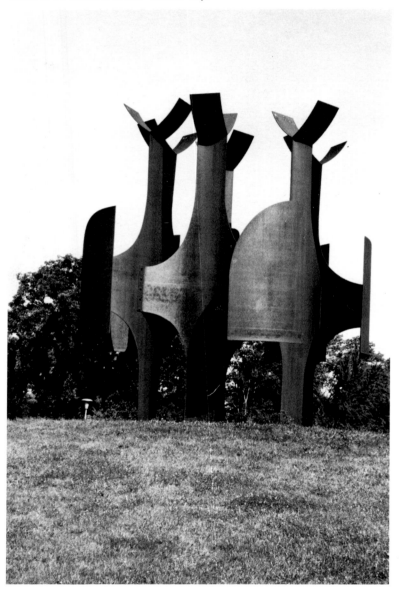

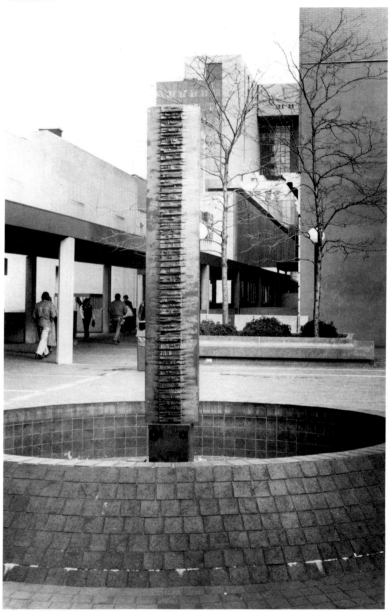

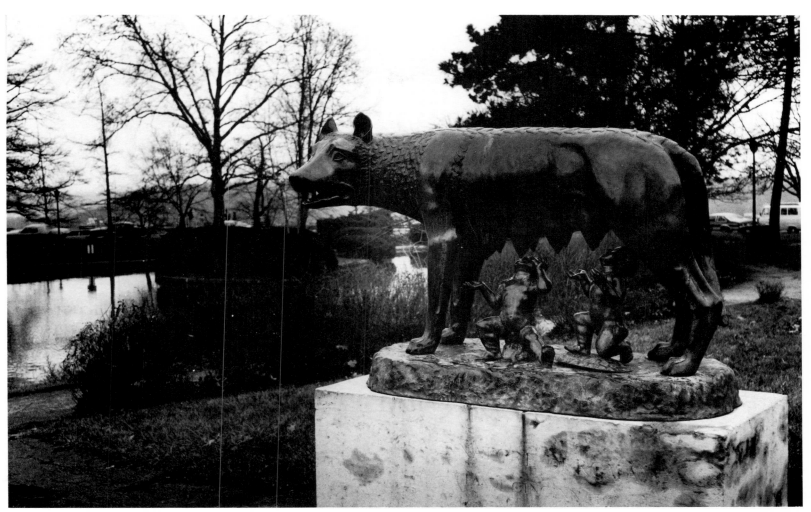

201. Capitoline Wolf (1931/32) River Overlook Eden Park, Cincinnati. This "she-wolf", symbol of the City of Rome for 2,500 years, was a gift of the Italian nation to Cincinnati at the behest of Mussolini. It was received in connection with the celebration of the bicentennial state convention of the Sons of Italy held in Cincinnati in 1931, in recognition of the fact that it is the only American city to bear the name of a Roman hero. The wolf is a fine specimen of Etruscan art of the 5th century BC; the suckling babies, Romulus and Remus, were a Renaissance addition to the original.

202. Relief Sculpture (1931) Cincinnati Union Terminal facade. Albert Feldheimer & Stewart Wagner, architects. Art Deco, of which this relief sculpture is a splendid example, flourished between the two World Wars (1918–1938). It represents, in sculpture, a distinct departure from the studied classicism of preceding centuries. "Elsewhere in the City there is a memorial to **William Cooper Proctor** by Bruce Haswell which, likewise, is a splendid example of the Art Deco period. In it, an engaged figure of Proctor, founder of Proctor & Gamble Co., stands at one end of the massive, limestone rectangle; while on a side figures in medium relief proceed a background suggesting the importance of river and rail transportation to the City.

203. Vortex V (1979), by Jon Barlow Hudson (1945-), stainless steel, 13'H, located before the Toledo Municipal Court Building. **Vortex V** was winner in a sculpture competition sponsored by The Arts Commission of Greater Toledo. "Vortes V is a highly original and imposing sculpture. It is totally resolved in its form, yet exciting. It is dynamic and highly dramatic with changing light sources and light intensity."—Roger Mandel, Director of The Toledo Museum of Art. Born in Billings, Montana, Jon Barlow Hudson attended Urbana College at Urbana, O. He received a BFA degree from The Dayton Art Institute in 1975 and was an Adjunct Instructor at Wright State University, Dayton, during the academic year 1976–77. (photo courtesy Mr. Hudson)

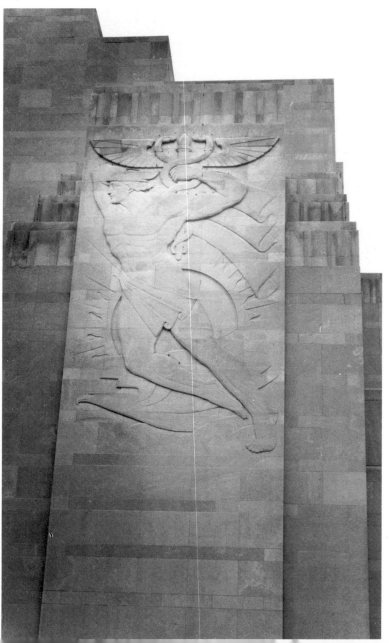

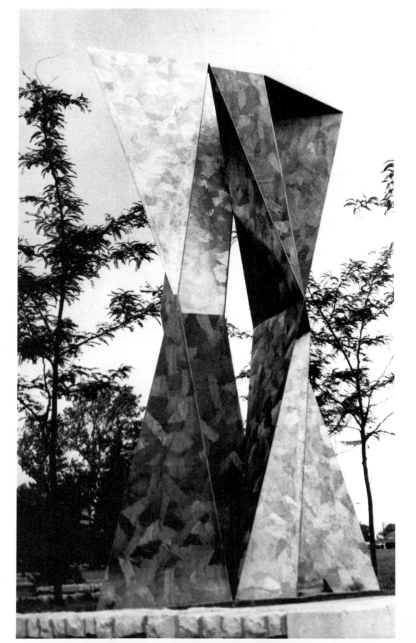

204. Chamber of Commerce Building (1889/1972) vestige at Burnet Woods, Cincinnati. In August of 1885 the great American architect, Henry Hobson Richardson, won a competition to design and build the Cincinnati Chamber of Commerce. The building, completed after his death in 1886, occupied a site 100'x150' at Fourth and Vine Streets in the heart of the City. It was a massive construction employing pink Milford granite for its outer, load-bearing walls-battered at their base and designed in his much imitated, personal interpretation of the medieval, French Romanesque style. Surviving remnants of this building which was gutted by fire in 1911, have been artfully arranged into an environmental sculpture by students and faculty of the College of Design, Architecture and Art, University of Cincinnati. The design competition for this "operation resurrection" in 1972 was won by Steven Carter.

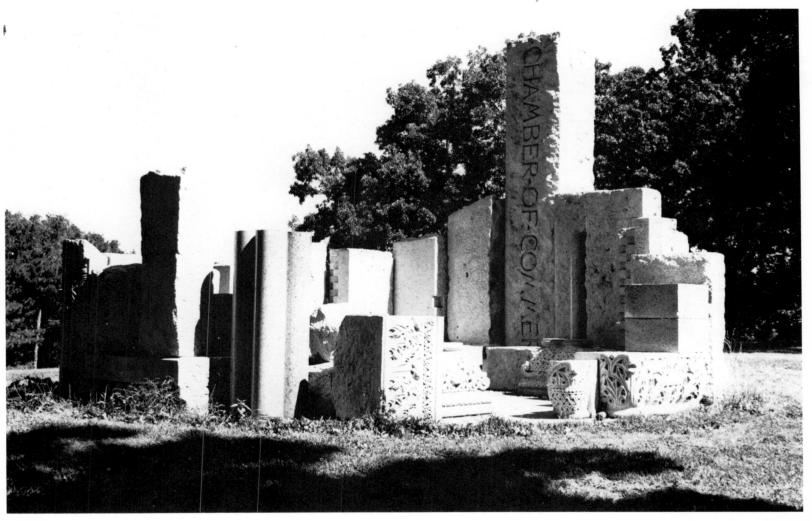

205. **Bright Medusa** by William McVey, Tennessee marble, size of a four-month old baby, located at the entrance to a private home in Moreland Hills, Ohio. One familiar with the work of McVey would spot this piece immediately as coming from his hand. McVey seems always mindful of Michelangelo's dictum that a good piece of sculpture ought be able to roll down a hill without sustaining damage. This lovely sculpture sets the tone for the sophisticated residence one is about to enter.

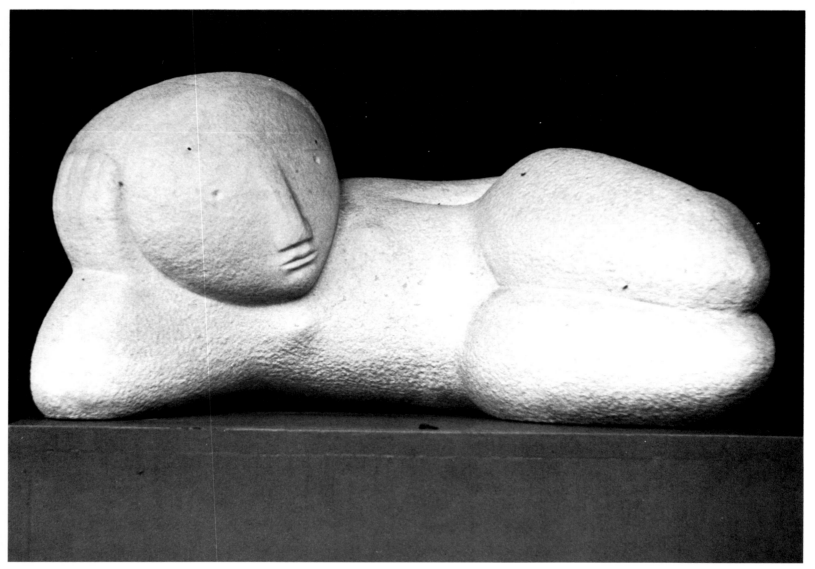

THE NEW PATRONAGE

Traditionally in America, governments and quasi-public institutions have been the major sponsors of sculpture to commemorate a great public figure, an historic event and/or to add beauty and meaning to a public space. One has but to review the patrons of the monuments and sculptures to the mid-twentieth century, contained herein, to substantiate this assertion. Occasionally, as with Cleveland's Fine Arts Garden (particularly that portion immediately south of The Museum of Art) a civic-minded individual or family has been prompted to make a gift towards the beautification of the city (Fig. 89). The Tyler-Davidson Fountain in Cincinnati is another, comparatively rare illustration of such civic enlightenment. (Fig. 7)

However, in our consideration of post World War II sculpture, most of it abstract, we have seen a new sponsorship of the art-form in an environment where previously it was rare, if not nonexistent; i.e. (1) on the college or university campus and (2) in close association (symbiotically) with commercial (and public) buildings. The intention here is to beautify, to enhance the environment, rather than to commemorate. On the campus we have seen Don Drumm's work at Bowling Green State University, Tony Smith's piece at Case-Western Reserve, Claes Oldenburg's at Oberlin, Helen Morgan's at Wittenberg College, James Anderson's *Urschleim* at Muskingum and others. Kenyon College at Gambier, which we have not heretofore mentioned, has a fine **Charles Eugene Gagnon** entitled *Renaissance Man and Woman* (Fig. 173) which stands before the College Library. Elsewhere on this campus, before Bexley Hall, one encounters *Rake Curls* fashioned of resin-impregnated fiberglass over plywood with trailing stainless steel troughs (Fig. 175) by **Barry Gunderson** of the Kenyon Art Department. One must imagine a giant rake scarring the earth. Painted red, 45' in length times 11' in height, it is popularly referred to as the "red spaghetti" by students. A comparatively new piece by **Michael Tradowsky**, entitled *Desire to Heal* (Fig. 188), also

of reinforced fiberglass, adds an artistic note to the otherwise stark entrance to the Dental School at Case Western Reserve University. The introduction of sculpture onto the college campus, as an environmental enhancer, is a quite new development. Elsewhere in the Nation, the John B. Putnam Memorial Collection at Princeton University (the gift of an Ohio family), comprised of twenty-one pieces by renowned sculptors, judiciously placed in the wooded, Gothic milieu, carry this trend to its ultimate realization.

Increasingly, businessmen too, are turning to sculpture as a means of enhancing the corporate image as well as the environment about its office headquarters. As this is written a George Rickey kinetic sculpture, one of his largest fabrications, is being placed in a public plaza before Cincinnati's Central Trust Co. Another is planned for a similarly important place before Cleveland's new National City Bank Tower now being topped-off at East 9th and Euclid Avenue. Elsewhere, we have seen this trend in the cast aluminum wall sculptures of Robert Koepnick in Sidney, Vandalia and Dayton; also in David E. Davis' projects before Lakewood's Beck Center and The Progressive Insurance Company at Highland Heights, Ohio.

The architecture of large public, as well as private, buildings is often so starkly geometric, today, so void of decoration, that it is becoming increasingly the mode to set-a-building-off, as it were,—to humanize it—by placing an abstract sculpture, most often fashioned of welded steel, in a symbiotic relationship therewith. Noguchi's *Portal* before the Cleveland Justice Center is exemplary of this contemporary practice, as are also the abstract sculptures by Tony Smith and Gene Kangas being installed, as this is written, before Cleveland's new State Office Building immediately east of the High Level Bridge. It needs emphasizing that these are not commemorative statues, as for example, the earlier realistic monuments of Pres. McKinley before the Lucas County Courthouse, Toledo and elsewhere, or the Kalish *Lincoln* before the Board of Education Building on Cleveland's Mall; rather they are abstract additions to

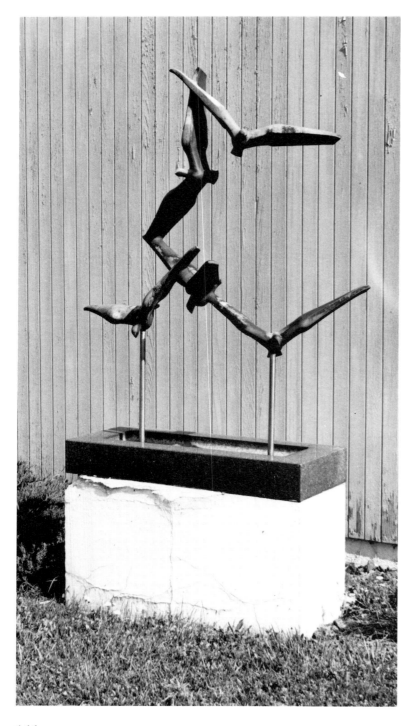

the immediate environment, *they are meant to be an aesthetic experience*. It is futile to look for further meaning in a Tony Smith *Spitball*, a David Davis *Harmonic Grid* or a John Clague *Auriculum*.

It can well be said that in the final half of the twentieth century sculpture, imbued with a new ferment, has come out of the park and out of the cemetery and become an everyday part of our public, commercial and educational life. This book serves a useful purpose if, to borrow Isamu Noguchi's words above, "it makes people more aware."

206A. Auriculum I by John Clague, Ashland College, Ashland, Ohio. (cf. also Fig. 110, page 92 and its caption). **Auriculum** is illustrative of the new patronage for sculpture and its increasing prevalence on the college and/or university campus.

206. Gulls (1955) by William McVey, left, bronze on a cementitious base, 4½' in height. There are two sets of gulls; one at The Brookside School in Detroit, the other, pictured here, before the contemporary home and studio of the sculptor in Pepper Pike, Ohio. The beauty of these, with the bare-wall back-drop, is that in brilliant sunshine large shadows are cast. This, says McVey, is one way to achieve a rather large effect from something comparatively small! It is meant to be a bird bath.

207. Anthropomorphic Observation (1978) by Jon Fordyce, welded steel, gift of the Robbins & Myers Corporation to The Springfield Art Center, 10' high. Jon Fordyce of New Carlisle, Ohio, was born at Cambridge (Ohio) in 1943. He received his BFA degree from Ohio University at Athens (1961–65), did post-graduate work at the Dayton Art Institute (1966–68) and was an MFA candidate at Ohio University in 1969. He has exhibited at numerous art shows in Ohio from 1964 to the present and has won prizes for his sculpture at Salt Forks Arts and Crafts in both 1975 and 1977. The intent here would seem to be the placement of things and the manipulation of volumes in space. **Anthropomorphic Observation** is indicative of the new patronage for sculpture.

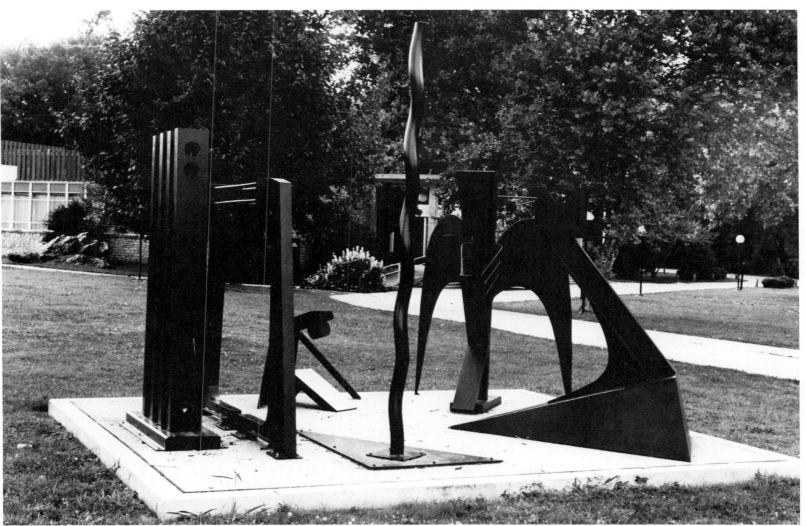

209/209A. Sounding Sculpture (1976) by Harry Bertoia (1915–1979), Tobin bronze rods circa 10 feet in height, weight-675 lbs. Alumni Center, Bowling Green State University. This sound sculpture and its splendid situation result from the total collaboration of the sculptor and architect Thomas T. K. Zung. The piece consists of 62 bronze rods of slightly differing height which are welded to a thin metal base, but are free to move at the top. In a gentle breeze they come in contact making a deep reverberating sound. In the years before his recent death Bertoia spent much time working on perfecting the interplay of sound, motion and sculpture - even as Cleveland's John Clague. Born in Italy, Bertoia came to Detroit in 1915. He spent six years at Cranbrook Academy both as student and teacher. In 1950 he established a studio at Bally, Pa. where he, at first, developed the Bertoia chair. Soon he commenced concentrating on sculpture. Internationally famous, his creations may be seen at the General Motors Technical Center, Warren, Mich.; at The Manufacturers Hanover Bank, N.Y., at The Northwestern National Bank, Minneapolis, and before the Allentown, Pa. Museum of Art. Several of the latter are examplary of the new patronage for sculpture.

208. Triad (1978) by Leon Gordon Miller (1917–), opposite, lower left, beaten copper, three 10' panels hung on 18' stainless stanchions, Cleveland State University. Although known internationally as an industrial designer, Leon G. Miller is a person of manifold talents including wood engraving, photography, interior and stainglass window design. A native of New York City, his career has been largely spent in Cleveland. "I believe, he says, "the really distinguishing talent possessed by artists is their ability to see — to perceive the beauty that exists in natural forms and to be inspired by this intimate view in the creation of their work."

209A. Bertoia Sounding Sculpture, opposite, lower right, this photograph illustrates the installation of Harry Bertoia's kinetic sculpture on its pedestal before the Alumni Center at Bowling Green State University.

210. Audrey I by Kenneth Snelson, stainless steel and aluminum, Cleveland Museum of Art Scultpure Garden. Snelson refers to a series of similar sculptures as "force diagrams in space. The tension of the stainless steel cables on the aluminum tubes and the simultaneous counter-pressure of the tubes against the cables, opens volumes of space which are punctuated, outlined and defined. "

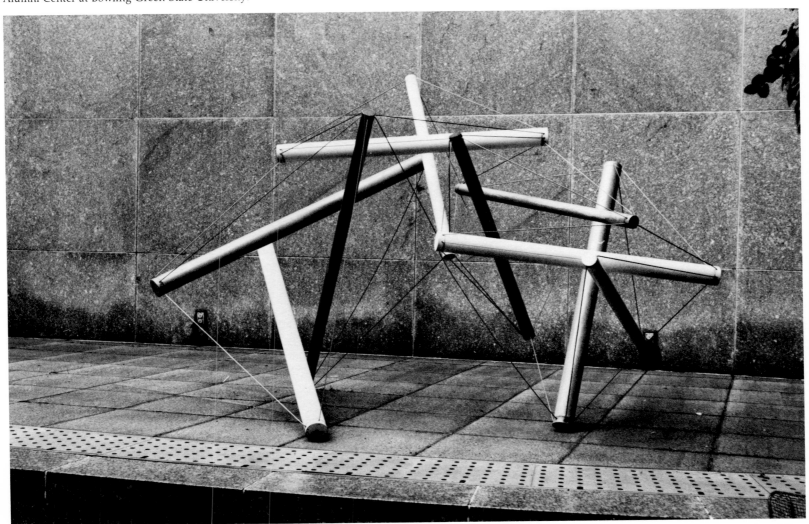

169

211. Terminal (1979) left by Gene Kangas (1944–), welded steel pipe in combination with ¾'' steel plate, 21'x32'x13', west end Ohio State Office Building, Huron Road at Superior Ave. Cleveland. **Terminal** was designed to enhance the environment at the knife-edge, western end of Cleveland's new State Office Building. Family members modeled for the steel silhouettes which now permanently 'inhabit' this corner. Overhead, simulated song birds entertain with their imagined chirping. Painesville-born Kangas received his BFA degree from Miami University (Ohio) and his MFA from Bowling Green State University. He was an instructor in art at the University of North Carolina from 1968–1971 when he joined the art faculty of Cleveland State University.

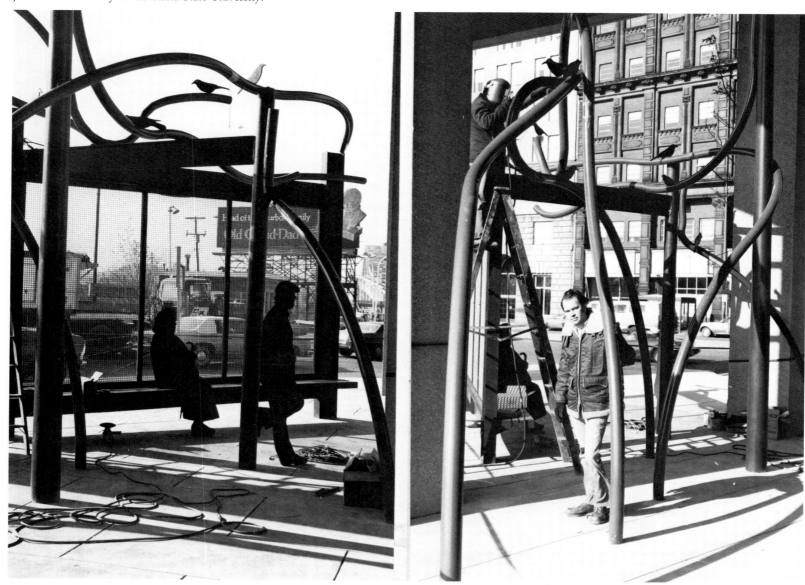

212. Last (1979) by Tony Smith (1912–), steel painted orange, 35'hx75', located at the eastern entrance to Cleveland's Ohio State Office Building. This monumental piece is a composite of six, hollow, rhomboidal sections, 6'x7', assembled in place and joined interiorly. The title stems from the sculptor's proclamation that this is the **last** arch he will undertake - having done others at MIT, the University of Nebraska and elsewhere. "This is very exciting," he said while watching the installation, "I am very happy about the way it sits in relation to the building. It is also typical of the classical quality I like to get into my work" (24) There is a dynamic quality in **Last** in that it is rigidly held out of perpendicularity. It was fabricated by the Industrial Welding Co. of Newark, N.J.

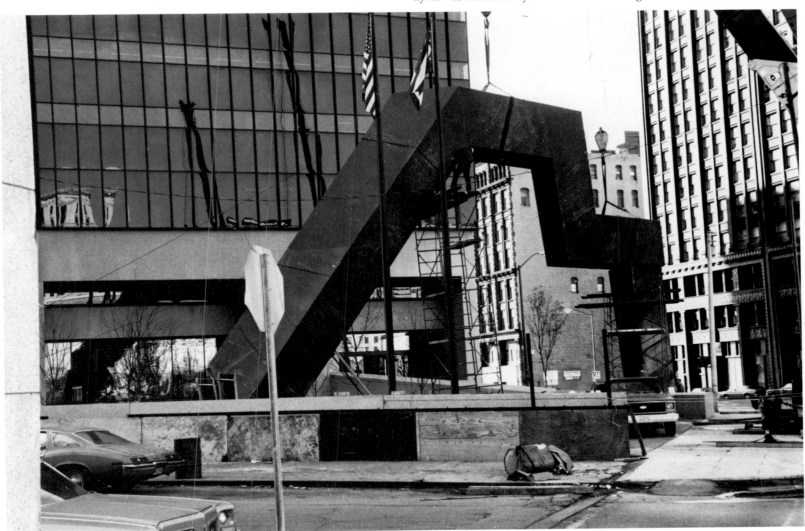

Notes

[1] *New York Sculpture* by Frederick Fried, Dover Publications (1976)

[1a] John Quincy Adams Ward was born in Urbana, O. in 1830. His last work was the pediment of The New York Stock Exchange. Other important commissions are: George Washington on the sub-Treasury steps, New York City and Pres. James Garfield on Capitol grounds, Washington, D.C.

[2] for details cf. *The Public Monument and its Audience*, Doezema/Hargrove

[3] From *200 Years of American Sculpture* in a biographical note on Clark Mills we learn: "Although Mills had never seen an equestrian statue, his model was accepted and on January 8, 1853, his bronze *Major Gen. Andrew Jackson* was unveiled in Lafayette Park opposite the White House. Cast by Mills, himself, in his "foundry" outside Washington, this statue was the first equestrian and first major bronze sculpture to be cast in America."

[4] Louis Rebisso (born, Italy-1837; died Cincinnati, 1899) was the first instructor in modelling at the Cincinnati Art Academy.

[5] Alexander Doyle's *Horace Greeley* (1890, Greeley Square, N.Y.) may have been Matzen's precedent (cf. New York Civic Sculpture)

[5a] 174 lives were lost in the calamitous Collinwood High School fire which occurred on March 4th, 1908. The monument was unveiled in this same year.

[6] The Gandola Brothers operated a monument shop (stone sculpture) on Euclid Avenue in Cleveland in the vicinity of Lake View Cemetery. The brothers, Attilio and Paul Mario, were born at Bassano, Italy in 1884 and 1889 respectively. Both had excellent art backgrounds. Paul Mario was a pupil at the Milan Academy of Fine Art and ultimately became associated with the Cleveland School of Art. They did stonework on many important buildings including Salt Lake City's Mormon Church, Cleveland's City Hall and CAC Buildings. Reference: *History of Cleveland Area*-Avery Q986.1-125 Vol 2.

[7] The reader is referred to *Federal Art in Cleveland*© The Cleveland Public Library, for detailed information on WPA art in the City. 1974 publication.

[8] These facts concerning Frank Jirouch's life stem from an interview with the author in 1964 at which time our photo was also taken.

[9] These facts concerning the career of Walter Sinz's life were derived from a personal interview in November of 1964. Among his beautiful medallions, I was shown (and photographed) those of Dag Hammarskjold (1905-61), Pony Express Centennial (1961), Kansas Statehood (1861-1961), U.S. S. Constitution "Old Ironsides" (1812-1962), Battle of Lake Erie (1813-1963), Nevada Statehood (1864-1964), John Rolfe (1585-1622) (Father of Tobacco), Boy Scouts of America (1910-1960), New Jersey Tercentennial (1664-1964), St. Louis Fur Traders: Pierre Laclede and Auguste Choteau (founders of the City) 1763-64).

[10] Cor-ten is the trade name of a steel alloy which rusts so far and no farther. *Solar Totem* is the name given by Drumm to his abstract metal sculptures of the *Bridge Over Troubled Waters* type. The *Kent State Four* refers to four students slain on that campus in connection with rioting when the US bombed Cambodia during the Vietnam War. The *Jackson Two* has reference to deaths in race rioting in Mississippi.

[11] *Hankchampion*, a 1960 work by Mark de Suvero, is pictured on page 188 of *200 Years of American Sculpture* published by The Whitney Museum of American Art, NYC.

[12] Quote from The Dayton Art Institute News Release Summer 1979 Sculpture Exhibit dated 7/79.

[13] For complete details and analysis of this piece cf. Dayton Art Institute Bulletin No. 1, Vol. 36.

[14] Correspondence with Ms. Gail Landy, Dayton Public Library.

[15] Dennis Oppenheim is a contemporary, avant-garde sculptor of the "conceptualist" school. Many of his sculptures would not be recognized as such by the average citizen.

[16] There is a duplicate of *Large Oval with Points* on the Princeton University campus, a part of the John B. Putnam Jr. Memorial collection.

[17] Gleaned from an article by Mary McGary, a columnist, in the *Columbus Dispatch* (1968).

[18] From an article on Athena Tacha by Monica P. Williams which appeared in the Cleveland *Plain Dealer* Sunday Magazine, August 26, 1979.

[19] Clement Meadmore presented an illustrated lecture concerning his sculpture under the auspices of the Blossom-Kent Summer Art Program, August 8, 1979.

[20] Quotes in this paragraph are from the same source as 18 above.

[21] *Bulletin* of The Cleveland Museum of Art, May, 1979.

[22] This musical symbol also suggests the letter "B" for the Blossom family whose generosity made the music center possible.

[23] pp. 17-19 *The Western Reserve:* The Story of New Connecticut in Ohio by Harlan Hatcher World Publishing Co. (1966)

[24] Quote from a full-page article with photos in The Cleveland Press November 16, 1979. Story by Helen Cullinan.

Bibliography

The Public Monument and Its Audience
> June Hargrove/Marianne Doezema
> Cleveland Museum of Art/
> Kent State University Press distributors

200 Years of American Sculpture
> Numerous contributors
> Whitney Museum of American Art, N.Y. (1976)

Outdoor Sculpture - Object and Environment
> Margaret A. Robinette
> Whitney Library of Design/Watson-Guptill Publications, N.Y.
> (1976)

New York Sculpture
> Frederick Fried
> Dover Publications, New York (1976)

American Sculpture in Process
> Wayne Anderson
> New York Graphic Society/Little Brown & Co. (1975)

Sculpture in America
> Wayne Craven
> Thomas Y. Crowell Co. (1968)

Dale Eldred: Sculpture into Environment
> Ralph T. Coe
> Regents Press of Kansas, Lawrence, Kas. (1978)

Ohio Art & Artists
> Edna Marie Clark
> Garrett & Massie, Publishers, Richmond 1932

The Outdoor Sculpture of Washington, D.C.
> copyright 1974 by James M. Goode
> The Smithsonian Institution Press #4829

Origins of Modern Sculpture
> Albert Elsen
> George Braziller, New York (1974)

213. Relief figures flanking the street level showcases of the Cleveland Public Library, completed in 1925; if not in the fully developed Art Deco style, these certainly are a departure from earlier classical precedent. They were modeled by Fischer & Jirouch.

General Index

Italicized numbers refer to photograph page numbers; normal type face to textual references.

214. Clench by Clement Meadmore, painted steel, circa 10′ in height, installed (January 1980) at the entrance of Developers Diversified, Inc., NE corner U.S. 422 and Ohio 91 in Moreland Hills, O. Clench is a stunning work, artfully positioned in symbiotic association with the firm's new, contemporary, corporate headquarters. In this, sculptor Meadmore continues his explorations with convolutions of the square tube on a massive scale. It is yet another example of the new (corporate) patronage of the art form. (cf. also Fig. 157, page 127)